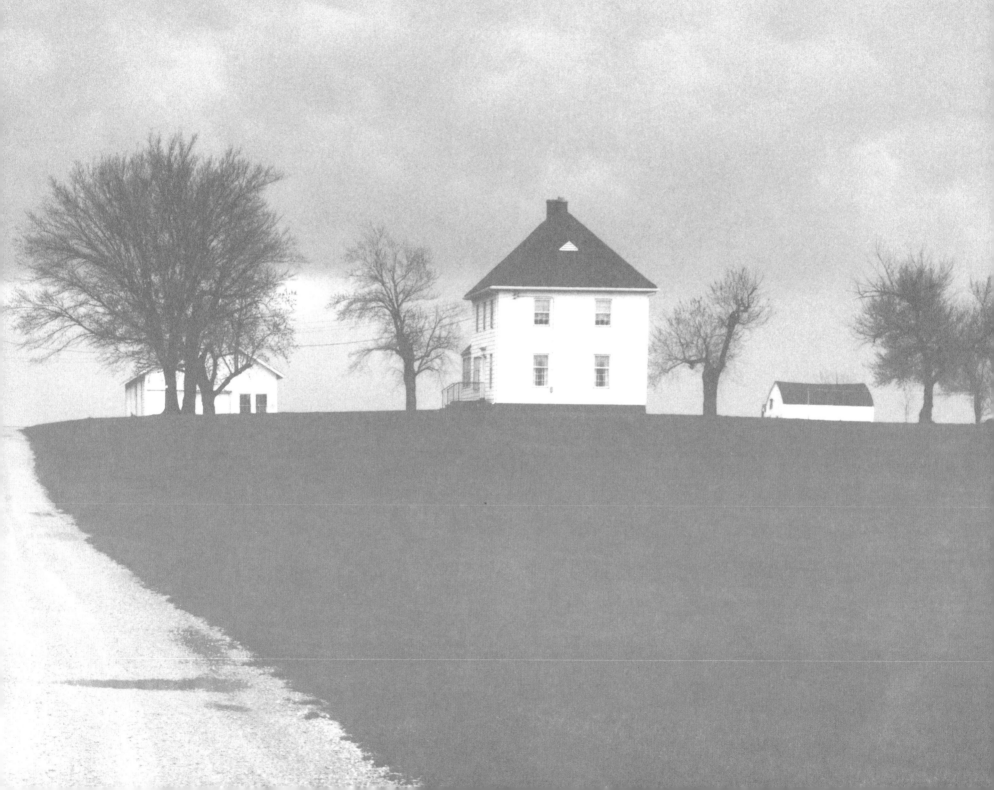

IMPRINTS

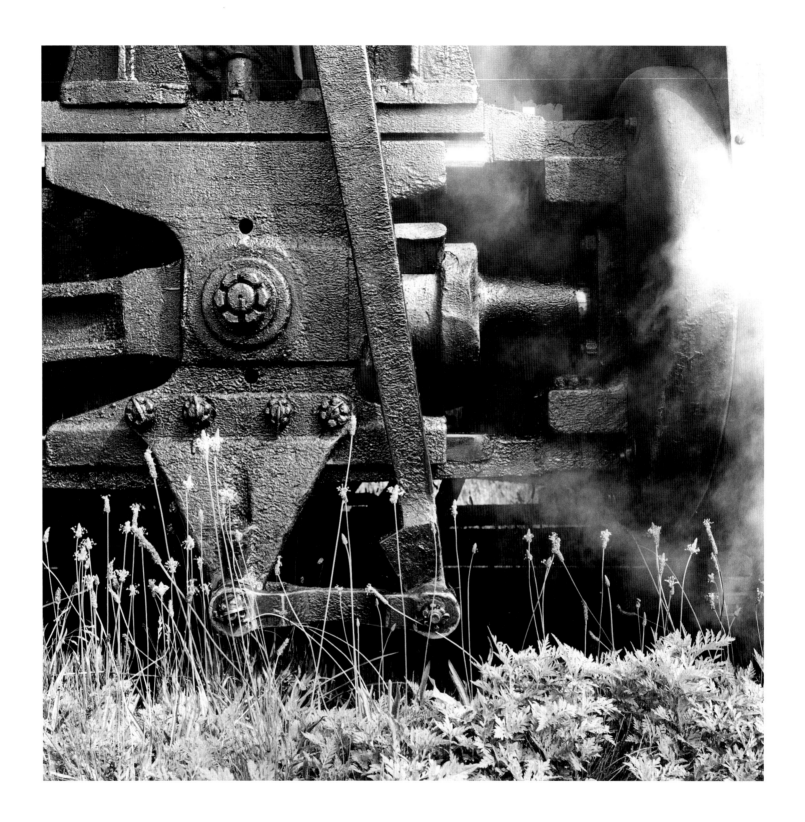

IMPRINTS

DAVID PLOWDEN: A RETROSPECTIVE

PREFACE AND TEXT BY DAVID PLOWDEN

INTRODUCTION BY ALAN TRACHTENBERG

A BULFINCH PRESS BOOK LITTLE, BROWN AND COMPANY

BOSTON NEW YORK TORONTO LONDON

FIRST EDITION

The author is grateful for permission to include the following previously copyrighted material:
Excerpt from *Sonnets to Orpheus* (second part, 10) by Rainer Maria Rilke, translated by M. D. Herter Norton.
Copyright © 1942 by W. W. Norton & Company, Inc.; copyright renewed © 1970 by M. D. Herter Norton.
Reprinted by permission of W. W. Norton & Company, Inc.

Library of Congress Cataloging-in-Publication information appears on page 203.

Bulfinch Press is an imprint and trademark of Little, Brown and Company (Inc.)
Published simultaneously in Canada by Little, Brown & Company (Canada) Limited

PRINTED IN ITALY

FRONTISPIECE:
CROSSHEAD DETAIL, STEAM LOCOMOTIVE, UNION TRANSPORTATION COMPANY,
NEW EGYPT, NEW JERSEY, 1959

DAVID PLOWDEN EXHIBITIONS
September 26–December 21, 1997 Beinecke Rare Book and Manuscript Library, Yale University
November 8–January 4, 1998 Albright-Knox Art Gallery, Buffalo, New York
June 13–August 1, 1998 The Museum of Contemporary Photography, Columbia College, Chicago
September 16–December 13, 1998 The Gallery, Albin O. Kuhn Library & Gallery, University of Maryland, Baltimore County

FOR SANDRA

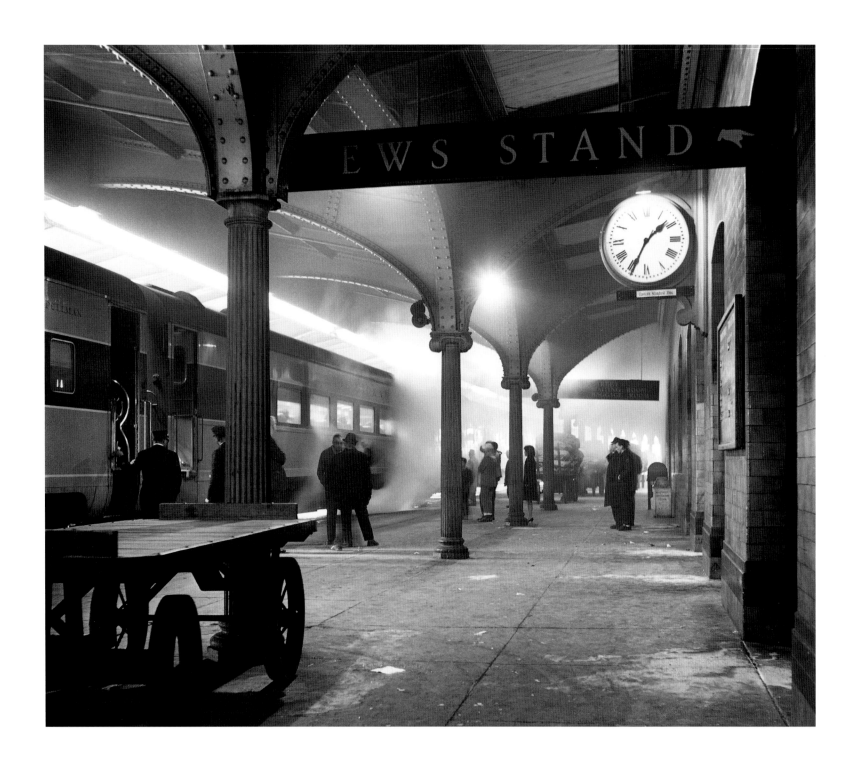

ERIE LACKAWANNA RAILROAD, WESTBOUND "PHOEBE SNOW" AT SCRANTON, PENNSYLVANIA, 1964

PREFACE

BY DAVID PLOWDEN

Imagine for a moment Nathaniel Hawthorne on the morning of July 27, 1847, sitting in a place he called Sleepy Hollow in the woods near his home in Concord, Massachusetts, awaiting "such little events as may happen." At first his impressions are of nature; then upon hearing a church bell and the sound of cowbells, he begins to write about what he perceives as being a harmonious relationship between society and the landscape. "These sounds of labor do not disturb the repose of the scene," he notes. But his reverie is suddenly shattered:

> But, hark! there is the whistle of the locomotive — the long shriek, harsh above all other harshness, for the space of a mile cannot mollify it into harmony. . . . No wonder it gives such a startling shriek, since it brings the noisy world into the midst of our slumberous peace. . . .

A century later and a scant hundred miles from Sleepy Hollow, my perceptions were very different. The shriek of the locomotive whistle brought life to the all too quiescent New England hills. As a young boy yearning for adventure, I did not hear it as a threat — quite the opposite. The fact that it was a harbinger of "the noisy world" was reassurance that I was connected to something far greater beyond the valley of the Connecticut River. I could hear "America singing" in the whistle as I lay in my bed at night dreaming of far-off places. That won-

derfully compelling sound stirred my being as no other. Once I had heard it, my imagination could not rest again.

I had yet to discover that those immense locomotives of the Central Vermont were symbolic of one of the greatest quantum leaps in all of human history. I took them entirely for granted, for by then the railroad had become as much a part of the scene as the church bell was to Hawthorne's world. I had not seen the change that the steam engine had wrought, nor did I understand that being part of our industrial arsenal, it was equally symbolic of the potentially destructive forces technology could unleash on society and nature.

The idea that rampant industrialization might have opened Pandora's box never crossed my mind until much later. Like most Americans, I viewed industry as beneficial, especially during World War II, when it was mobilized with singular purpose. Long after the war I continued to look upon it as the embodiment of our ability to make useful things to serve us. I had yet to see the trail of waste, the rape of Appalachia, and the dreary, gray mill towns. The question never occurred to me whether technology could as easily turn against humanity as serve its needs. I had not begun to weigh the benefits of technological progress against the cost. When I began to question what I saw, I realized that serious consequences might lie in wait for generations hence.

Quite obviously my work reflects a growing ambivalence

about what I have seen. It was my unabashed love for the locomotive that brought me to photography in the first place — there is no sound that stirred my soul like that of a steam whistle. I still stand in awe before our great bridges and rejoice in the productivity and unsung beauty of the Midwestern farmland. Perhaps nothing symbolizes my ambivalence more than a steel mill or the industrial panoply that one beholds around the crescent at the lower end of Lake Michigan. It is at once magnificent and apocalyptic — a definitive expression of mankind's inherently productive and creative, as well as destructive, nature.

Whether one believes that we have abused this power, few would disagree with the English philosopher Herbert Spencer, who postulated that the simple act of lighting a fire had incalculable ramifications on the course of history. When one adds water to the equation and heats it over fire, the result is steam. And when harnessed, the power of this vaporized water gave us dominion over our fellow creatures and became the indispensable force allowing us to do what we could not do by our hand alone.

The power of steam spawned the Industrial Revolution, which arrived just as America was beginning to flex its fledgling muscles. Those were the confident years. All vestiges of European imperialism in this hemisphere were crumbling away, only to be replaced by our own brand of economic lebensraum. We were no longer a provincial experiment among nations. Never before in our history had the possibilities seemed so unlimited, never had there been so much for so many. Not for all, of course. The industrialization of America in the nineteenth century created a chasm of inequity between mill owners and those who stoked the furnaces. Cruel, merciless poverty dwelled on the flats and on the South Side, while wealth was

flaunted shamelessly up on Summit Avenue. But still America beckoned, and millions took the wager. They left their homelands with the belief that no matter what, life would be better. One could always dream in America.

We Americans have always been restless: sprinters, not as often long-distance runners. To "take time" in the philosophical sense has never been part of our approach to doing things. As a result, we have often emphasized the act of accomplishing rather than the accomplishment itself. This fact was not lost on the nineteenth-century bridge engineer Thomas Curtis Clarke, who made some fairly trenchant comments about American design. He said that in a country where most things were by necessity constructed in great haste, aesthetic considerations were often ignored. "Utility governs their design . . . few care how they look."

America was immense, unsettled; the resources of a vast unexplored and bountiful outback were there for the taking by an eager, impatient young nation. We were in a hurry to fulfill "our manifest destiny to overspread the continent allotted by Providence for the free development of our yearly multiplying millions," the phrase coined by the journalist John L. O'Sullivan in 1845. Our concerns were not about the future. The new technology of the Industrial Revolution was at hand waiting to be utilized, and we ingenious Yankees had the ability to find solutions that enabled so much to be accomplished in so short a time. It was almost inevitable that we should develop the most proficient machinery for getting things done more quickly than any other people had ever believed possible. It became our stock-in-trade.

I was born astride two eras. The fact that the demise of the steam locomotive and the beginning of my career occurred simultaneously was a coincidence that determined the course of

the rest of my life. It was that initial sense of loss — and perhaps that my father died later the same year — that greatly influenced the way I view the world. It also made me keenly aware of photography's unmatched ability to preserve the moment and, thereby, to capture things on film before they disappeared. It began to dawn on me that I hadn't simply been documenting steam locomotives in their final hour. I was witnessing something of far greater consequence: the transformation of a culture. In this light, the body of my work depicts an America almost unrecognizable from the one I began photographing forty years ago. The urgency to record has become ever more imperative as I have tried vainly to stay one step ahead of the wrecking ball. But it is impossible to keep the pace, for America is being transformed at warp speed. Today, change itself seems to have become a singular preoccupation.

Postwar America saw both the beginning of a new world order and the systematic destruction of the gene pool of our heritage. Suddenly we looked upon anything that was not up-to-date as standing in the way of progress. In our race to rebuild we systematically undertook to "unbuild" what had taken generations to create. Using the right of eminent domain; the bulldozer; and our newfound sense of purpose, the second conquest of the American land, we obliterated national treasures and neighborhoods by the score, often because they were simply old, old and often historic — and in the way. We paved over the land with concrete and built highways through the heart of farmsteads. The result is a nation that exhibits a discontinuity of historic development and a paucity of cultural diversity. This is a tragedy, for it has been said that by wiping away the memories of what a nation was, it loses the sense of what it wants to be.

According to historian Frederick Jackson Turner's contro-versial thesis, we as a people have always been influenced by the frontiersman's ethos. The American character, he postulates, was formed by our experience on the frontier, where daily survival overrode all other considerations. We were conditioned, then, to believe nature was the adversary that stood squarely in the path of progress. It is written in the Bible that man was to have "dominion over the fish of the sea, and over the fowl of the air . . . and all the earth . . . and subdue it . . ."

This book is a "core drilling" of my photographs. Its sequence is without concern for place, time, or topic. Although I have been called a documentary photographer, my subjects have never been as important to me as what they symbolize: the "hand of Man," his "imprints."

To those familiar with my photographs, it may appear that I have spent my life glorifying works of an age past, that I have tried to enshrine them with an immortality before they vanish. I am filled with a sense of loss, but not just the loss of steam engines, iron bridges, small farms, and the stores of Main Street. I am distressed by what I perceive as a pervasive disregard for the future. I do not hear "America singing" anymore.

I was once an angry young man. I was angry about what I saw being done to my country, angry about our rampant profligacy, indifference, the waste. I believed that I could inspire people to take up arms by going forth and producing books in the spirit of Peter Blake's polemic, *God's Own Junkyard*. Now, after forty years of recording both the beautiful and the profane sides of my land, I am still angry and even more concerned that the conflicting cultural, economic, and environmental agendas of our times have reached the flash point. I realize, too, there are no simple solutions — perhaps no solutions at all.

Yet, I keep remembering that after Pandora closed the box,

after all the scourges had been loosed, the only thing that did not escape was hope. And hope ensures a future, that we shall still be here. And I, too, can hope that we might rediscover that "in wildness is the preservation of the world," as Thoreau said.

Perhaps one day there will be a realization that technology is something to keep in our back pockets, to use but not allow to take command. Should we not, finally, look inward and realize that mankind's true driving force is the human spirit?

All we have gained the machine threatens, so long
as it makes bold to exist in the spirit instead of obeying.
Lest the lovelier lingering of the glorious hand
longer invite us,
for the more resolute building starker it cuts the stone.

It nowhere stays behind so that we might just once escape it
and oiling in silent factory it would belong to itself.
It is life, — thinks it knows best,
that with equal resolve arrays, produces, destroys.

But to us existence is still enchanted; at a hundred
points it is origin still. A playing of pure
forces that no one touches who does not kneel and marvel

RAINER MARIA RILKE
"Sonnets to Orpheus," II, 10 (1923)

INTRODUCTION

BY ALAN TRACHTENBERG

David Plowden's photographs are a continual source of revelation for me, not just for *what* they show but *how*. Their power lies as much in their acts of picturing as in what is pictured, the everyday world of vernacular American places and things. For Plowden's photographs, like any pictures worth looking at more than once, don't present simple records of a world "out there" — what you might have seen yourself, say, from the window of a railroad car coming to a full stop — but instead are dramatic encounters of a specific person with a world toward which he holds complex feelings and ideas. Plowden's images may appeal at first as deliciously detailed pictures of familiar things fascinating and even soothing to the eye: the beautiful curved section of a steel truss bridge, the contours of a newly plowed field, the lovely arrangement of a corner in someone's living room. Before long we realize that while the subject may dominate our interest, it doesn't exhaust it. Something else in the picture, the personal presence of the photographer, comes to seem equally important, inseparable from what the picture is ostensibly about. It's as if we are taken in by the prospect of having a good, slow look at a grand or intricate subject, only to realize that it's not the bridge or field or storefront or living room that's the main event, but something more difficult to name and thereby richer in meaning.

Take that allusion to the window of a railroad car. Railroad engines were Plowden's first love as a photographer, and references to the railroad experience abound in his writings. In *Commonplace* (1974) he writes: "As a photographer, there is a particular view of our landscape which has had great influence over the way I have looked at my country; the view from a train window." Plowden calls that view a "vantage point," a "limited field of vision, [in which] we begin to see things that perhaps we would not otherwise notice." It is something given, a perspective you may not have particularly desired or expected, but there it is.

> When the train stops, there framed in the window is a scene arbitrarily placed there, as far as we are concerned, by the decision of the engineer. We may only see it in one way, as it is presented beyond the glass, like a silent movie on a screen. It is a set. No more than the photographer can tear down a pole that is in the way, or add a building that isn't there, can we move the train for another point of view.

In part, these words offer a credo of "straight" photography. Plowden is one of those photographic artists — they sometimes seem a dying breed — who accept the world as it is, as it appears to the wide-awake, infinitely curious eye. But there's more to be gleaned about the inner life of his pictures from this passage than his love of framed views in which everything becomes visible at once.

The image of the train slowing to a stop, with Plowden's eyes glued to the window until a fixed perspective appears, serves as a metaphor for his entire work. In his earlier books Plowden typically organizes his pictures to describe or investigate a particular subject: railroads, steamboats, farmland, small towns. *Imprints* takes a different tack. The thematic structure here, which disregards unities of time and place, frees his pictures from subject categories and allows us to see them more clearly as pictures in their own right, in interaction with one another, and as integers in an ongoing forty-year conversation David Plowden has been holding with the American scene. And the railroad metaphor alerts us to recognize how much of that conversation takes place in motion, on the road, while moving across the land from here to there. Think of the prominence in his pictures of means of transport, railroads and steamboats and automobiles, railroad tracks and bridges and roads and streets. Virtually everywhere you look in this cumulative book of Plowden's career, you see symbols of motion, of being both on the road and being where the road delivers you, the precise still locus of the picture. You need to plant your feet and steady your tripod to make the picture, and you need to move your feet or wheels to arrive at that exact place. Motion and stillness, the getting there and the being there, form the inner life of the pictures in this collection, individually and as a whole.

There is a story in these pictures, then, beyond their subject headings. Indeed, subjects matter a great deal in David Plowden's work; they matter overwhelmingly. And with their marvelously exact and textured descriptions of the visible world, his pictures seem like (and can function as) inventories, archives of a material man-made world in the grip of change. To say that the word *documentary* falls short of our experience of

his photographs is not to say that the term doesn't fit at all. They are documents, to be sure, disclosures of scenes he positioned and commanded his camera to see and transcribe. Faced with his lavish compendia of things linked to the steam-driven world that our nation and much of the globe has put so rapidly and inelegantly behind it, we feel a debt of gratitude for the knowingness of his eye, his accuracy in identifying the visible forms of the underlying forces of "progress" reshaping the look of everyday life.

His pictures capture facts of life, making a permanent record of things that may or may not persist in the world. "One step ahead of the wrecking ball," Plowden has said about this side of his work, and not without a bemused sense of its absurdity. "Like a three-legged dachshund trying to keep pace with a Great Dane." He chases doggedly, having but two legs and no eyes in the back of his head, after man-made things that in modern America may not outlast the day or week or year. His many books and tens of thousands of pictures reassure us that the score is pretty much in his favor, which probably makes for small consolation if you want to get it *all* down before it goes away.

By dint of extraordinary persistence in his vocation, by sharp attentiveness to the changing scene in the parts of the country most meaningful to him — the farms, the small towns, the edges of big cities — and by hard research and hard traveling, David Plowden has compiled an unmistakably unique archive of "man-made America" during a period (since the end of World War II) of fiercely unrelenting change: the often ugly death pangs of the industrial age. What he records is the end of the steam power era as we once knew it, with poignant overlappings at both ends: signs of preindustrial ways down on the farm, and postindustrial outcroppings in new landscapes that

can hardly no more be called urban than rural, the old designations themselves a major casualty of change. Like a one-man Farm Security Administration (FSA) project, working on his own with occasional support from one institution or another, Plowden has come pretty close, closer than anyone else, to keeping a step ahead of the ruination of time — not the scythe that dooms everything and everybody to eventual demise but the ruefully secular instrument of some speculator's wrecking ball. His accumulated images have History written all over them. They're here for study, for knowledge, for getting onto better terms with the recent past, the better to see where today has come from and where tomorrow may be headed. How pitilessly our culture shuffles every "today" into the file of nearly forgotten "yesterdays," Plowden laments, and sets about to salvage a few yesterdays for today's appreciation and perhaps delight.

Anyone looking with care at Plowden's books over the past three decades will not be surprised by what is revealed here, the consistency not only of subject but of certain intellectual and artistic concerns. For one, as the concise and evocative texts accompanying the pictures testify, Plowden is an author as well as photographer, a fact of no small import to our view of his work. Not exactly unique among photographers in writing his own texts — not captions, but commentaries — he belongs in the small and noble company of innovators, a cross between Walker Evans in his *Fortune* essays and Wright Morris in his "photo-texts." The fact that we might recognize in many of his pictures allusions to the work of these two photographers, especially Evans, who befriended Plowden and served as a mentor of sorts, underscores the younger man's membership in this company of photographer-artists of the American scene. His interest in the creative interaction of two modes of communica-

tion alone complicates the impulse to put Plowden down simply as a "documentarian."

In fact, Plowden has never meant to "document" for its own sake; he has always had something else in mind — a purpose, a desire to communicate something that might otherwise, if the viewer-reader were not alerted by the texts, remain invisible within the pictures. The leading idea of his work filtered through the written texts as plain as unpolluted air has been evident from his earliest published work, only more urgently insisted upon in recent years. In obeisance to the values and ineluctable laws of "progress," the nation has endangered its root system, its nourishment in the ground of the past. It has ripped itself loose from the necessary nurture and sustenance that come with the living presence of old things. It's a kind of eco-historical vision that comes through Plowden's work, a vision of the interconnectedness of things, of the flow of the land in rapport with the roll of the road, of "nature" mixed creatively with "the hand of Man." The vision is manifest in this book in the sequence of pictures, which provides a framework for considering the unavoidable question of whether the nation has lost touch with its roots to the extent of endangering its identity. Has the country lost its soul? There is indeed celebration in Plowden's pictures, joy and pleasure in the carpentry of farm buildings, in the down-home friendliness that persists in small towns, and in the magnificence of the great bridges and machines. But the predominant tone now is unmistakably elegiac, the tone of a man who misses the good things lost, gone, irretrievable except in photographs.

It's clear that what drives Plowden at the deepest level is not just the desire to picture things for the sake of assembling an inventory. Just as the moral intention crystallizes so lucidly in this collection, so too do the elements of Plowden's art. For it

is fundamentally as an artist that he takes his stance. One cannot so regularly make the sort of pictures displayed here, so finely detailed and composed, without a passion not just for the subject but for the process, the act of picturing. I mean "picturing" in a sense broader than the medium in which he works, wider than photography. Of course, it means something important to say that his eye is "photographic," that he is drawn to subjects lending themselves especially well to the format of the camera, typically square or horizontal. But there's a sense in which Plowden's subjects lie within his camera as much as outside it, a sense in which we can say that he creates his subject rather than finding it, by using his camera in a certain distinctive way.

Look, for example, at the spatial dimension of his work evident in the way the images are arranged in this book. Instead of his early typical organization of pictures centered on a single subject, he presents a sequence designed to highlight process and dialectic: land and machine, past and present, celebration and condemnation, hope and despair. Each of the sections — from flatlands, prairie, Main Street, and backstreets to wasteland and eclipse — represents a spatial demarcation, yet each shows signs of inner tension.

We learn at the outset that there are no pure beginnings free of human intervention, that the open vista pleasing the eye will have a road slicing down its middle, from bottom to top, a row of telephone poles alongside, or laterally, a cut of freight cars slashing with an unnatural straight-line evenness across the horizon at Havre, Montana. It's difficult to pinpoint the moment in Plowden's vision when the balance between nature and civilization begins to tip the wrong way, but it is manifest that it is the "hand of Man" that delivers to us even the most picturesque "landscape" in the flatlands and prairies. Moreover,

as much as they thrill the eye with limitless prospects of growing things, the glorious open lands in the early sections insinuate a note of something dark, as in a Robert Frost poem, by the sheer scale of their impersonality.

A brilliant example of just this tension appears in "Saline County, Missouri, 1974" (see page 33). A wooden frame building, a church resembling a farmhouse, reaches about a third of the way into the right side of a horizontal image, opening on its left upon a flat stretch of land, a clump of trees in the distance the only deviation from the straight line of the horizon. A near-blank sky fills about three-quarters of the space against which the church abuts. The light is also flat, virtually shadowless, giving the two carpenter's Gothic windows a bold, challenging presence. The space inside their white frames and mullions shows utterly black. The scene lies menacingly still: "nature" limitless and without definition on one side, and on the other, a sacred white edifice like an outpost of civilization. The ambiguous play of open and closed spaces, of what belongs to nature and what to man, and the dialogue of whiteness and blackness in the church itself, jars the viewer from any complacent view of the culture of the Midwestern plains.

At the other pole, even in the most pitilessly besmirched wasteland scenes at the edge of industrial cities, we detect some little things of hope, a clump of sorry-looking scrub grass in a cracked pavement or a vine crawling up one of the those blank scornful walls of the new industrial-corporate regime (see pages 167 and 176). In another register, tension between traveling and arriving, between movement and destination, appears often in pictures of bridges that seem to come from nowhere and lead nowhere, existing for our eyes solely as means of passage, the purpose of which lies nowhere visible in the scene. Or take the picture with the innocent-looking white-

capped fireplug in Marion, Kansas (see page 73). In a compelling composition of ambiguity, Plowden organizes the view in three tiers: the bit of sidewalk and fireplug in the foreground, the wide expanse of street in the middle (the width alone bespeaking a Main Street "out West"), and the unprepossessing row of shops across the street, tilted so that the right flank of the corner building catches the full fury of a merciless sun. That cinder-block flank exposes the cast-iron palatial facade with its obscure pediment as a false front, a forgotten gesture toward a civic elegance never realized and now hardly noticed. It's the street that dominates, empty save for one parked car, the thoroughfare symbolizing motorized passage through a place that has no visible identity, no monument to defend the place and its name from the erosion of time — unless it be that dumb, graceless fireplug and its distant echo across the street.

In *Small Town America* (1994) Plowden writes that the book might be better thought of as a novel than a catalog. The same can be said of *Imprints:* not a novel in the literal sense, but analogous to narrative in that images connect with one another in relationships governed by a "plot" — the movement from open land and limitless space re-created by human effort into nourishing farmland, to the wasteland of the postindustrial city, its debris-littered streets at its wretched edges being of one discouraging piece with the blank walls and sharp-edged facades of new corporate structures. The formal principle at work here is that each image connects with the others not by subject matter but by more subtle means of tone, composition, the juxtaposition of revealing details. Just as the industrial world is revealed as one interconnected network of roads, railroad tracks, bridges, telephone lines, and underground water supplies (the fireplug), each individual image has its meaning enhanced by its place within the larger scheme of Plowden's intensely moral vision. As the photographs proceed sequentially, they accumulate associations, each image lending its own inner tension to the encompassing pattern of opposition between, for example, images of a settled way of life in comfortable (even if, as in the picture of the plains church, antagonistic) rapport with its natural setting, and images of "eclipse," of cities crumbling in disrepair, new fantastic lunarlike landscapes cropping up without discernible human origins or purposes, and civility damaged perhaps beyond repair.

The book is judgmental, yes, a kind of jeremiad in iconic form. But the lasting impression finally is of one man's experience: Plowden's reshaping his earlier work, combining it with new pictures, and laying a new set of tracks through the contemporary American landscape. The sequence reveals his own movement across the land, his being there. It's the quality of his being that captures our attention here, as much as or completely inseparable from the quality of his eye: kindly, attentive, open to surprises, a reader of signs. We are witness to a masterful photographer making his own marks on the landscape of the American cultural pysche. His pictures are also constructions, artifacts of collaboration between human desire and a machine, the camera, that carves its shapes from the material of light.

The beauty to which Plowden's eye is often witness, and to which his art pledges its allegiance, gives a measure of the indignation aroused by scenes of beauty profaned and civility eclipsed. Taken individually, one at a time, Plowden's pictures refresh the eye; they instruct, they remind, they warn, they engage us in dialogue about the present state of our world. Cumulatively, they provide a memorable legacy of American imprints in their own right.

THE FLATLANDS

Many years ago when I was crossing Kansas on a train, I went to the dining car for lunch. Once there, I discovered to my horror that all the window blinds had been pulled down. The steward seated me, and I immediately raised the blind so I could look out on the immensity of the flatlands, so different from the intimate eastern countryside I called home. A moment later the steward reappeared, reached over, and pulled the blind down again, assuring me that "there's nothing out there to look at, son."

Perhaps not to his eye, but certainly to mine. I raised the blind once more and have never lowered it since.

The vast expanse of prairie and plain that constitutes the very heartland of America is among the most unsung and most unappreciated of all landscapes. Perhaps it is because the mountains and seacoasts are, in fact, more beautiful or because the flatlands are mostly a working place, not a playground. Maybe we simply equate "flat" with "boring." True, there are few "picture postcards" here; little that is intrinsically scenic in the traditional sense of the word. There is no wilderness, little that has not been touched by the "hand of Man." Whatever the reasons, except for those who dwell here, there are many to whom this is still the Great American Desert. For years my only experience with these limitless flatlands was as a place to cross on the way to somewhere else. I knew them only from the window of transcontinental trains, where the view was a synthesis like the broad brushstrokes of a painting. The fine points, the intimate nooks and crannies, were seen too fleetingly to be savored. Only the obvious architecture of human presence was visible: grain elevators, the toylike farms on the horizon, a field of corn stubble, and mile upon square mile of plowed earth. Nonetheless, from the train the land's elemental simplicity was strikingly revealed. The train's speed seemed to amplify the magnitude of the land. Its expanse was breathtaking, limitless, without hills or mountains to confine the spirit: a landscape that appeared to have been reduced to the basic fundamentals, just sky and earth. "Elsewhere the sky is the roof of the world," wrote Willa Cather of an analogous landform, "but here the earth was the floor of the sky."

It was only much later, when I came to photograph it, that I began to understand this landscape is like a stage upon which the players are light and shadow, wind and storm, and where the drama takes place within the elements rather than on the land itself. It is not all flat, as those unfamiliar with it often believe, but infinitely varied — if one takes the time to look. It is a land of extremes: where the climate is unameliorated by the sea, and the seasons arrive howling, accompanied by appalling excesses of weather — tornadoes, blizzards, and thirty-degree temperature changes within an hour. When the wind blows from the southwest in spring and early summer, I have watched as great thunderheads mount up to blacken the sky and have realized there are no hills to stay the wind, nowhere to hide from such elemental fury.

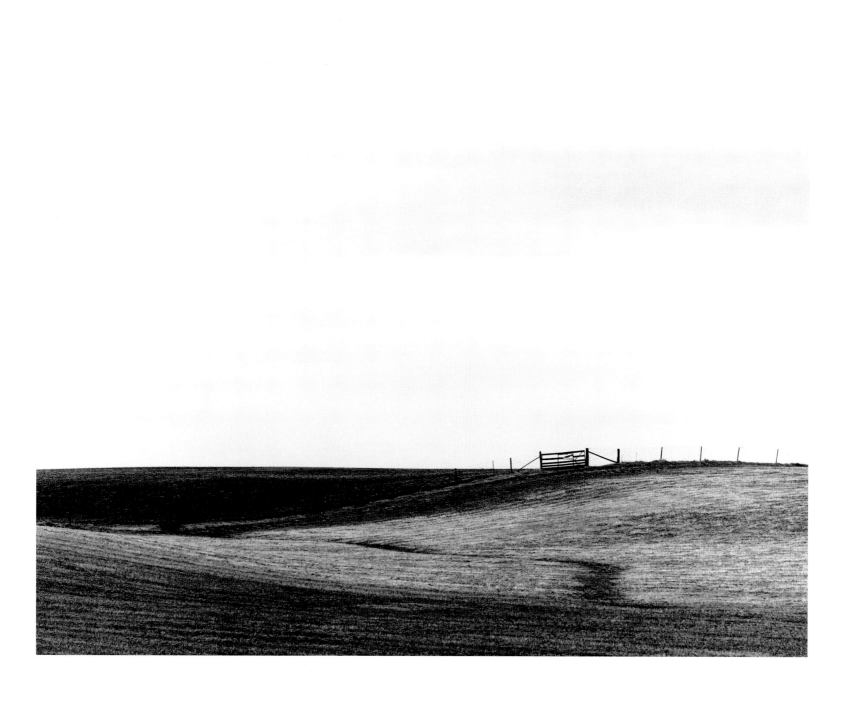

NEAR PETERSBURG, DELAWARE COUNTY, IOWA, 1987

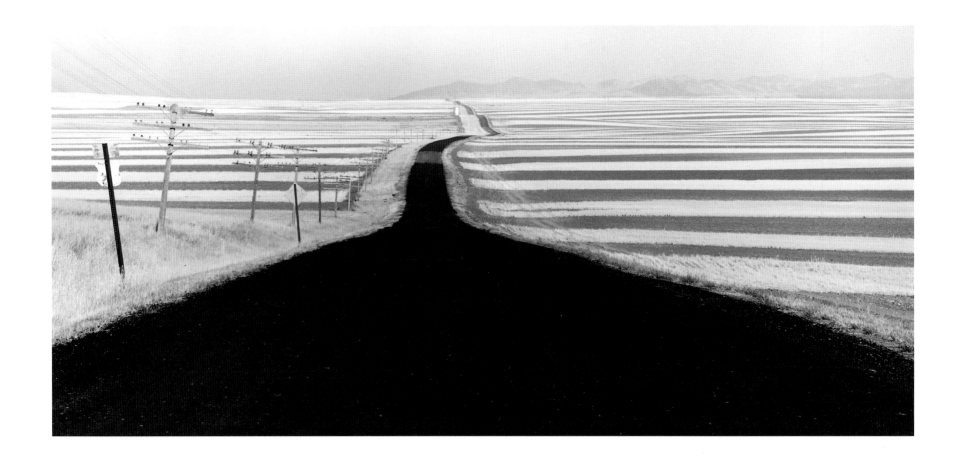

WHEAT FIELDS NEAR GREAT FALLS, MONTANA, 1971

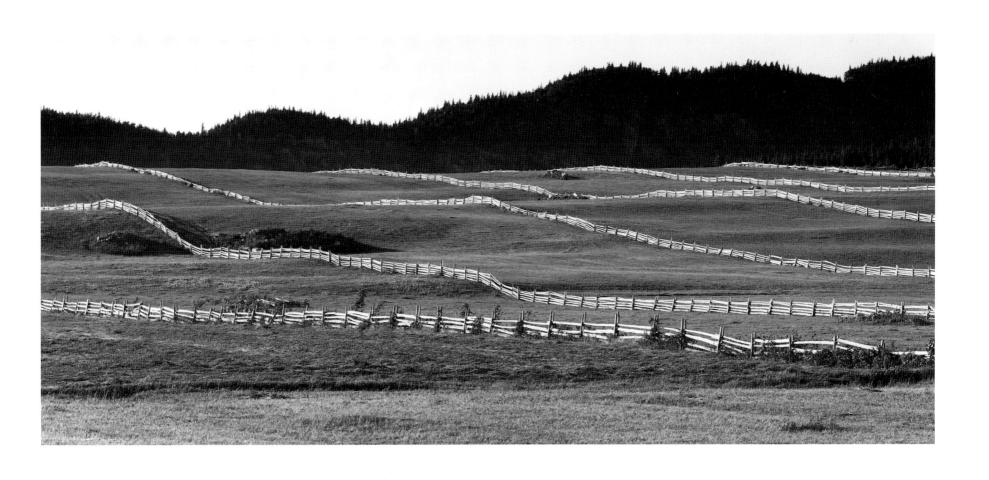

FENCES NEAR RIMOUSKI, QUEBEC, 1969

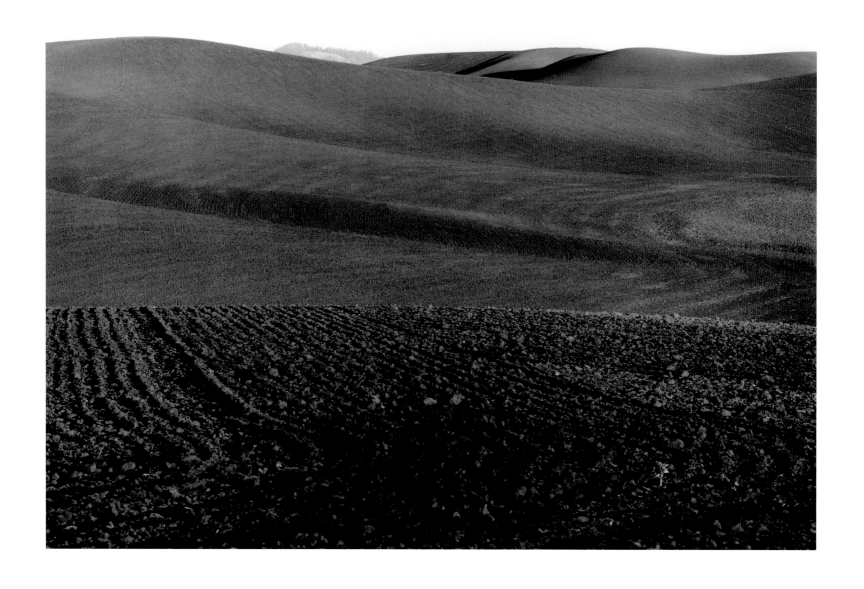

PLOWED WHEAT FIELDS, WHITMAN COUNTY, WASHINGTON, 1972

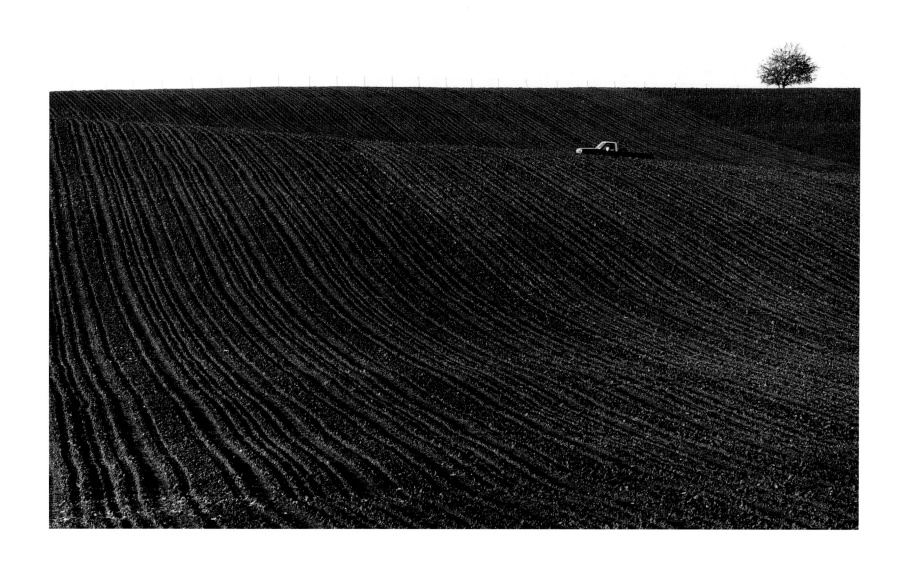

CEDAR COUNTY, IOWA, 1985

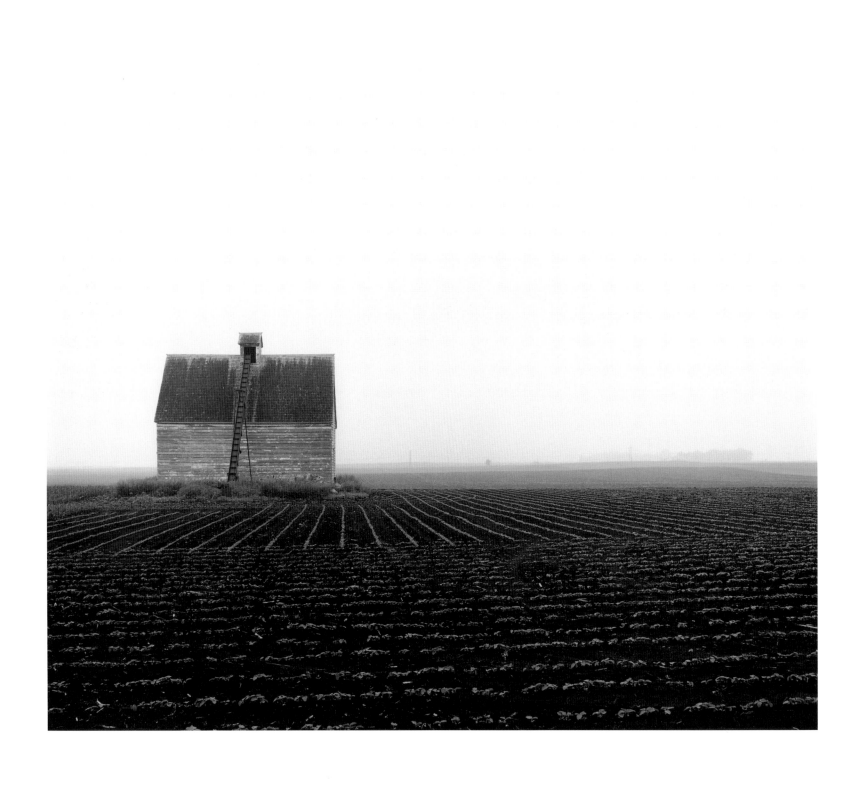

GREENE COUNTY, NEAR GRAND JUNCTION, IOWA, 1981

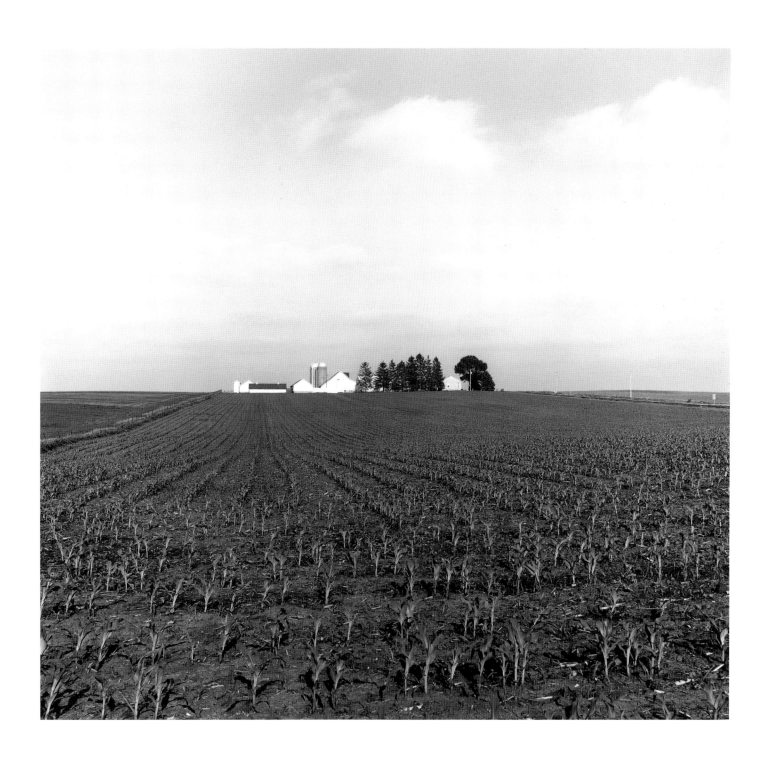

JONES COUNTY, IOWA, 1987

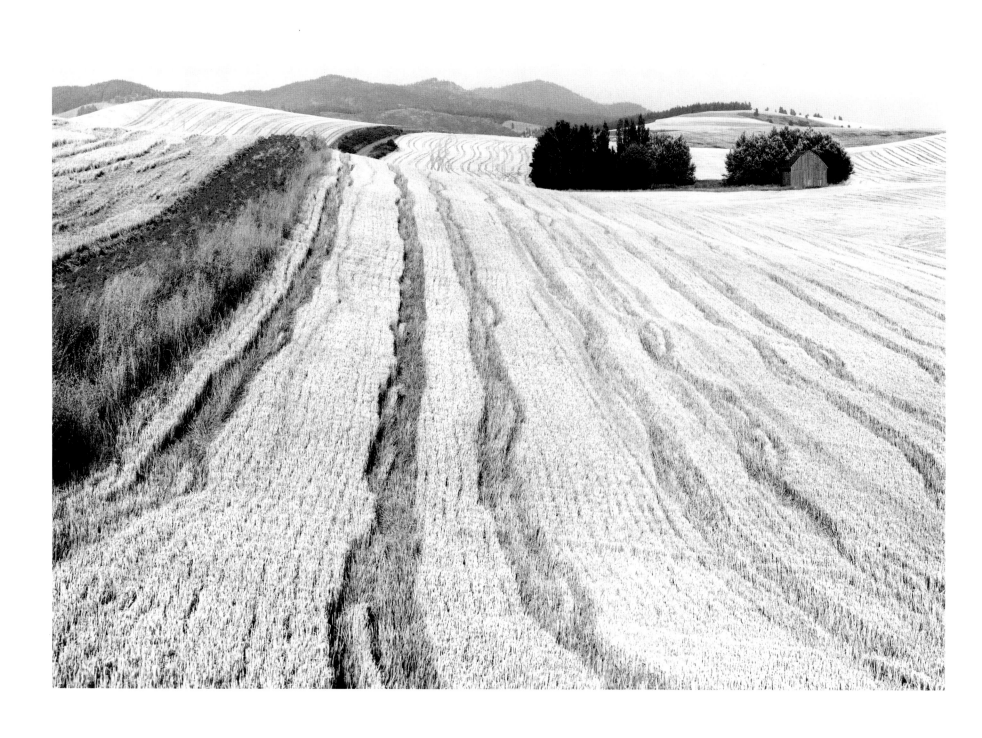

HARVESTED WHEAT FIELDS, WHITMAN COUNTY, WASHINGTON, 1973

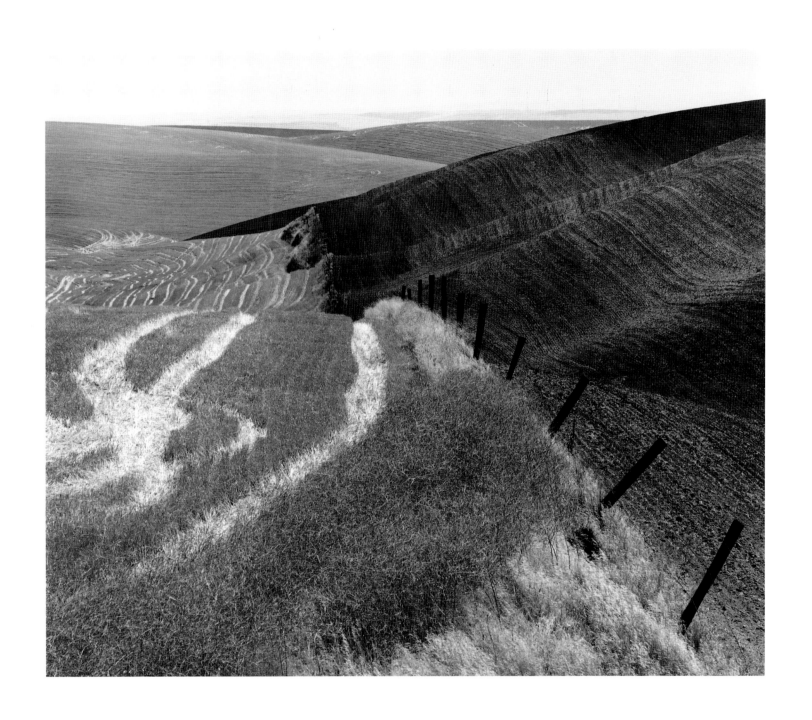

HARVESTED WHEAT FIELDS NEAR DUSTY, WASHINGTON, 1973

MARSHALL COUNTY, ILLINOIS, 1981

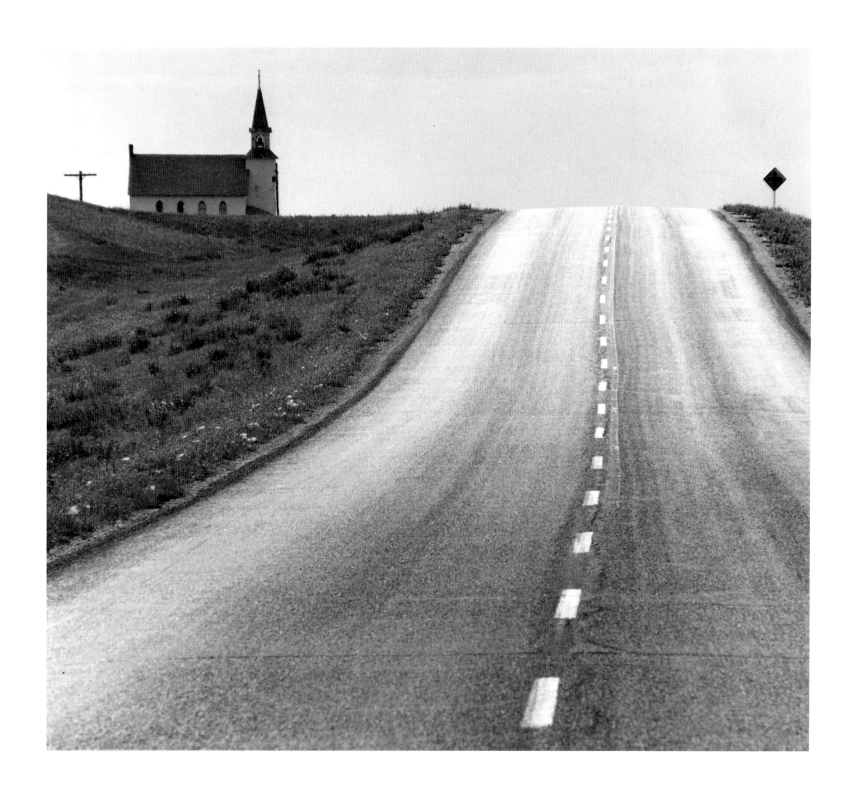

APPROACHING NINETY-EIGHTH MERIDIAN, STEELE COUNTY, NORTH DAKOTA, 1968

THE PRAIRIE

One spring evening I was driving along a section road in the midst of what seemed a very faraway place. At one point I stopped by the roadside, turned off the engine, and got out of the car. I walked to the brow of a hill, where I stood looking and listening, feeling the wind in my face. At first, I felt as if I were in paradise, or at least as if Persephone had returned once again to the world from her yearly sojourn in Hades. From everywhere came the song of the meadowlark, and the smell of freshly plowed earth hung in the air all round. It was the kind of evening that one yearns for in February but begins to believe will never come again. The sun, an hour or so from setting, was low in the western sky and bathed everything in deep golden light. The merest pebble in the road and each blade of grass appeared to be etched in boldest relief. It was that time of the day when for a precious moment the world seems preserved in amber, suffused in an ageless calm that would be shattered if one spoke above a whisper.

But then, predictably, came the sound of an internal combustion engine: a tractor growling in the distance, faintly at first, but more pronounced the longer I listened. Though it was never once in sight, eventually it overwhelmed the lark's caroling. At the same time, I became aware of an acrid smell in the air and realized that the bountiful harvest these fields would yield in the fall depended as much on chemicals as on the fecundity of the soil itself.

This was the breadbasket: we had transformed the prairie into a working, useful place, not a wasteland. The tractor was not a machine of war. Against the sky it was diminutive, a gauge of our ephemeral grasp on things. The sound of its engine, so jarring at first, belonged now. It was just as much a part of the landscape as the lark. For a moment, at least, I could believe that here, civilization and nature had achieved a state of harmony.

Farther on, the road dipped and crossed a stream whose silt-laden water ran coffee-colored toward the Mississippi. I stopped on the bridge and remembered that Big Muddy's water used to run clear on its journey to the sea. That was before we first broke the sod, less than a century and a half ago.

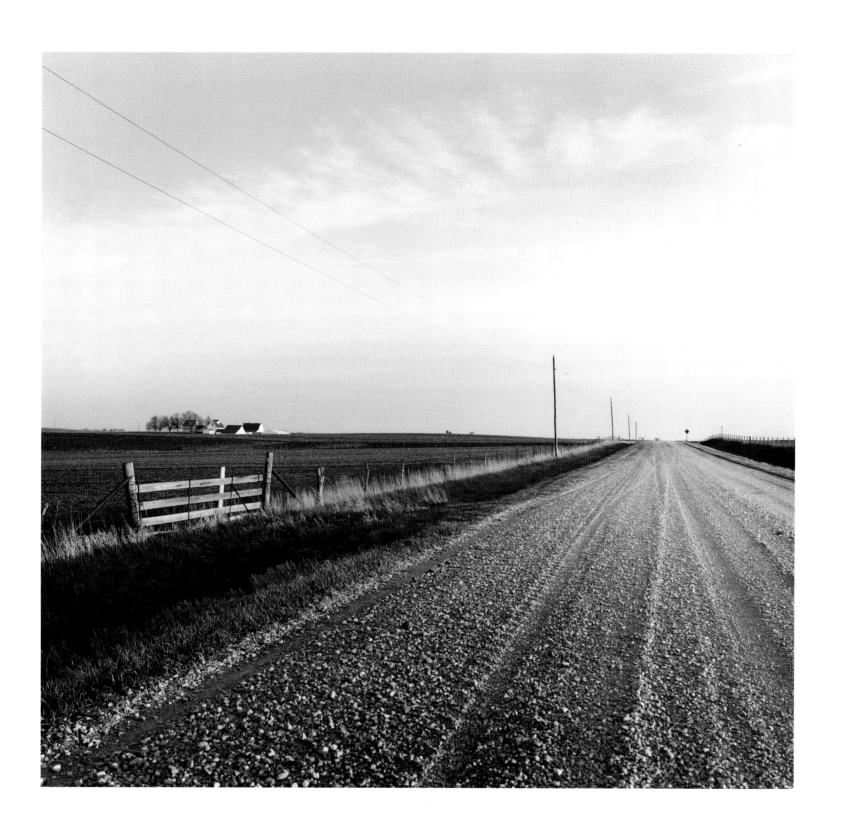

SECTION ROAD, SCOTT COUNTY, IOWA, 1986

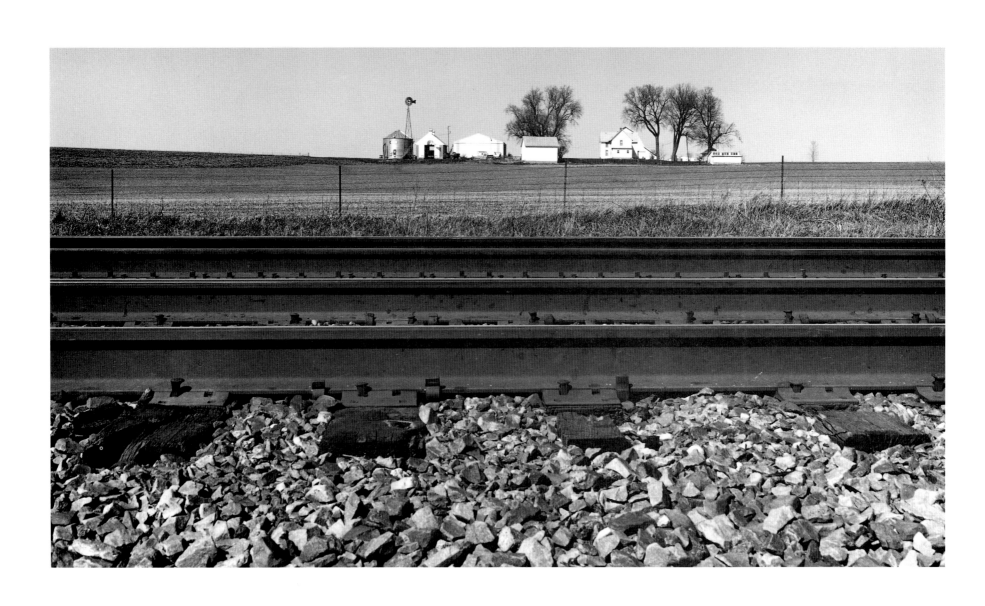

FARM BY CHICAGO AND NORTH WESTERN RAILROAD TRACKS, MECHANICSVILLE, IOWA, 1986

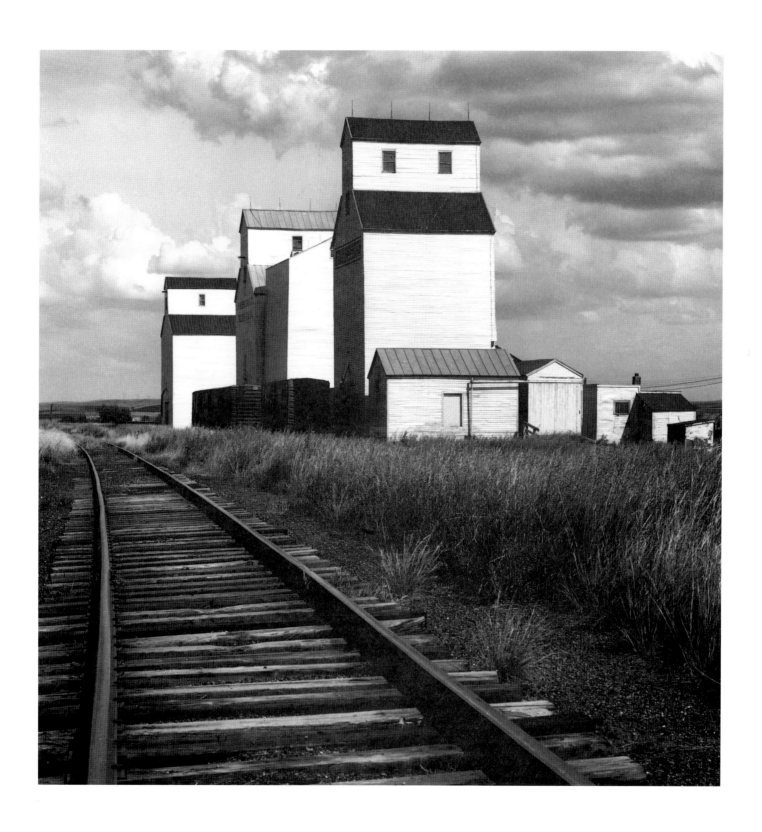

GOLDEN VALLEY, NORTH DAKOTA, 1971

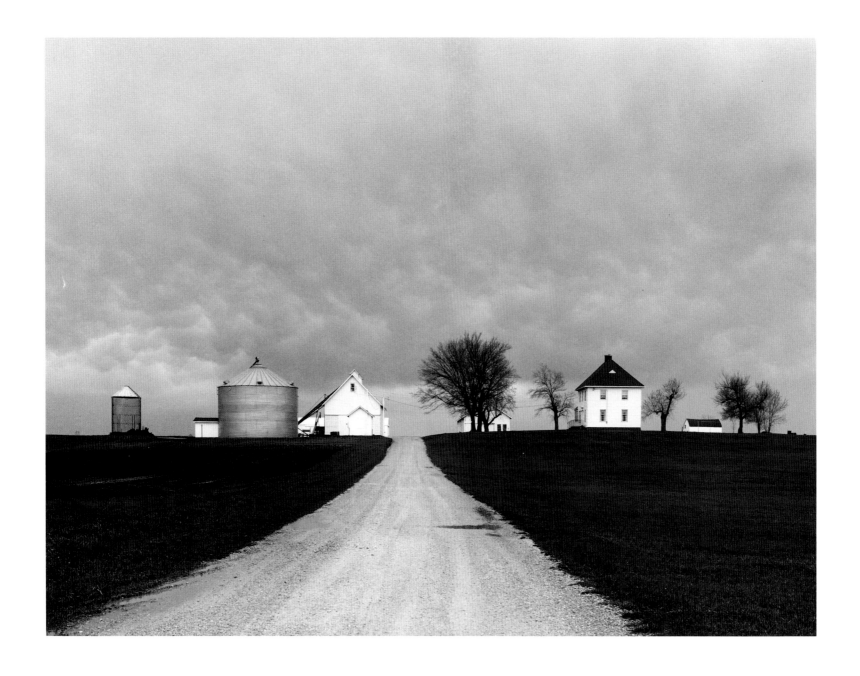

FARM, WILL COUNTY, ILLINOIS, 1981

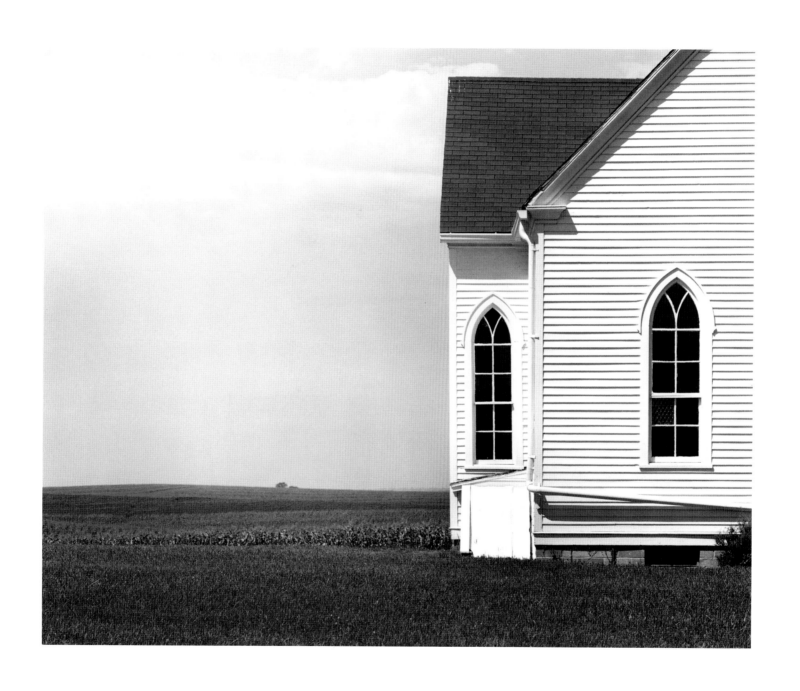

CHURCH, SALINE COUNTY, MISSOURI, 1974

33

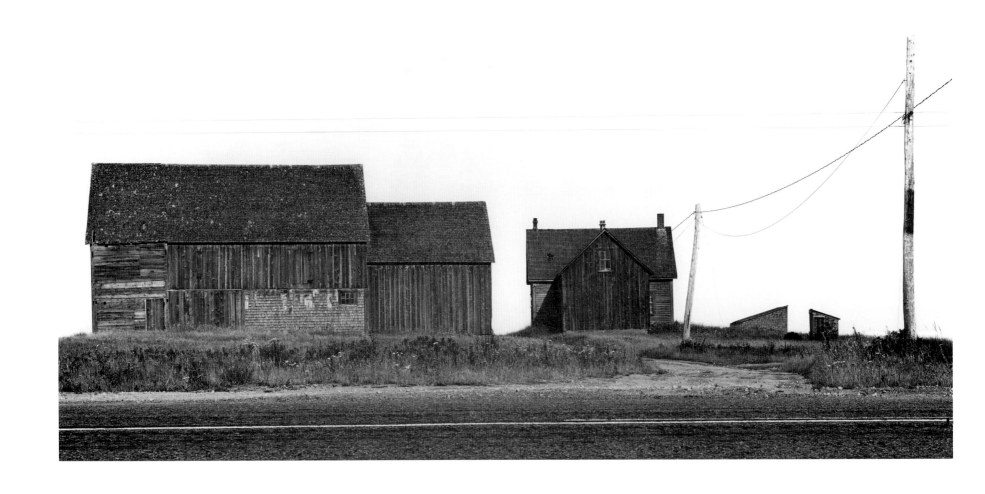

FARM, CAPE LUMIÈRE, NEW BRUNSWICK, 1969

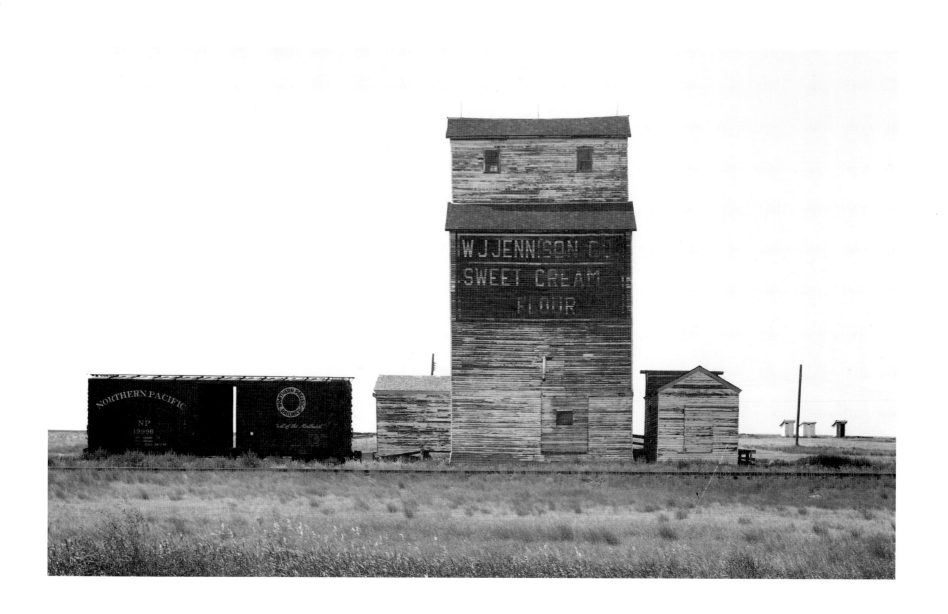

GRAIN ELEVATOR, ANTELOPE, MONTANA, 1971

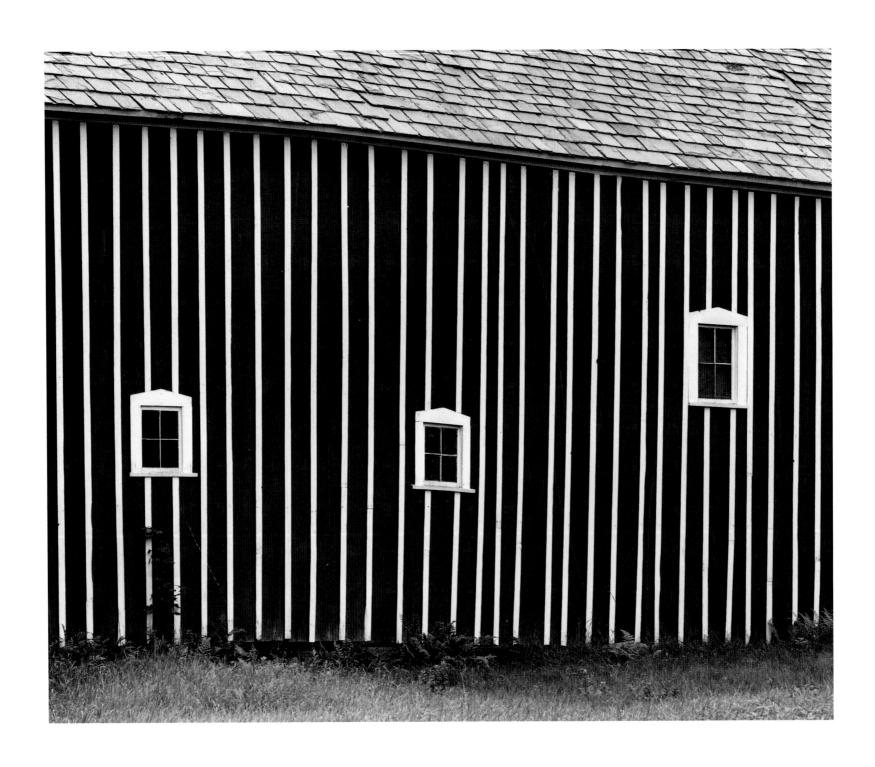

BARN, NEAR GUILFORD, VERMONT, 1965

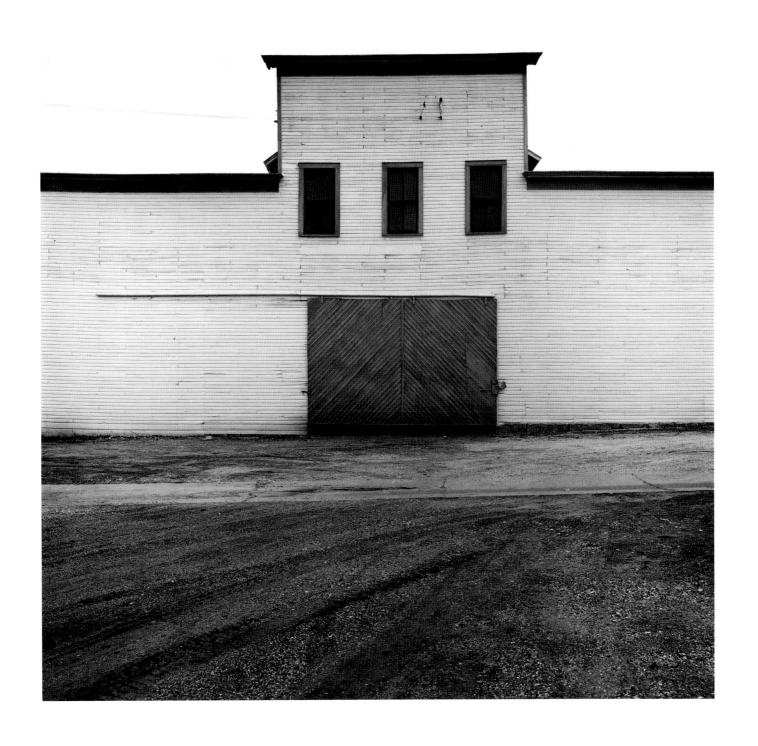

ARMSTRONG LUMBER COMPANY, DYERSVILLE, IOWA, 1987

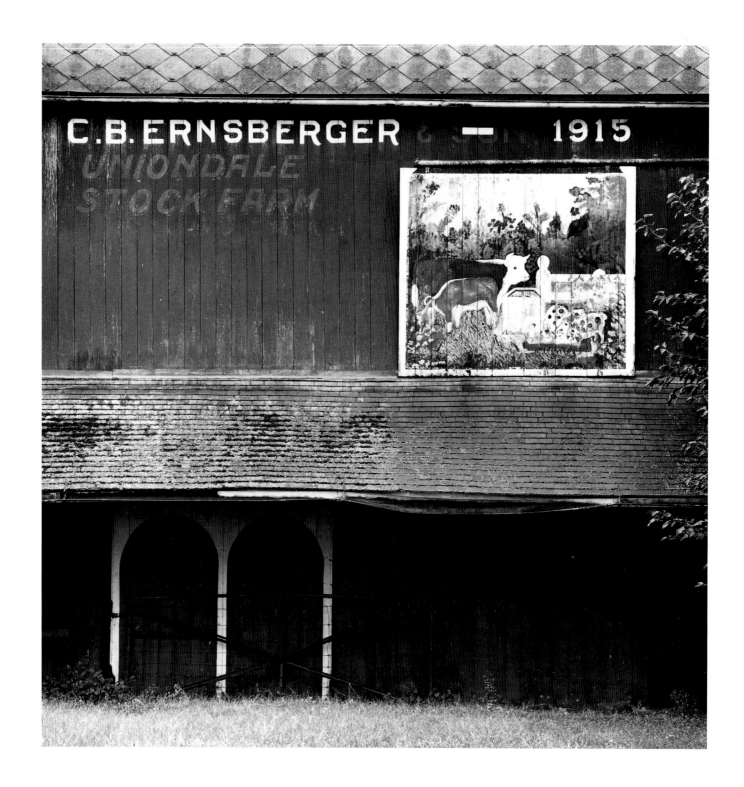

BARN, NEAR ANGOLA, INDIANA, 1969

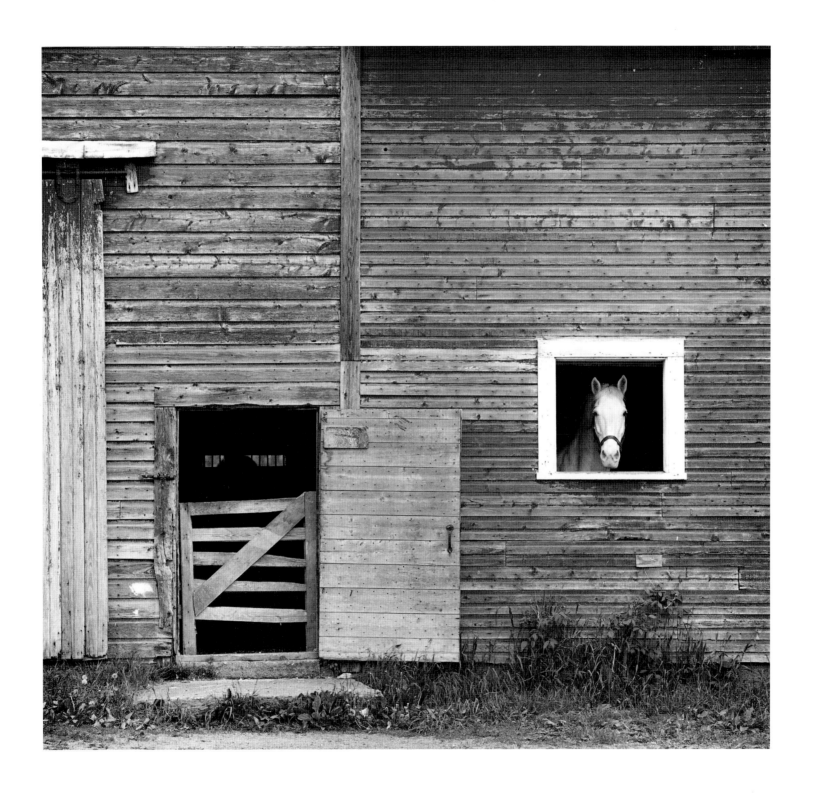

AJAX, BURLINGTON, VERMONT, 1972

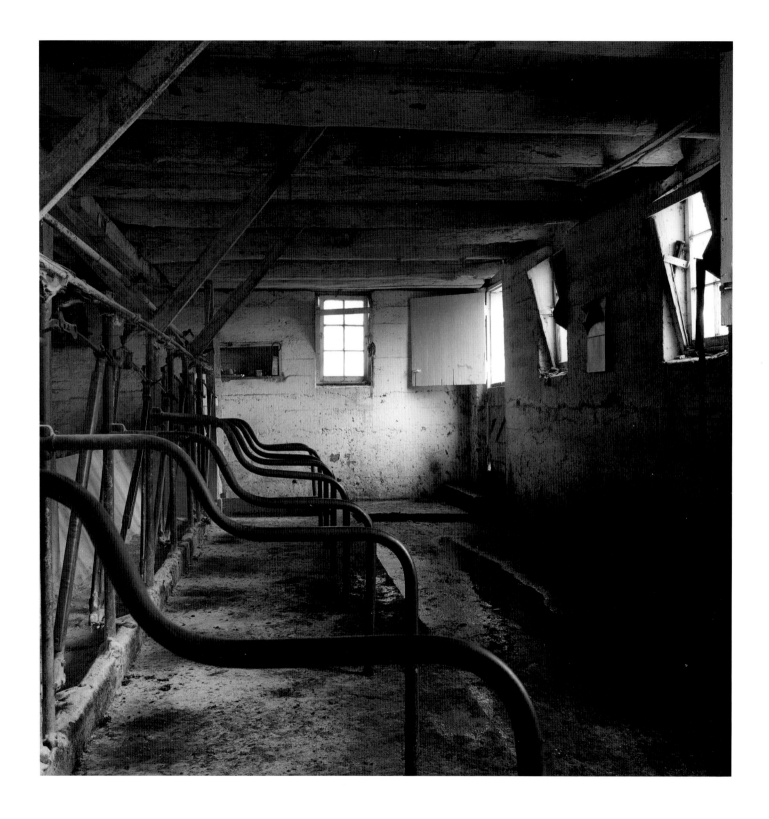

COW BARN INTERIOR, ISABELLA COUNTY, MICHIGAN, 1975

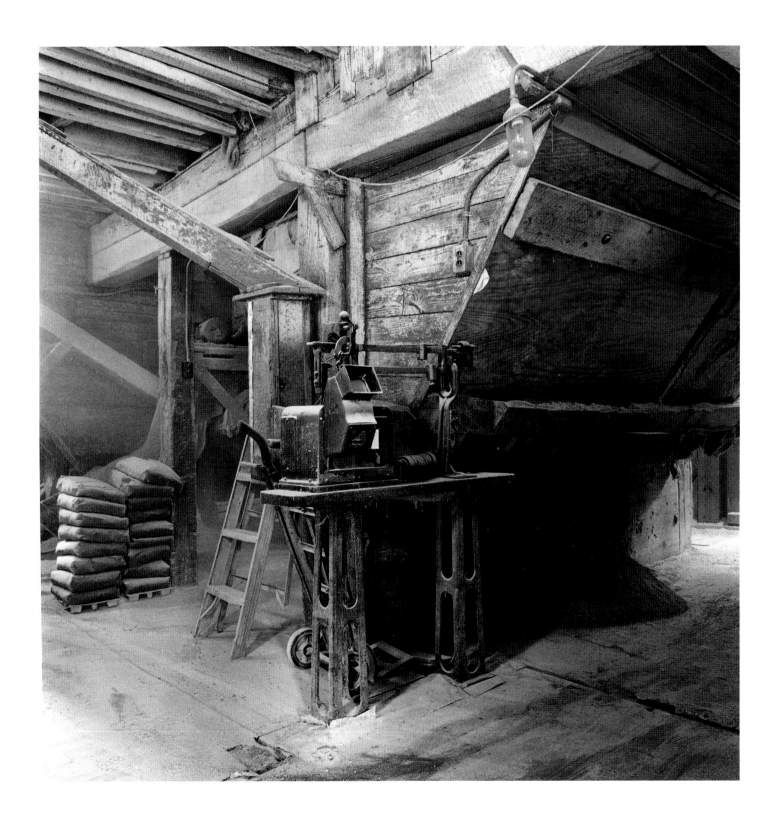

GRAMCO FEED COMPANY, MILL, SPRINGVILLE, NEW YORK, 1992

CLARENCE CO-OP ELEVATOR, CLARENCE, IOWA, 1987

SHOVELS IN FARMER'S CO-OP GRAIN ELEVATOR, DIKE, GRUNDY COUNTY, IOWA, 1983

SMALL TOWN

It is very hard to walk slowly if you've ever been a New Yorker, but whenever I think about the meaning of the word *community,* I visualize myself walking slowly along the sidewalks of small-town America. It is most often a place of common cultural heritage — a rich archaeological site that reveals much about those who live there and the way the place has been used. Clues abound in a hundred years or more of eclectic architectural styles; in how the houses have been renovated or not; in the size of a garage, the kind of lawn ornaments, and the number of satellite TV dishes; in whether there is a motorcycle or a pickup — or both — in the driveway. Up on the hill, on some secluded street, there was a house grander than the others, the place where the richest man in town once lived. Whether he was reviled for his parsimony or revered for his largesse, the house today is usually a funeral parlor.

Most streets are tree lined; most houses are frame, anonymous in their plainness, and painted white. Most are set back from the street. A good many have front verandas where couples still sit and rock in the cool of the evening watching the passing traffic. In the fall the pungent smell of burning leaves raked into little piles is present in the air. In summer the chorus of unseen cicadas shatters the oppressive heat of August afternoons, when it is even too hot for dogs to scratch themselves. There are daffodils in the yards in spring, and on weekends or on warm evenings men and boys often wash their cars in the driveway to the strains of country or rock blaring from a radio in the garage doorway. At Christmastime the evergreens by the front door are festooned with strings of colored lights.

If you listen, you will hear myriad familiar sounds — clues, too, to the nature of the place: a baby's cry, the voices on a TV soap opera (and occasionally a real-life drama as well) coming from an open window, the banter of two teenage girls pedaling by on bicycles on their way home from school, and always, from spring to fall, the noise of at least one power lawn mower. In small towns, you can always hear footsteps on the sidewalk. Here, too, everybody knows everybody and calls one another by their first names. At twelve o'clock the firehouse siren announces the noon hour is at hand, and all work will be put aside for its duration. I myself will head for the café down on Main Street. If I should sit there sipping coffee and listening long enough, chances are I will know just about everything of importance that's going on in town.

Main Street was not ordained to be a particular way. It evolved, adapting to the priorities of those whose needs it served. Its fortunes ebbed and flowed with the times — prospering or, as often, languishing in a prolonged half-life of decay. Today Main Street has more than its share of crumbling foundations and gaping holes, as if a tooth had been knocked out. Yet, despite the automobilization of America, Wal-Mart, Kmart, and the "mall" (all of which seem to be well along the way to killing off Main Street), in all but the most defunct towns there is inevitably a post office downtown, with the flag fluttering from a pole set in the sidewalk in front. Even if all the other stores have been boarded up, one place usually remains purveying to the needs of the community, if only on the most rudimentary scale. Almost always there is a place to buy gas at either end of the "main drag" and often a garage as well, where you can have flats fixed and where there is a real mechanic who can fix almost anything else on your car. Lately, a video store, a beauty salon, or one of those boutiques that reek of incense and sell ridiculously overpriced gewgaws has come to squat. Rows of computer games, too, have replaced the pool table, but not always, I am happy to say. I have almost

never found a town without at least a bar or two. In fact, along more than one Main Street I've photographed, the bar was the only place still doing a brisk business — judging from the cars always parked out front. There is a dearth of drugstores, but chances are, if there is one, it will have a soda fountain complete with a row of revolving stools, where you can get a hand-dipped ice cream cone, where Coke doesn't come out of a bottle, and where your frappe will be made with a noisy Hamilton Beach blender.

In my travels with the camera I have often come across true anachronisms — the real item, not bogus reconstructions — where it is still possible to buy nails by the pound and Clabber Girl baking powder. Such a place was the general store in Cedar Bluff, Iowa, which I discovered one February afternoon. When I opened the door, heard the bell tinkle, and crossed the threshold, I was ten years old again, back in S. L. Davis's store in Putney, Vermont. It was the same place, the same musty smell, the ornate cash register; even the same boxes of Red Wing shoes were there on the shelves, just as I remembered.

Si Davis's store was heralded with the same Yankee frugality that character-ized its owner: a simple sign that read S. L. DAVIS in raised bronze letters.

Nothing more was needed. Everyone in the area knew who Si Davis was and what he sold, so further advertising would have been pointless.

I am sure that Cedar Bluff's general store was equally well known in its heyday. But that was long ago. The current owner, an elderly spinster lady who had kept shop for nearly half a century, told me that the distributors who used to supply her no longer thought it worth the trouble to drive a few miles out of the way to make a delivery. Now they delivered only to the supermarkets "right off the interstate." Recently, she explained, anything she needed to restock her shelves had to be ordered from a place in Kentucky, which sent it by freight or UPS. That was "too costly." So now she was selling off only what remained on the shelves. That, she figured, "would last until school was out."

In this, the age of the automobile, when there are virtually no small-town depots, it is difficult to imagine that "train time" was once a major event to those who lived in rural America. There is no equivalent today. Then, trains were more than just a means of transportation. They were couriers from distant places. Being at the depot was in a way rather like tuning in to Peter Jennings or Tom Brokaw on the

evening news. At "train time" one could feel in touch with the rest of the world, if only for a moment. The difference was, of course, that it was not a media event.

In generations past, the depot was the place where small-town America had its firsthand experience with the world beyond Main Street. Be it Bethel, Maine or Beowawe, Nevada, the depot was the focal point of activity. Almost invariably it was located downtown, where quite liter-ally and figuratively it occupied a central position in the affairs of the community. Even if there was no business to transact or relative arriving from afar on the 4:20, the depot was definitely the place to be if one wanted to feel in touch with things. It became a place to congregate, to kill time while "chewing the fat," in much the same manner as the general store and barber-shop. More than anything, though, it was the place to be at "train time." The trains would carry you afar, to the big city: to Cleveland, Chicago, or even New York. At the station you could buy a ticket to almost anywhere and set forth to discover the world. Even if you didn't, your imagina-tion could. You could always sit by the "high iron," dreaming of faraway places.

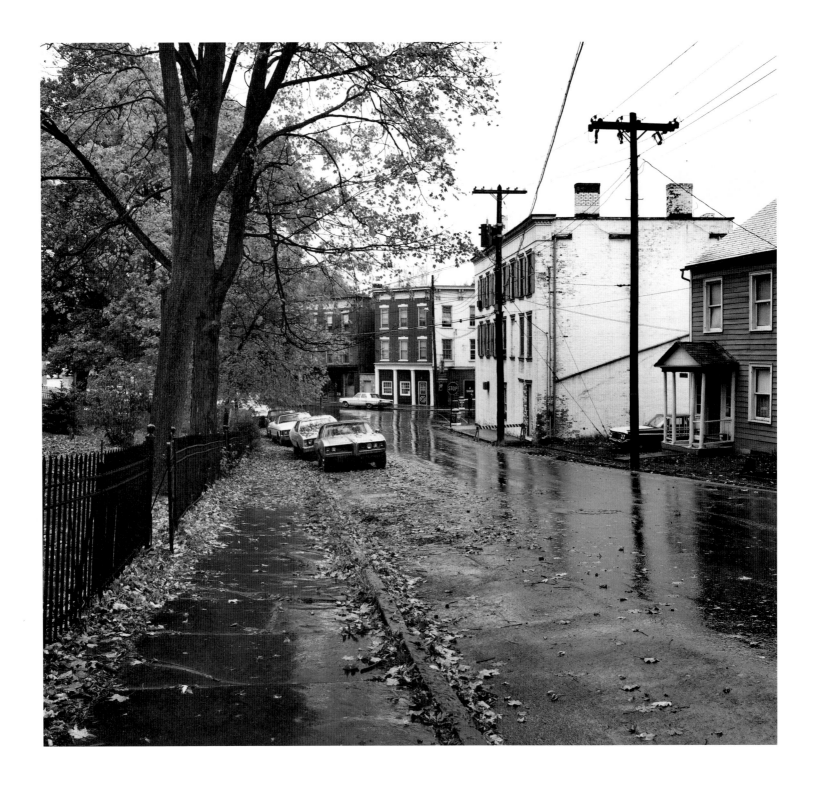

COXSACKIE, NEW YORK, 1973

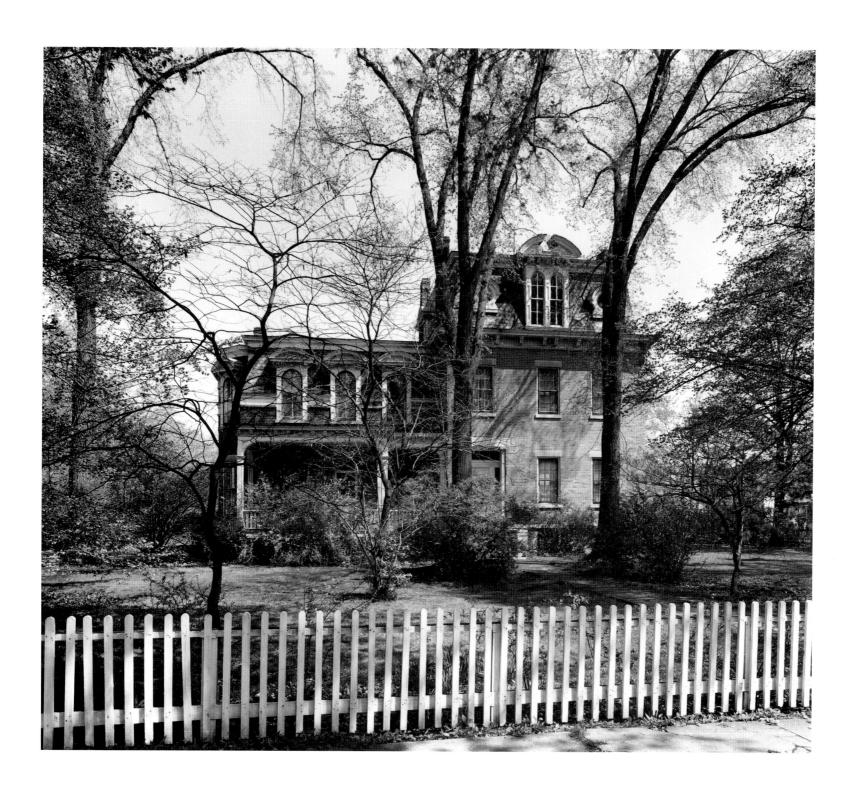

THE BEAUMONT HOUSE, LYONS, NEW YORK, 1966

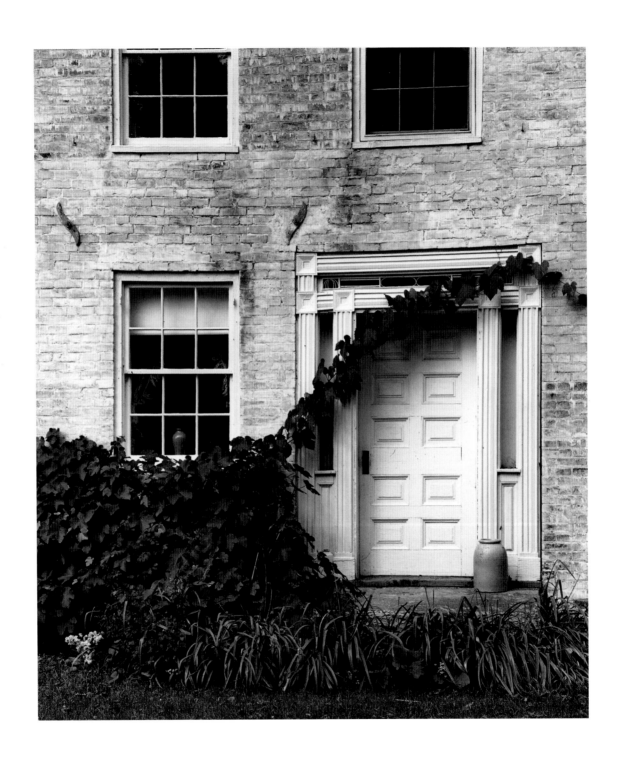

CHIPMANS POINT, VERMONT, 1963

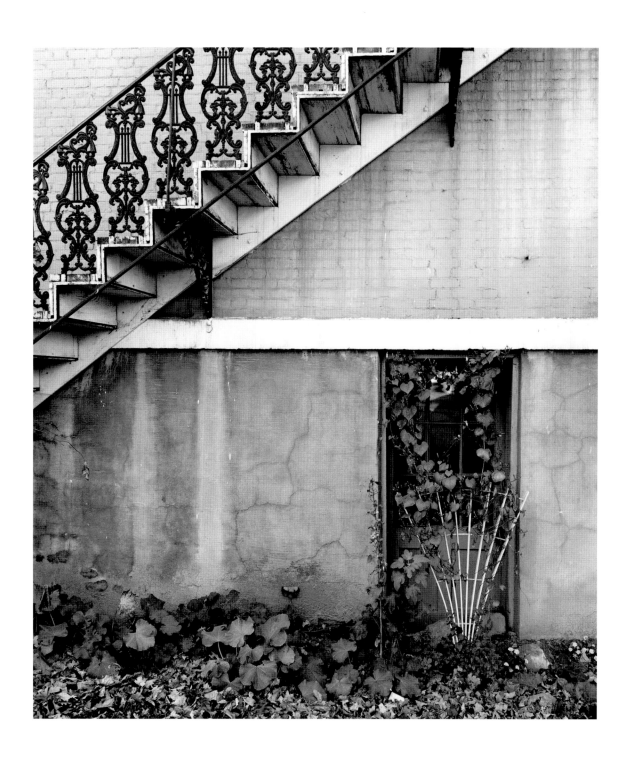

DETAIL — SIDE OF BUILDING, WATERVILLE, NEW YORK, 1973

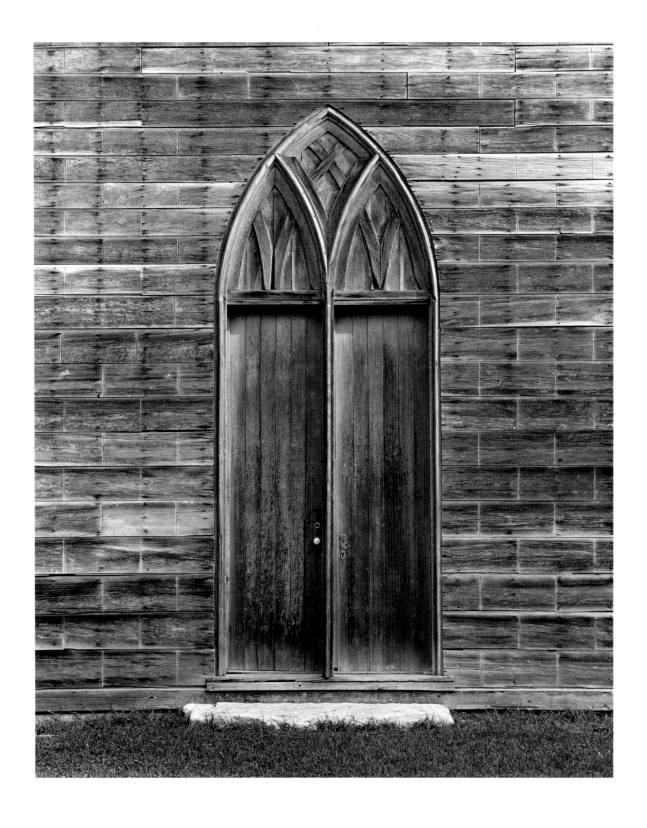

CHURCH DOORWAY, NEW DIGGINGS, WISCONSIN, 1992

BLOCK ISLAND, RHODE ISLAND, 1973

DINING ROOM, JOE AND ELLEN TETZLOFF'S HOUSE, JANESVILLE, MINNESOTA, 1991

CHAIR, JOHNSON HOME, PETERSON, IOWA, 1986

BATHROOM, HOTEL BROOKLYN, BROOKLYN, IOWA, 1987

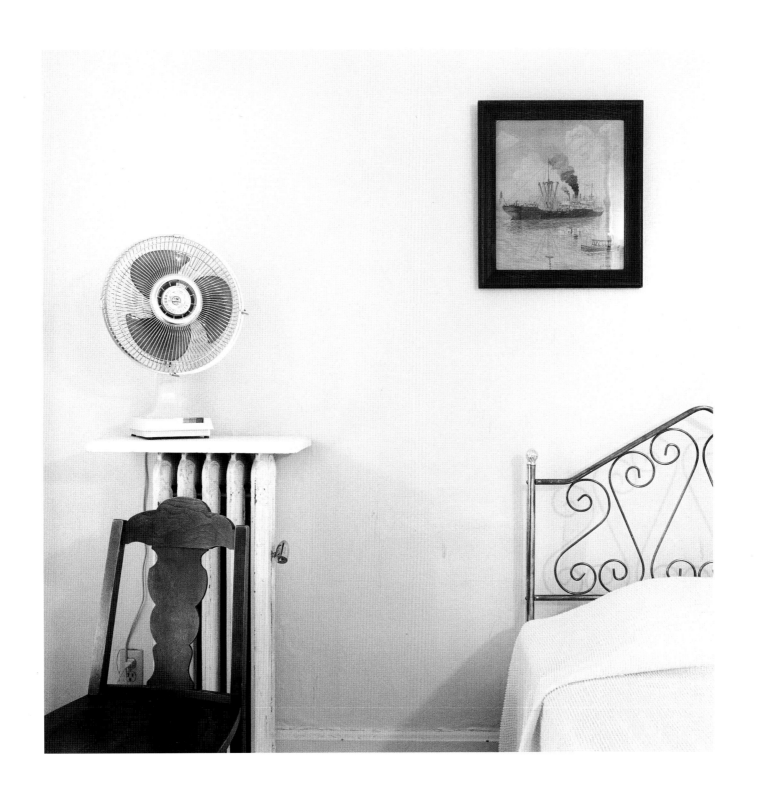

BEDROOM, HOTEL BROOKLYN, BROOKLYN, IOWA, 1987

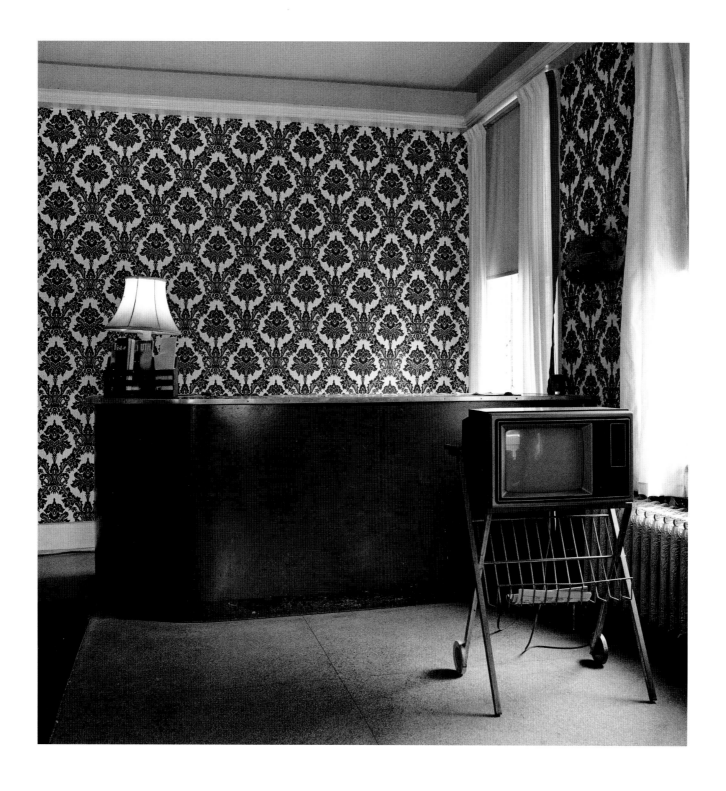

HOTEL LOBBY, COLUMBUS JUNCTION, IOWA, 1984

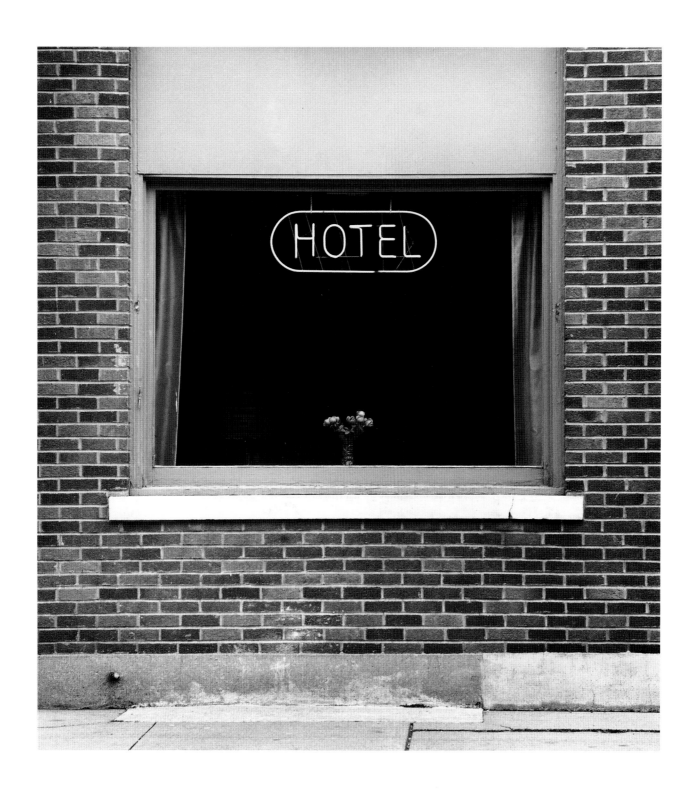

HOTEL WINDOW, CLARION, IOWA, 1973

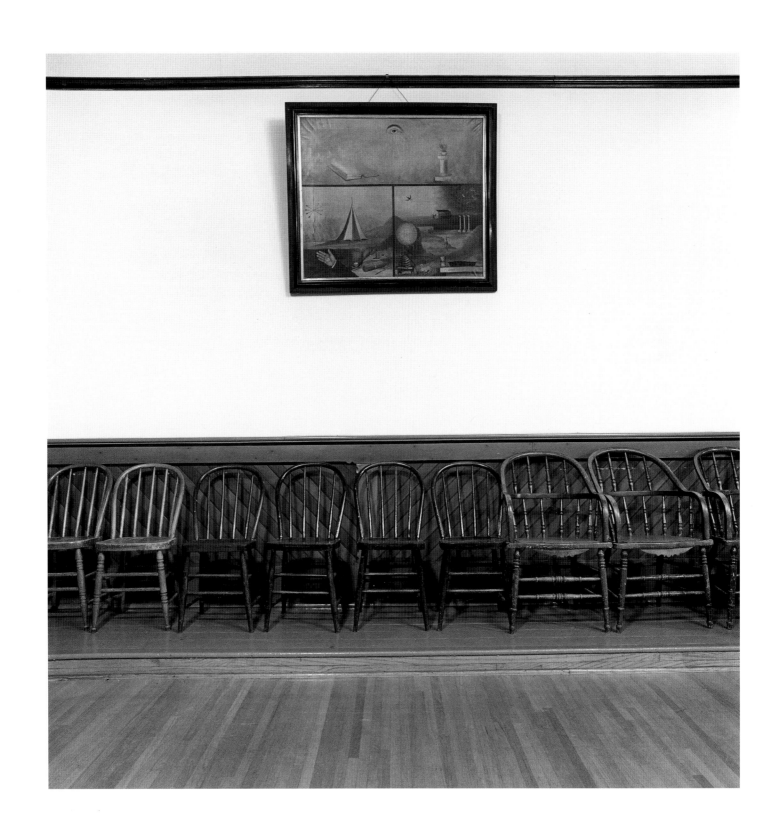

INDEPENDENT ORDER OF ODD FELLOWS (IOOF) LODGE HALL, SHULLSBURG, WISCONSIN, 1992

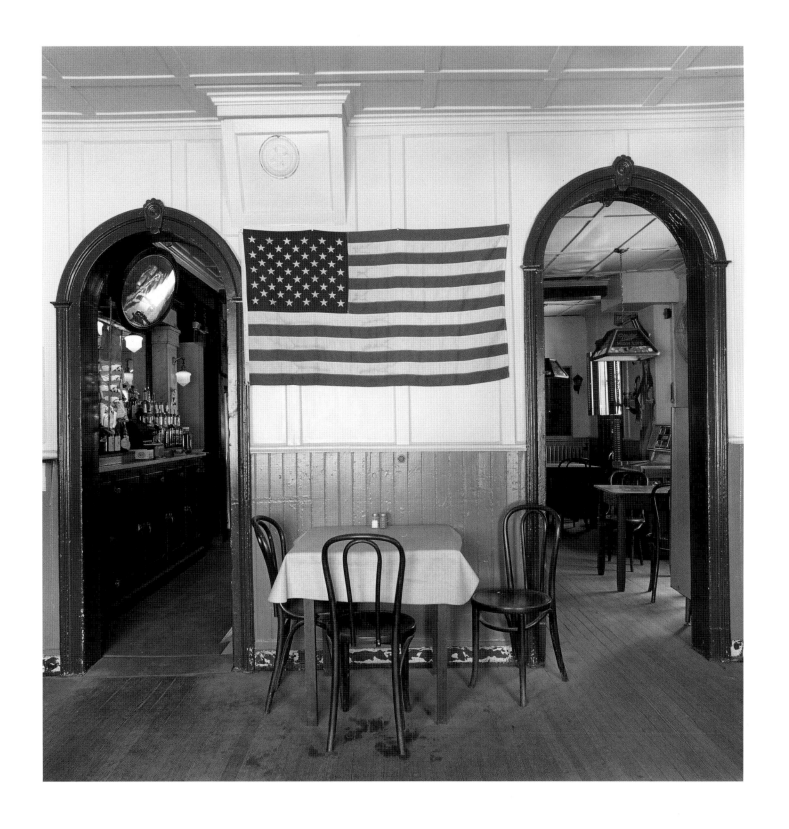

MAIN STREET, CAZENOVIA, NEW YORK, 1966

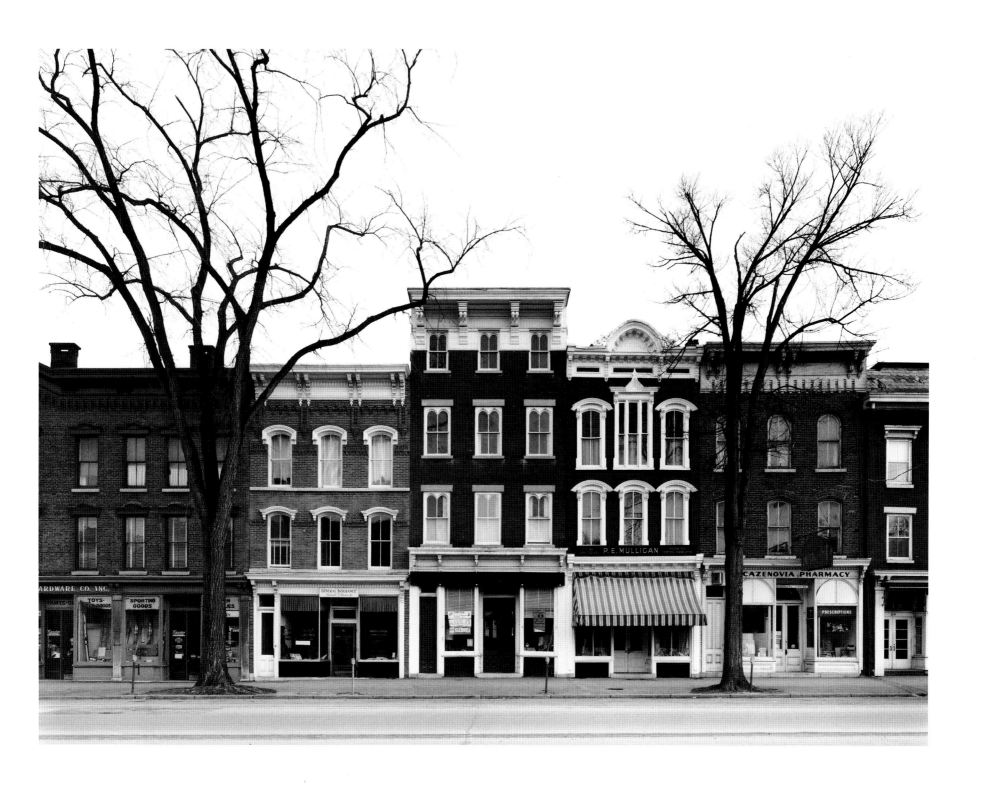

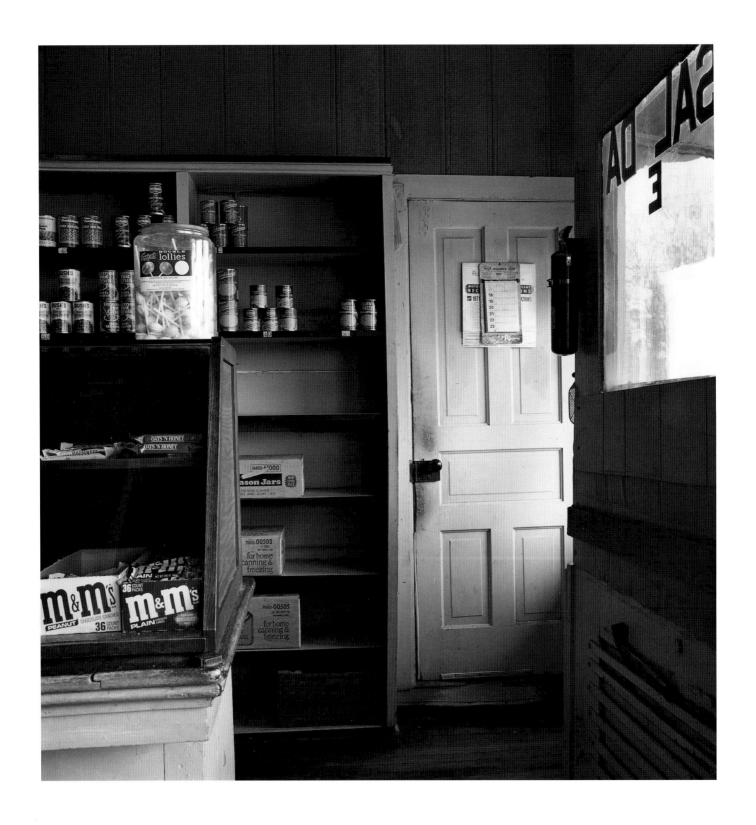

GENERAL STORE, CEDAR BLUFF, IOWA, 1987

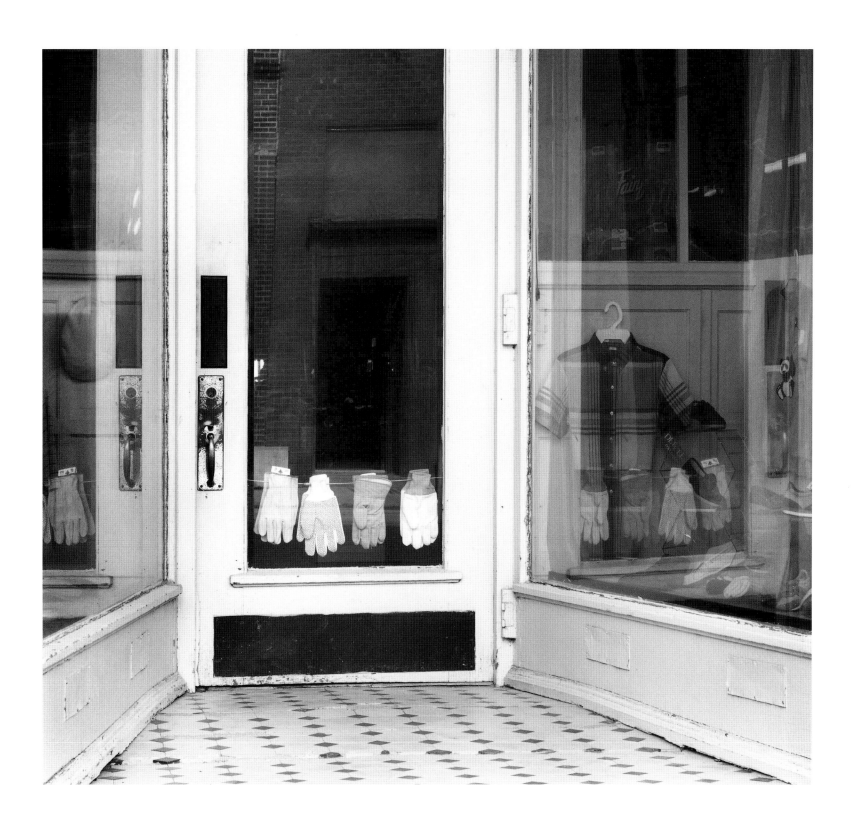

VAN'S CLOTHING, VICTOR, IOWA, 1986

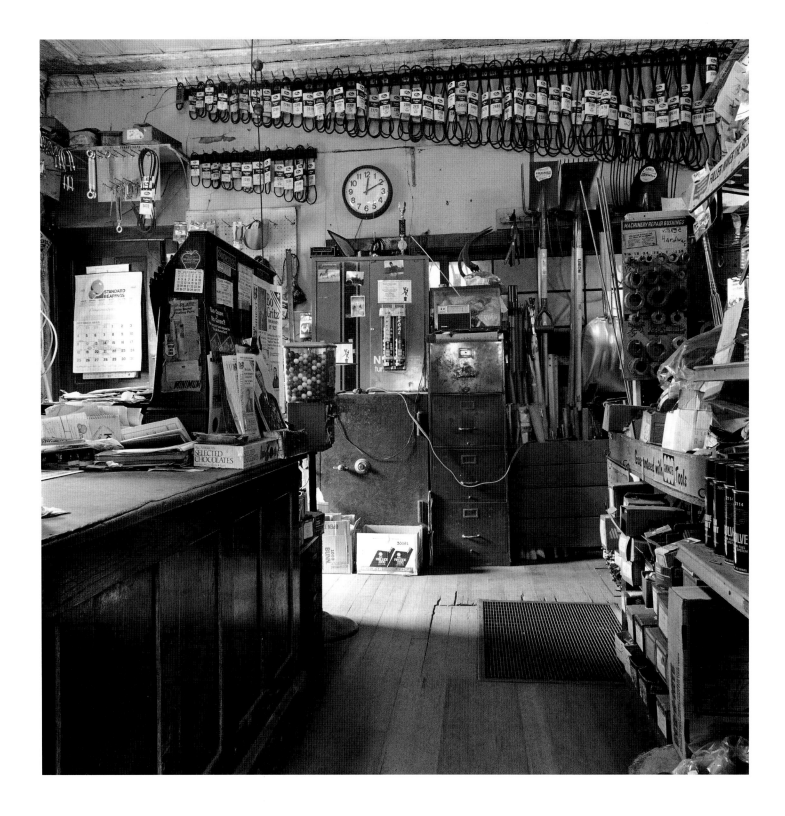

VILLAGE HARDWARE, SCALES MOUND, ILLINOIS, 1992

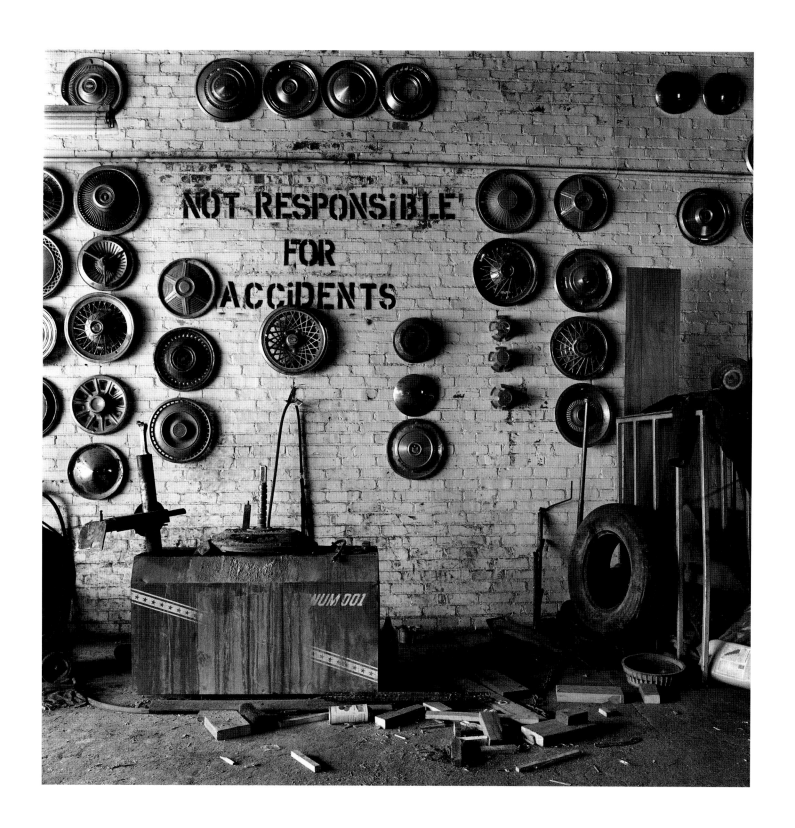

MAURICE STRODA'S GARAGE, RAMONA, KANSAS, 1991

OFFICE, ERIE RAILROAD DEPOT, THOMPSON, PENNSYLVANIA, 1966

WAITING ROOM, READING COMPANY, OUTER DEPOT, READING, PENNSYLVANIA, 1963

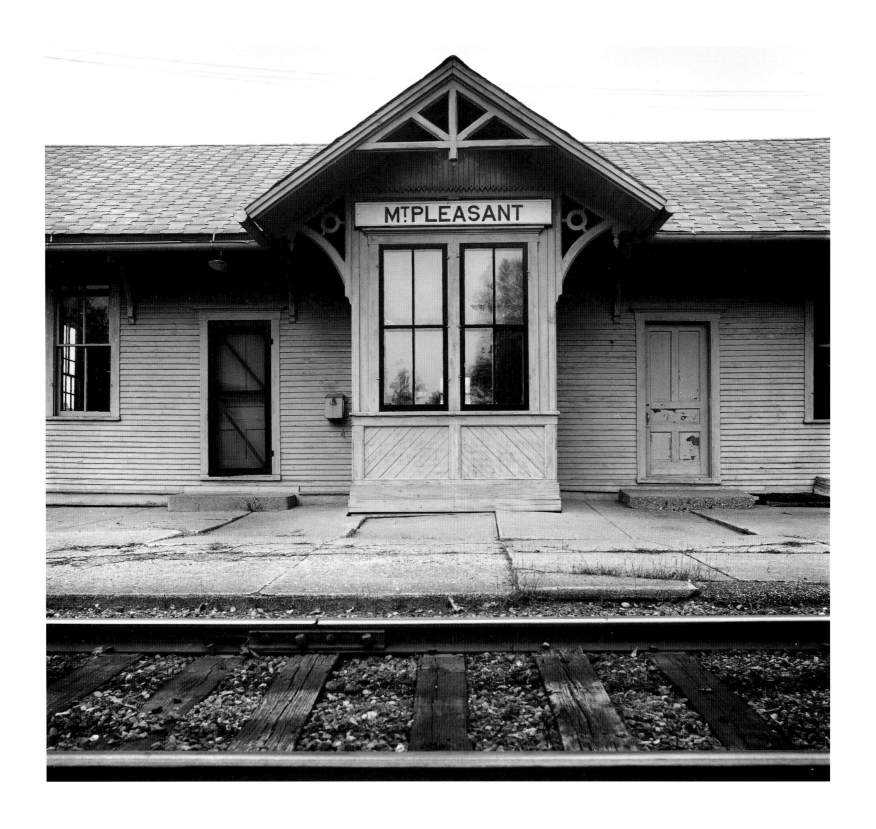

ANN ARBOR RAILWAY DEPOT, MT. PLEASANT, MICHIGAN, 1975

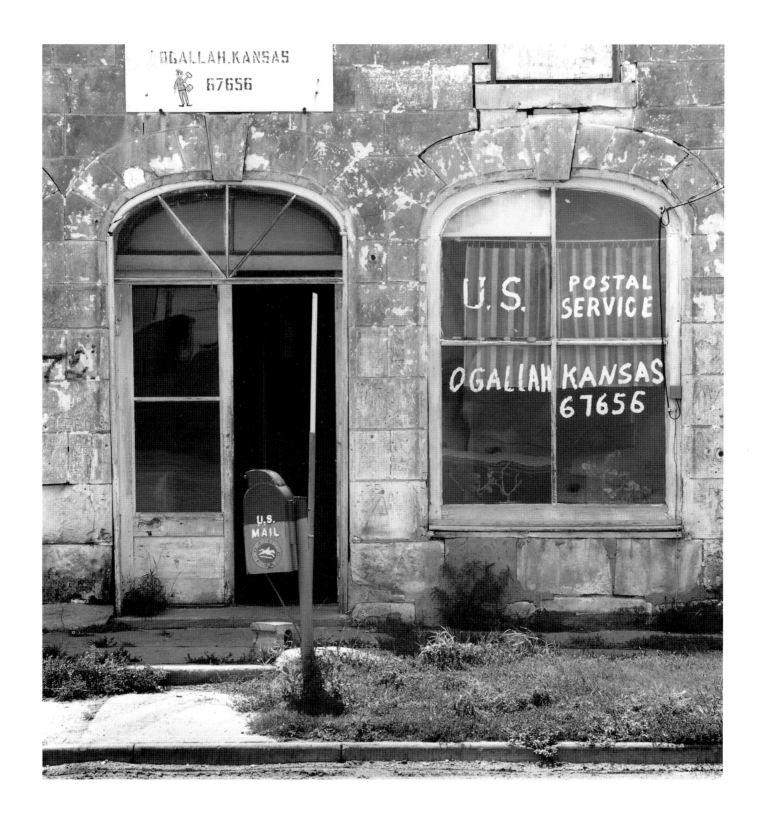

OGALLAH, KANSAS, 1973

SEA CLIFF, NEW YORK, 1974

GLEN COVE, NEW YORK, 1974

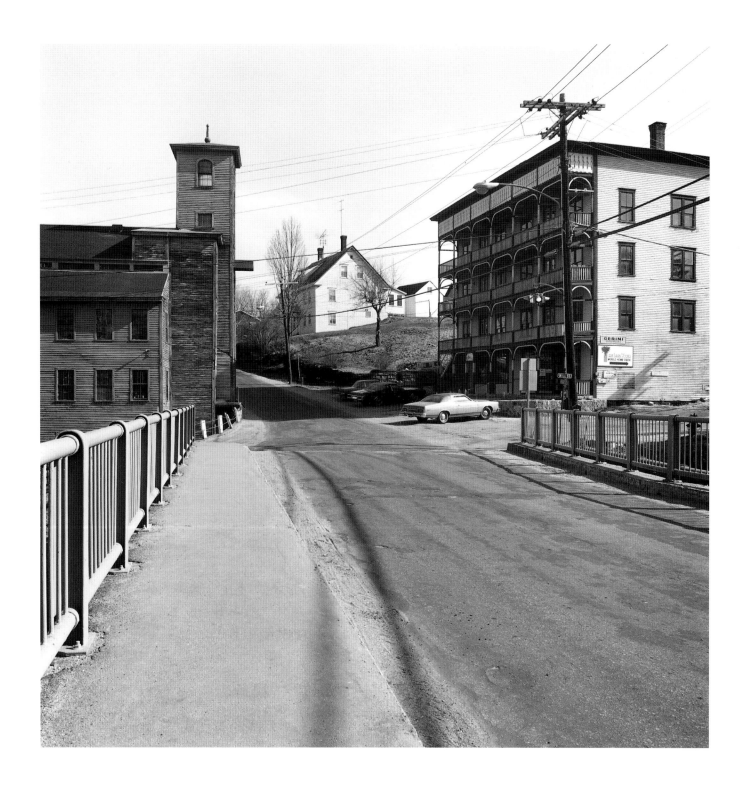

HILLSBORO, NEW HAMPSHIRE, 1975

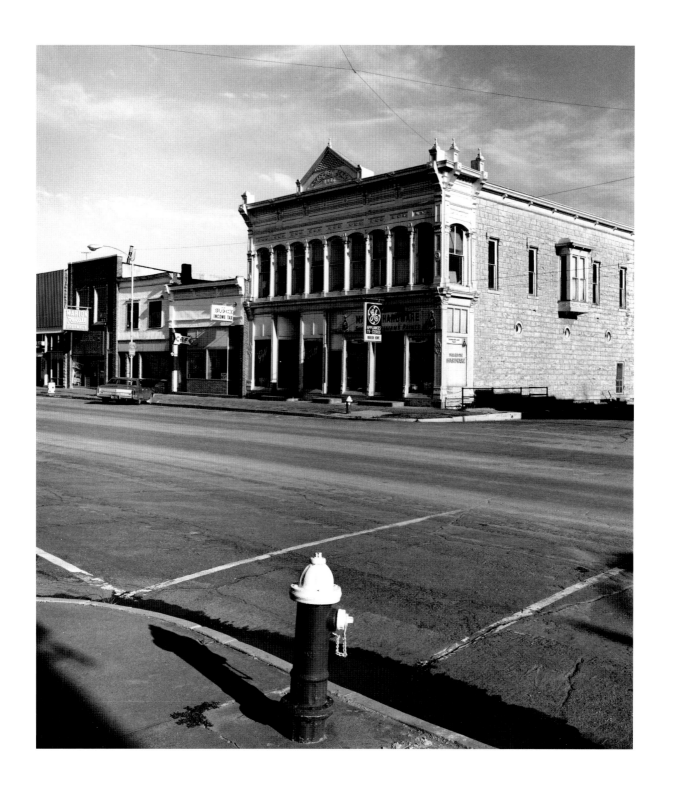

MARION, KANSAS, 1973

PEKIN, NORTH DAKOTA, 1973

FAXON, OKLAHOMA, 1969

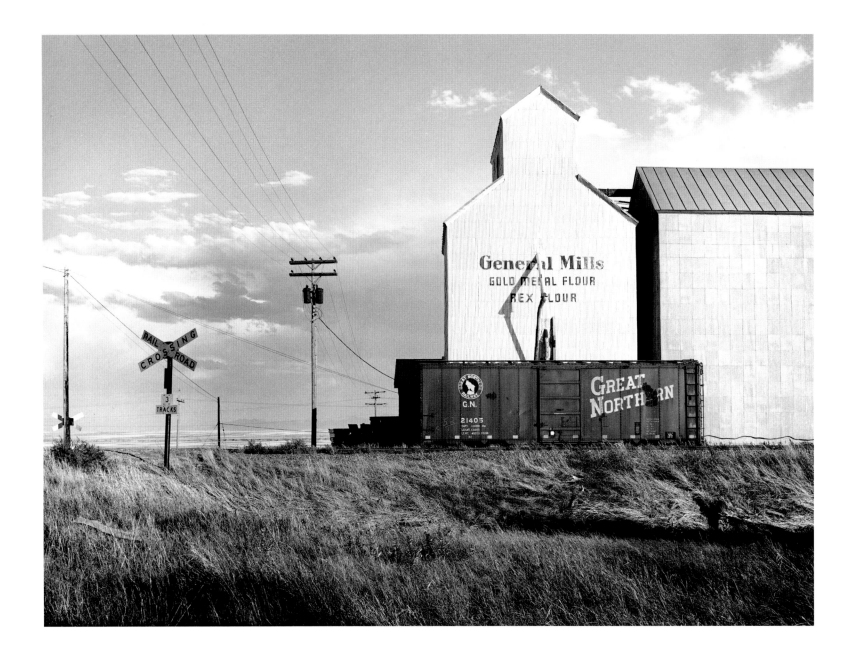

CARTER, MONTANA, 1971

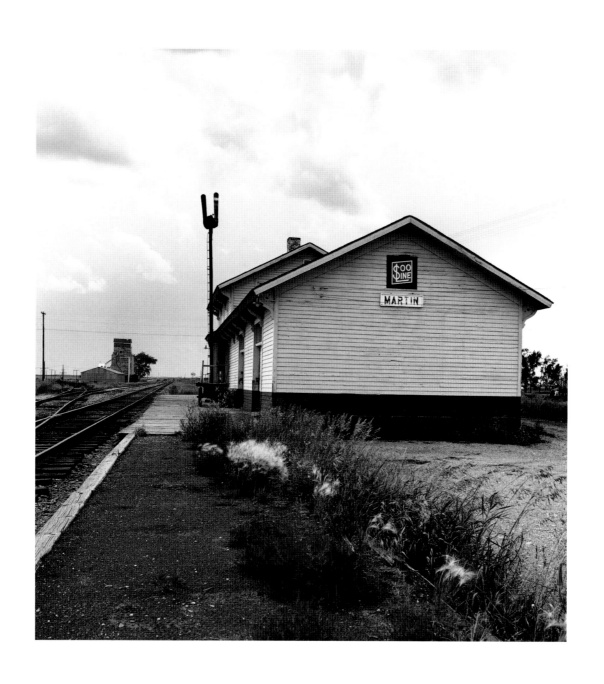

SOO LINE RAILROAD, DEPOT, MARTIN, NORTH DAKOTA, 1968

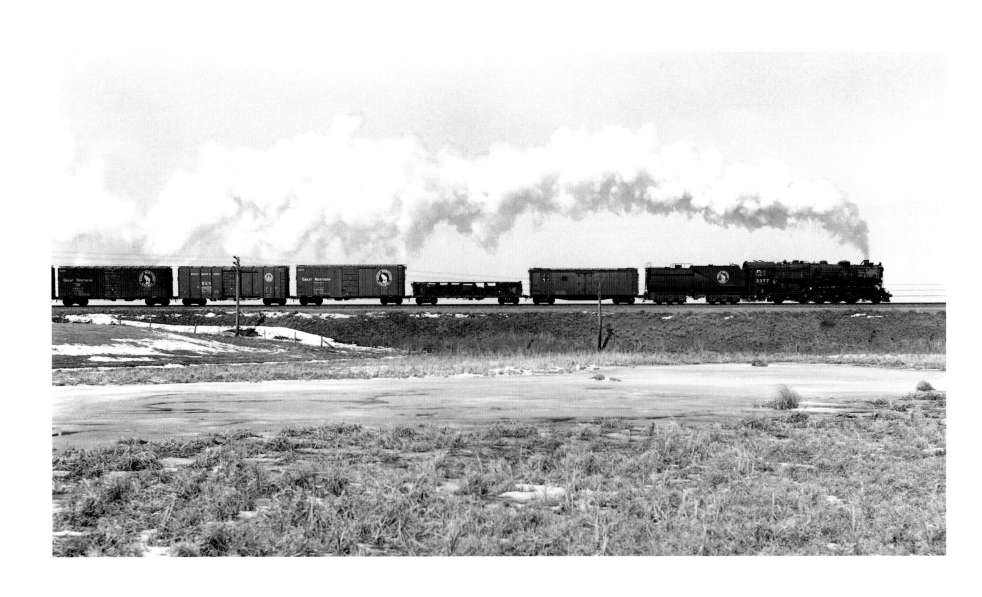

GREAT NORTHERN RAILWAY "EXTRA 3377 EAST," NEAR ATWATER, MINNESOTA, 1956

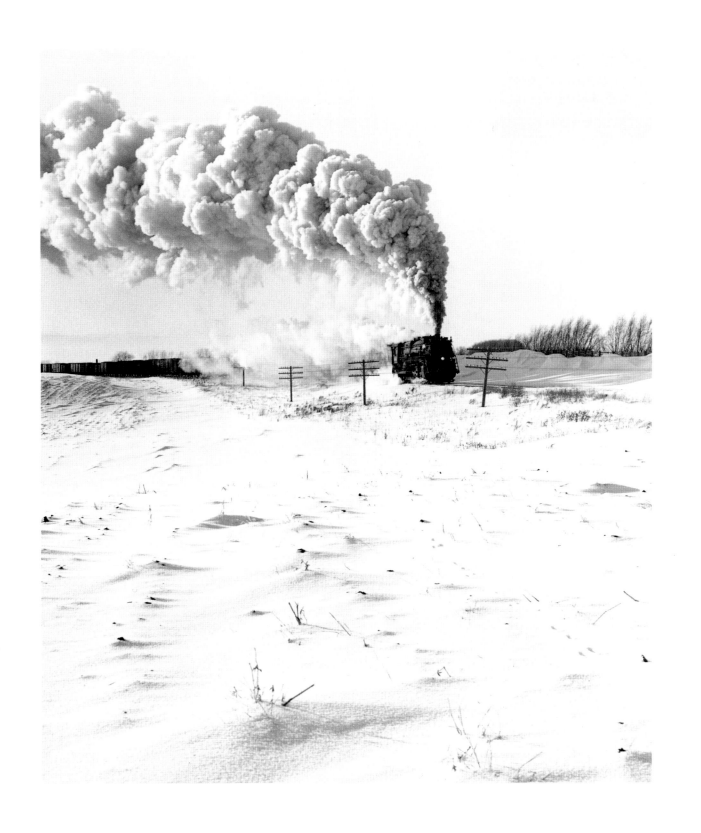

GREAT NORTHERN RAILWAY "EXTRA 3387 EAST," NEAR DELANO, MINNESOTA, 1956

TRACKS

In Vermont, where I first heard the whistle, the twisting little single-track railroads upon which the locomotive trod seemed to have achieved only the most tenuous claim on survival. The surrounding forests and fields appeared poised on either side of the right-of-way, ready at a moment's notice to overwhelm it and reclaim their ground. Mankind's presence here was indeed ephemeral, if one were to judge by appearances. It was little more than a path — just two rails, four feet eight and one-half inches apart, spiked to square-cut rectangular wooden crossties laid in a bed of gravel, beside which was strung a line of wire attached to a row of telephone poles. There was nothing else. Nothing until the distant incantations of a steam whistle and the urgent sound of the locomotive at full throttle growing louder announced that man and his machine were on their way to take command. All at once the locomotive burst upon the scene, as it had upon America a century and a half before. It roared past, flat-out, howling and hissing — a flash of swirling rods and churning, rolling driving wheels. A cloud of steam and the smell of coal smoke and hot grease left hanging in the air had forever changed the world. The solitude might return momentarily, but the locomotive would be back again and again. The rails now shone brightly, burnished by the driving wheels of human ingenuity and the power to transform the world.

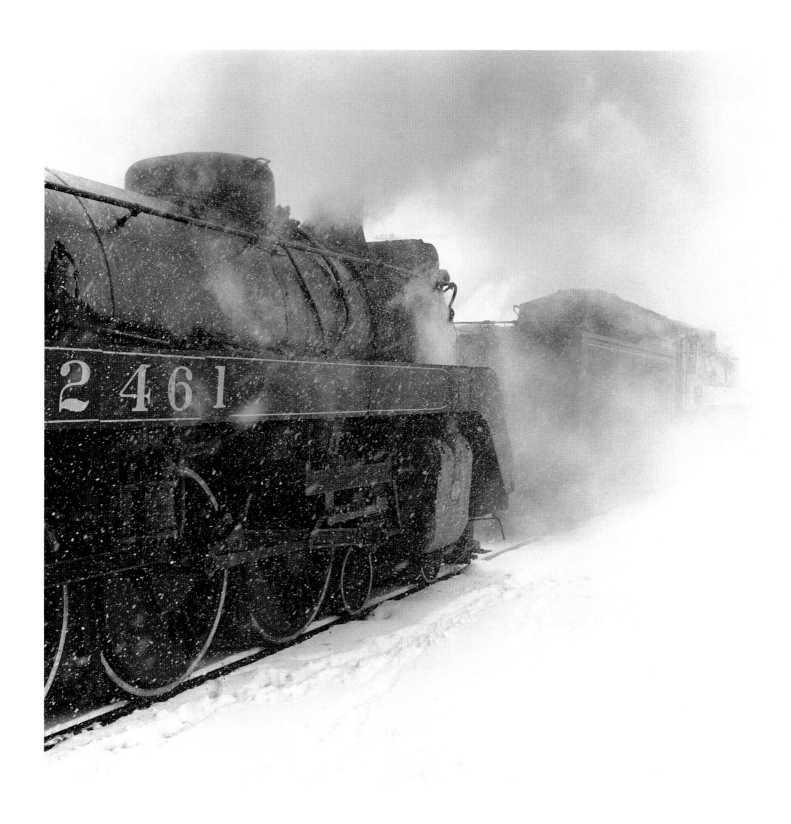

CANADIAN PACIFIC RAILWAY, STEAM LOCOMOTIVES IN ENGINE TERMINAL, MONTREAL, QUEBEC, 1960

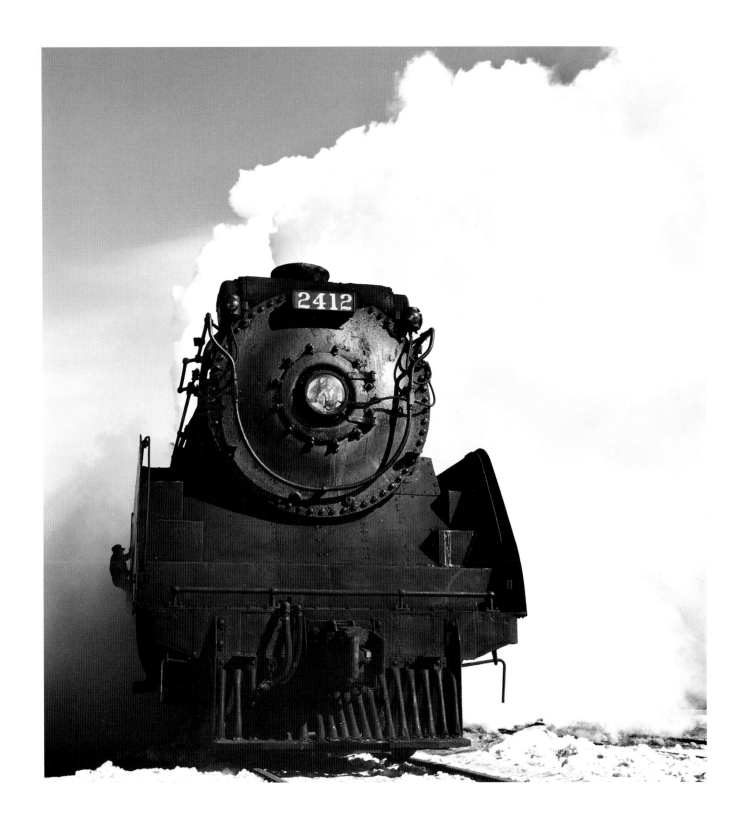

CANADIAN PACIFIC RAILWAY LOCOMOTIVE NUMBER 2412, MONTREAL, QUEBEC, 1960

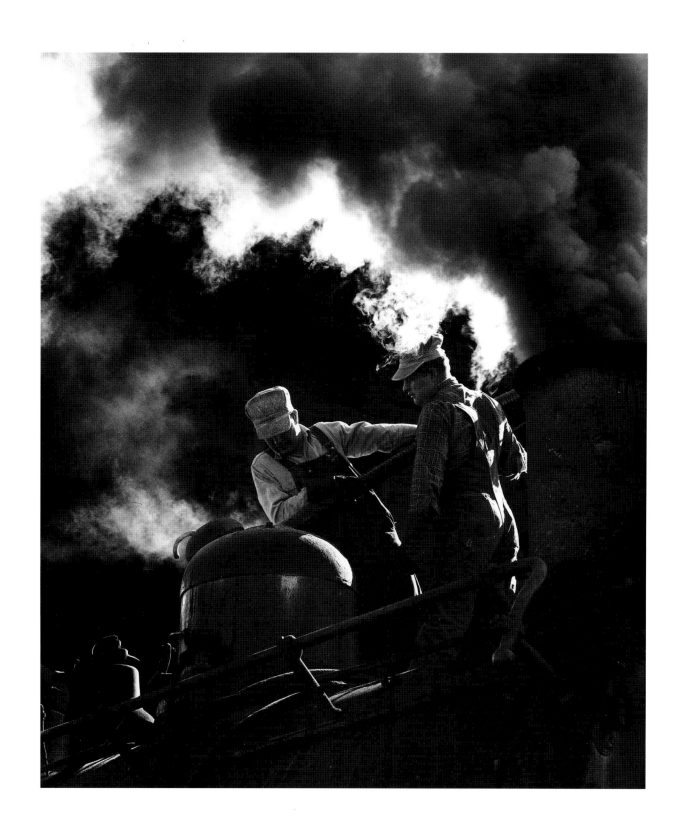

SANDING LOCOMOTIVE, DENVER AND RIO GRANDE WESTERN RAILROAD, CHAMA, NEW MEXICO, 1962

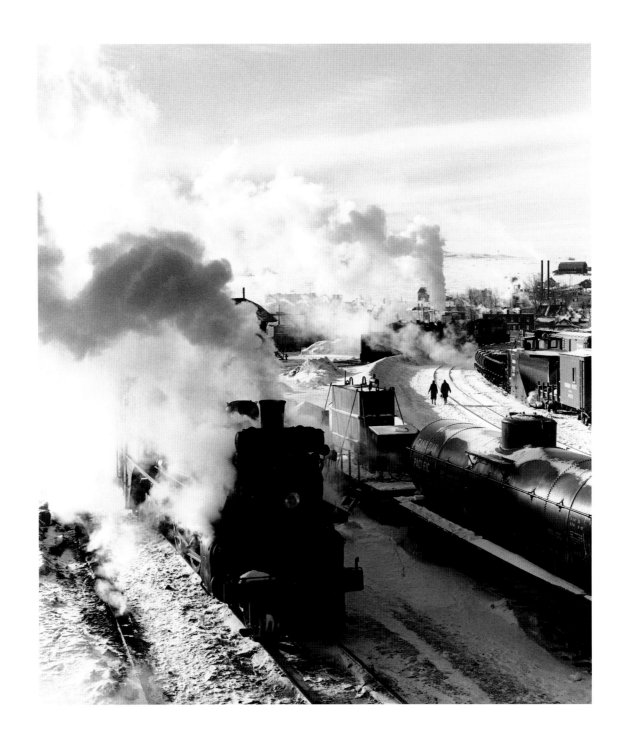

CANADIAN PACIFIC RAILWAY YARD, MEGANTIC, QUEBEC, MARCH 27, 1960

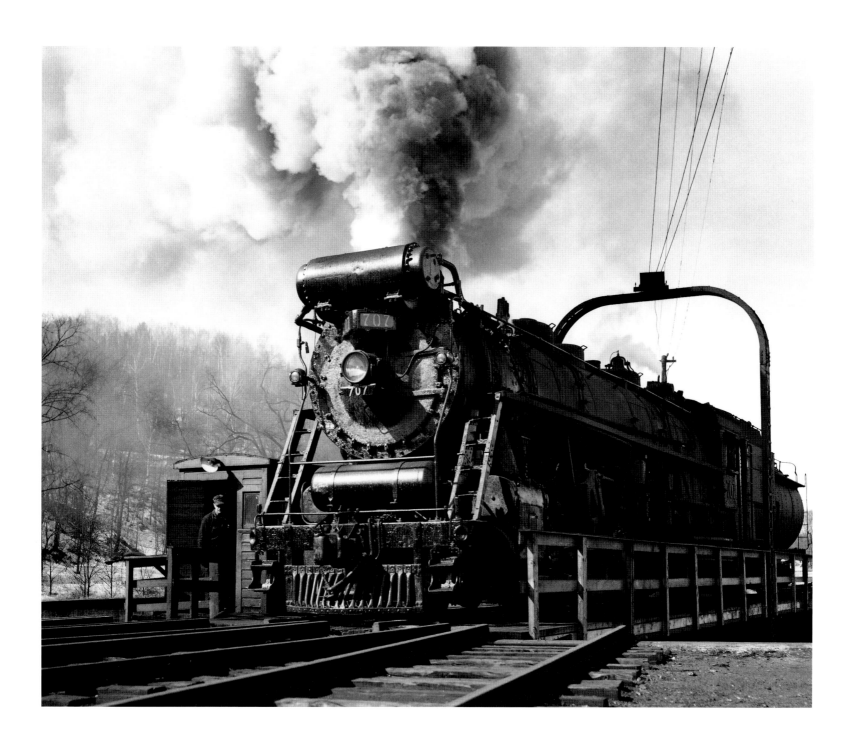

CENTRAL VERMONT RAILWAY LOCOMOTIVE NUMBER 707 ON TURNTABLE AT WHITE RIVER JUNCTION, VERMONT, 1954

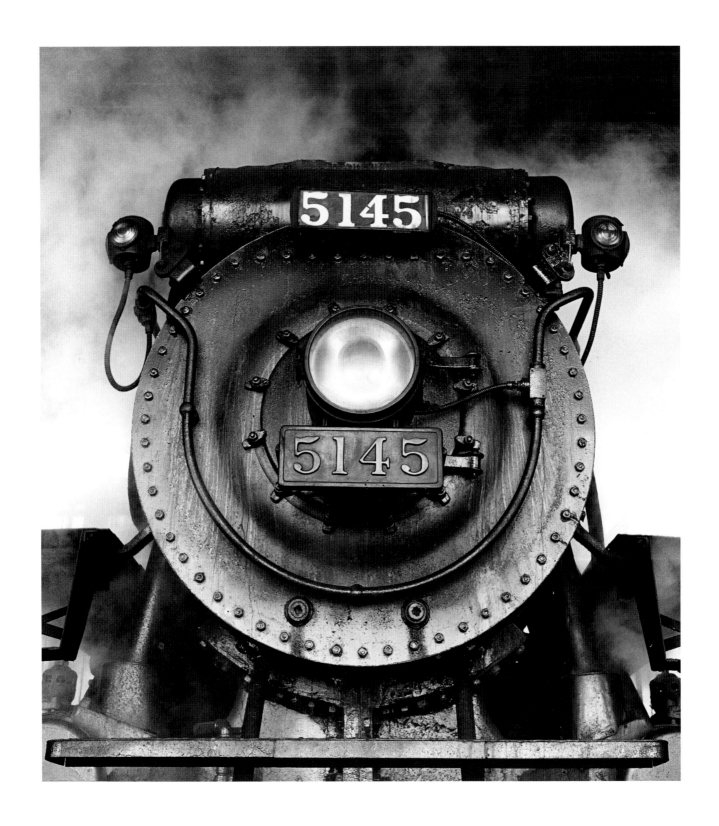

CANADIAN PACIFIC RAILWAY LOCOMOTIVE NUMBER 5145 IN ROUNDHOUSE, MONTREAL, QUEBEC, 1960

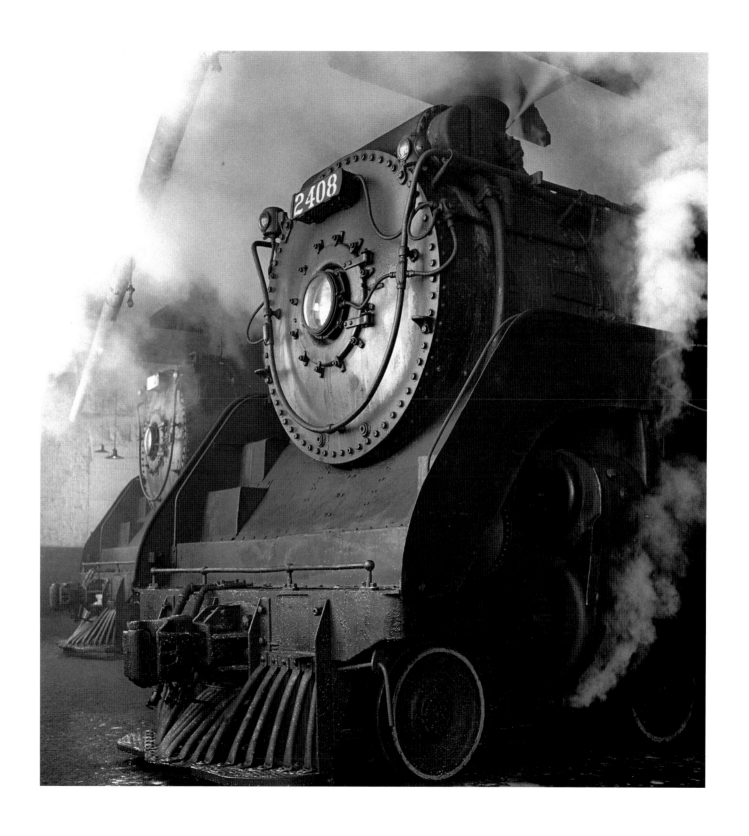

CANADIAN PACIFIC RAILWAY, LOCOMOTIVES IN ROUNDHOUSE, MONTREAL, QUEBEC, 1960

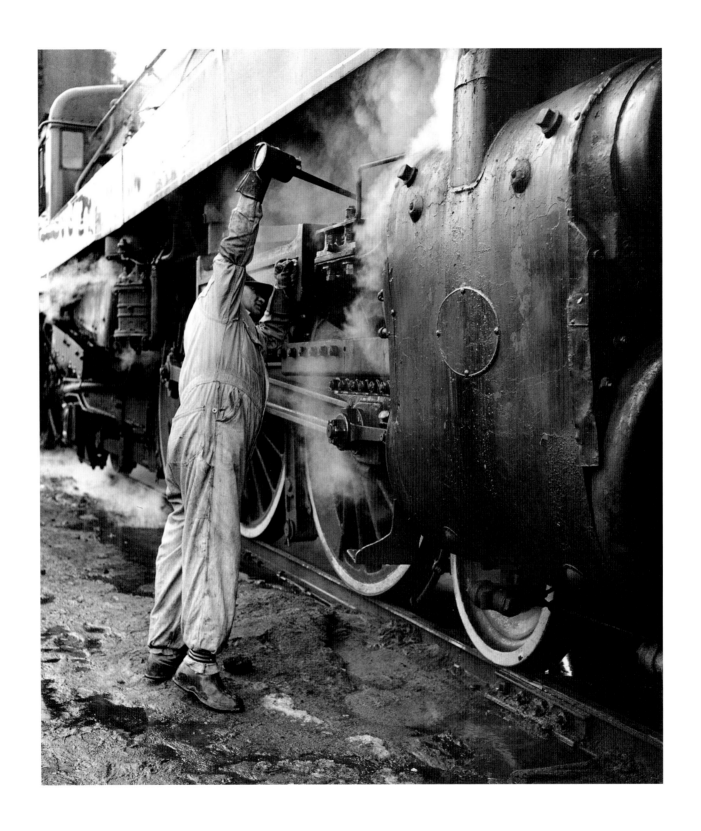

CANADIAN PACIFIC RAILWAY, ENGINEER "OILING ROUND" LOCOMOTIVE, MONTREAL, QUEBEC, 1960

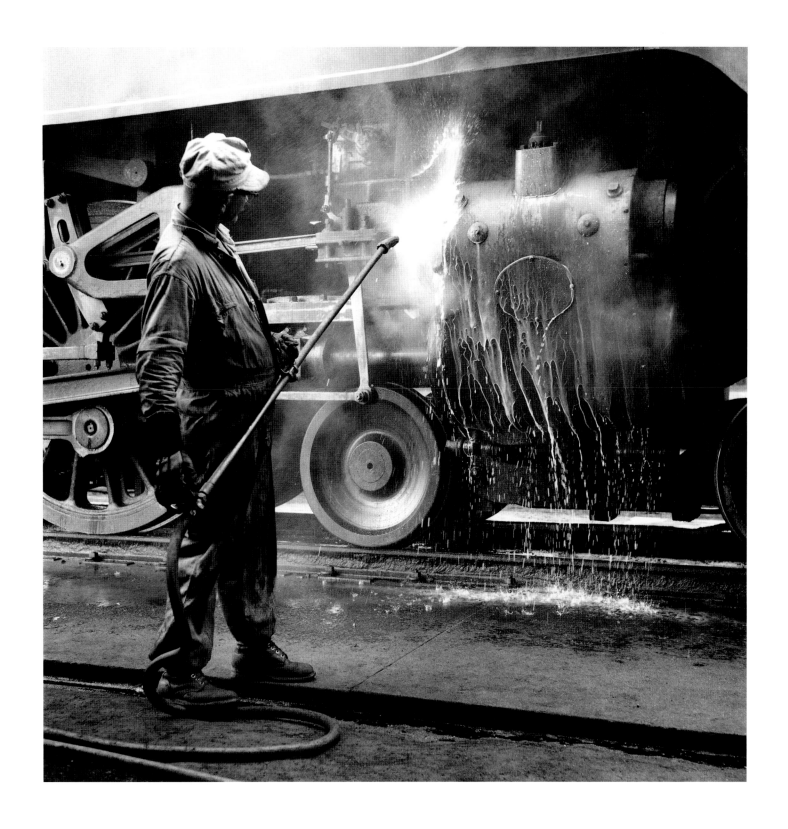

CANADIAN PACIFIC RAILWAY, HOSTLER WASHING STEAM LOCOMOTIVE, MCADAM, NEW BRUNSWICK, 1959

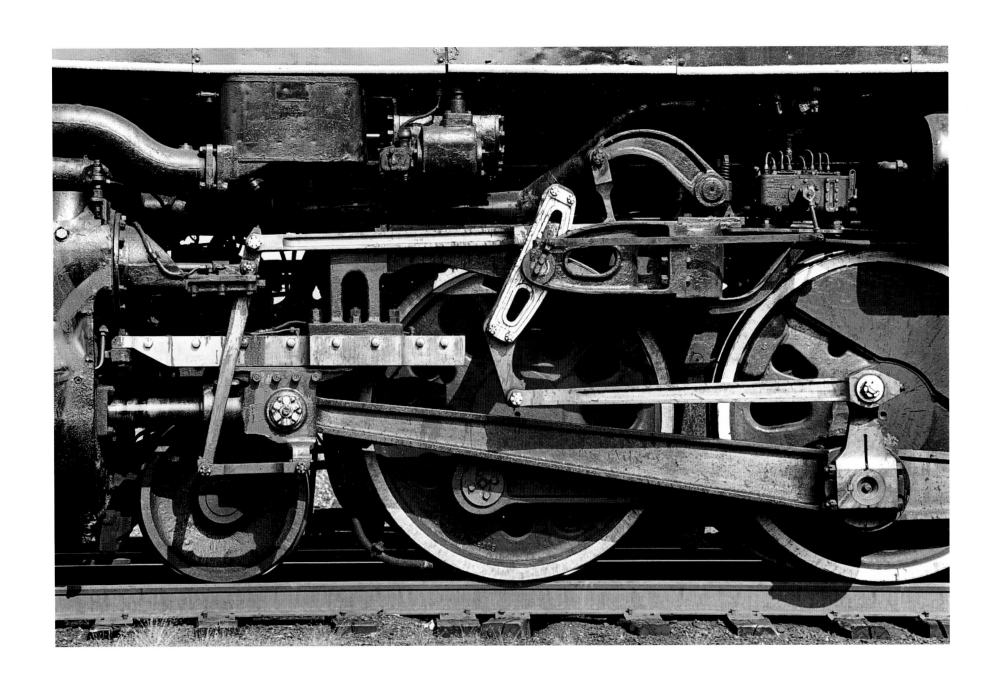

DRIVING WHEELS, READING COMPANY, 4-8-4 NUMBER 2124, SHAMOKIN, PENNSYLVANIA, 1961

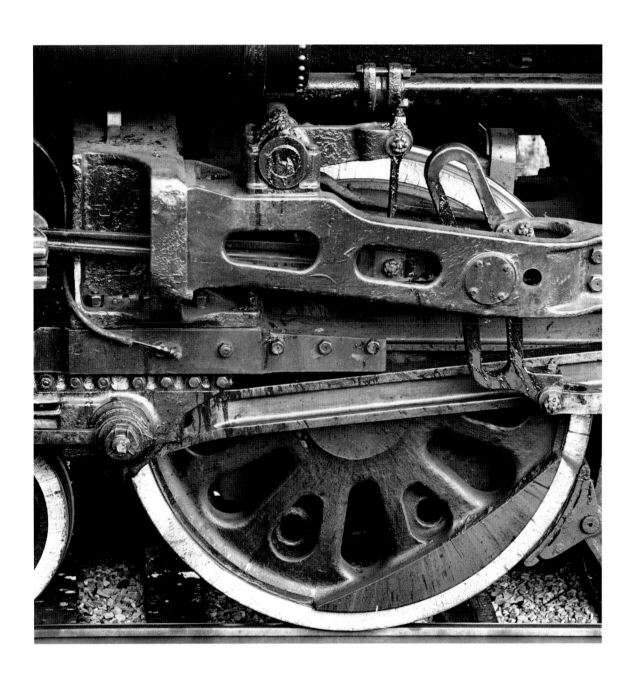

CROSSHEAD DETAIL, CANADIAN NATIONAL RAILWAY LOCOMOTIVE NUMBER 6218, MONTPELIER JUNCTION, VERMONT, 1965

DETAIL OF CONNECTING RODS AND CRANKS, LENZ STANDARD MARINE ENGINE, STEAMER *J. BURTON AYERS*, 1990

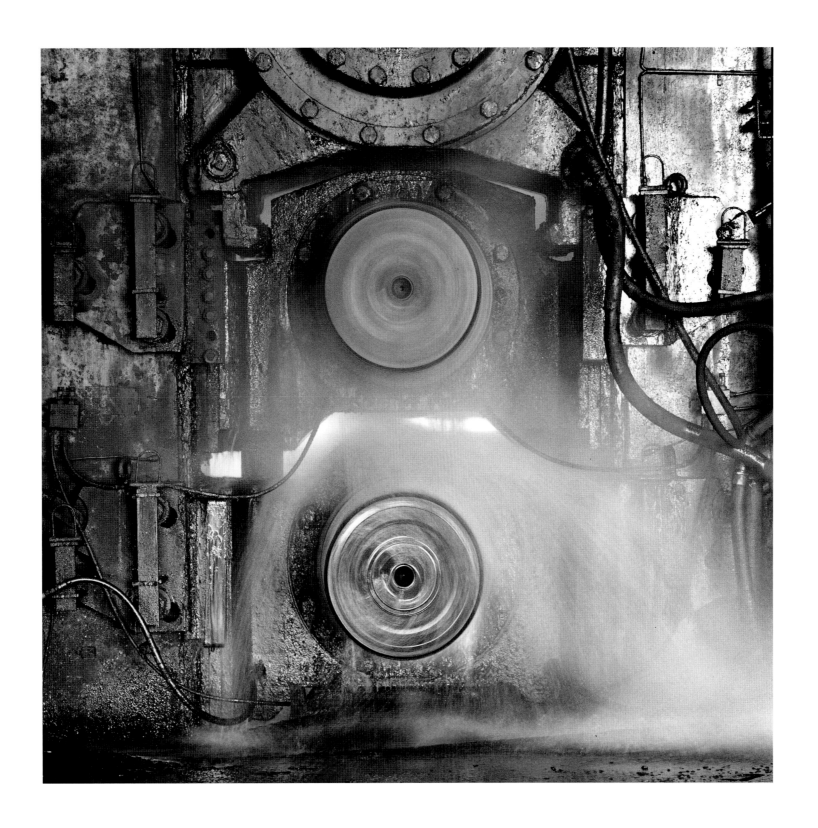

STEEL MILL, EAST CHICAGO, INDIANA, 1979

FIREHOLD STEAMER *WILLIAM A. MCGONAGLE*, 1985

LAKESIDE PRESS, CHICAGO, ILLINOIS, 1983

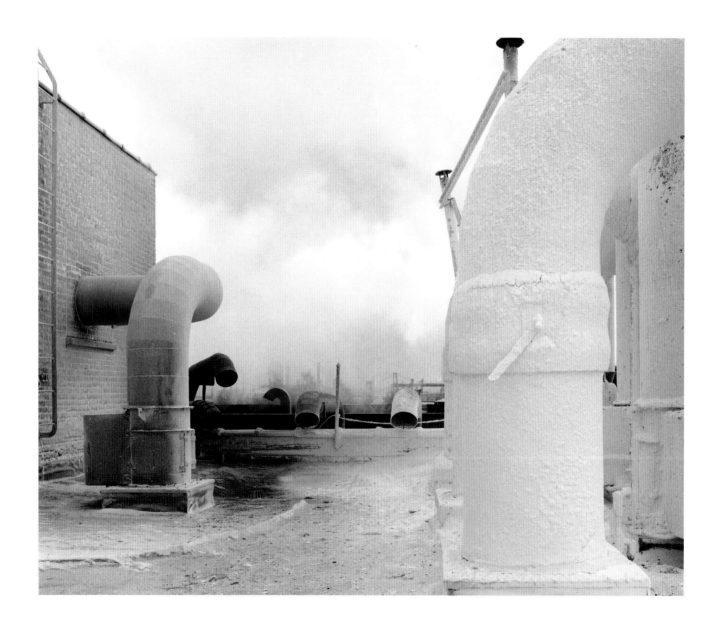

ROOF OF GENERAL MILLS FLOUR MILL, CHICAGO, ILLINOIS, 1983

COAL MINE VENTILATOR FAN, SESSER, ILLINOIS, 1980

STEAMER *S.T. CRAPO*, CABIN DOOR DETAIL, ON LAKE MICHIGAN, 1990

DETROIT RIVER CAR FERRY *LANSDOWNE*, DETAIL OF PADDLE BOX, 1964

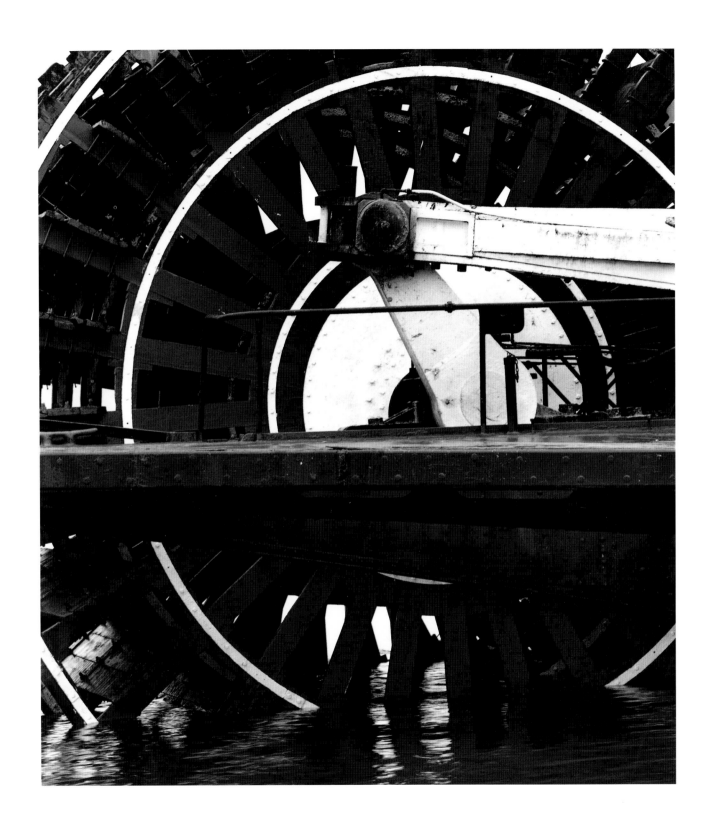

STERNWHEEL, STEAMER *DELTA QUEEN,* ROCK ISLAND, ILLINOIS, 1964

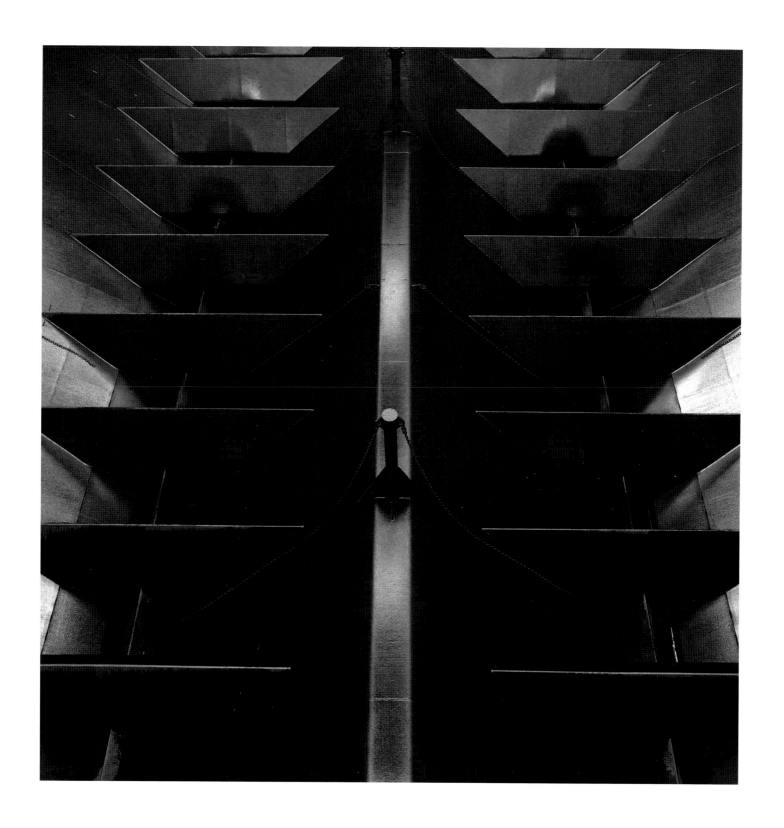

CARGO HOLD, STEAMER *CRISPIN OGLEBAY*, 1990

SMOKE

I was sitting in the pilothouse of the veteran lake steamer *S. T. Crapo,* heading diagonally across Lake Michigan, six hours out of Milwaukee. At 11:08 the car ferry *Badger* appeared out of the haze 4.5 miles away, bearing 44 degrees, laying down a heavy trail of coal smoke.

As I watched the *Badger*'s progress, I realized there was a time when a line of coal smoke being drawn across the horizon was commonplace. She could have been any steamer, and with a little stretch of the imagination, I could have been on the Mediterranean, not Lake Michigan. I followed her with my eye, until she was barely visible in the haze: a chimera. How extraordinary that all this smoke, which hung like a thin black contrail across the sky as far as one could see, should have come from but a single vessel. And how insignificant the *Badger* seemed in comparison to what it had left behind; improbable, too, that something so small could leave such a mark. Much like mankind I thought. Viewed in the larger context, the thin black line did not simply mark the course of the *Badger*'s passage; it appeared to mark our passage as well.

I looked again. The contrail had disappeared. There was no discernible evidence that it had ever existed. I pondered the question as I stood looking astern over the empty expanse of water: What of the imprint of our sojourn here? Will our civilization, all our smoke, too, evaporate without a trace?

FUNNEL DETAIL, STEAMER *HENRY STEINBRENNER*, BUFFALO, NEW YORK, 1989

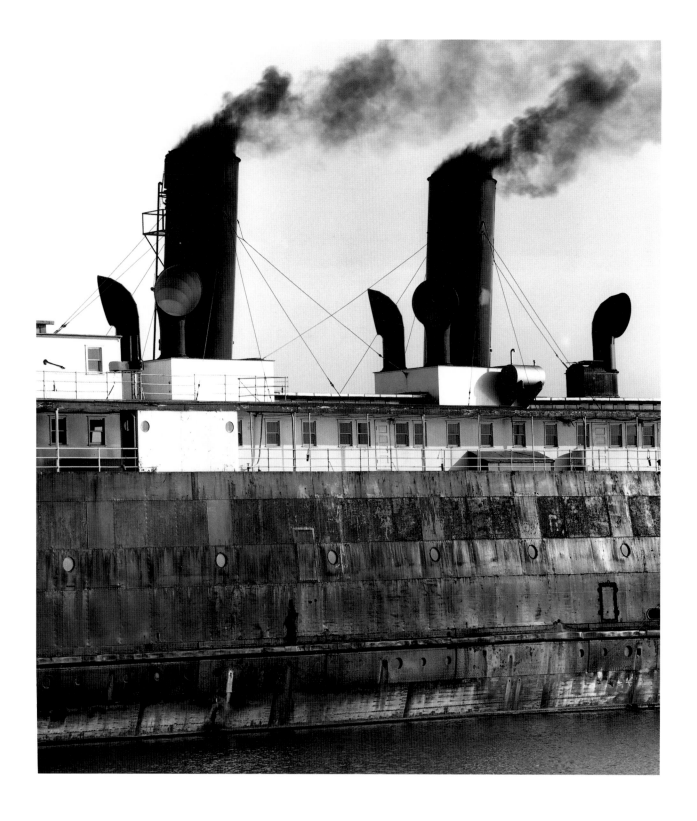

CAR FERRY *CHIEF WAWATAM*, ST. IGNACE, MICHIGAN, 1975

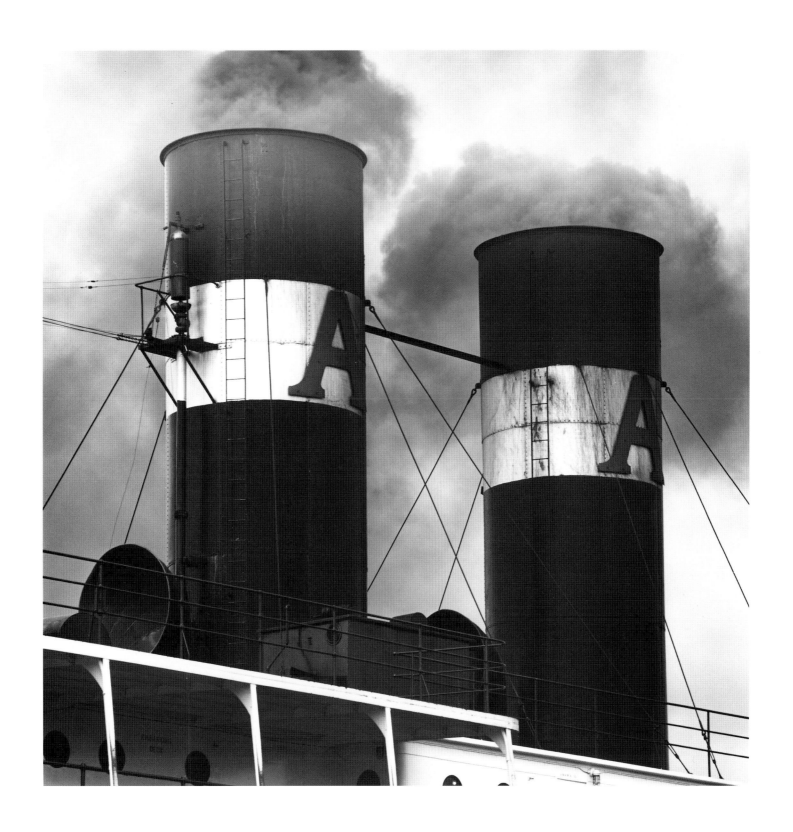

FUNNELS, CAR FERRY *ANN ARBOR NO. 5*, MANITOWOC, WISCONSIN, 1964

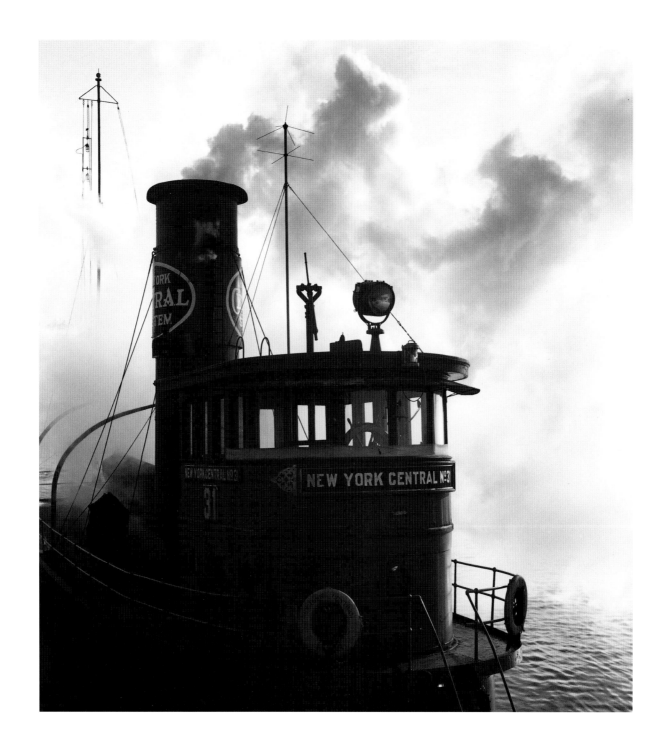

STEAM TUG *NEW YORK CENTRAL NO. 31*, WEEHAWKEN, NEW JERSEY, 1963

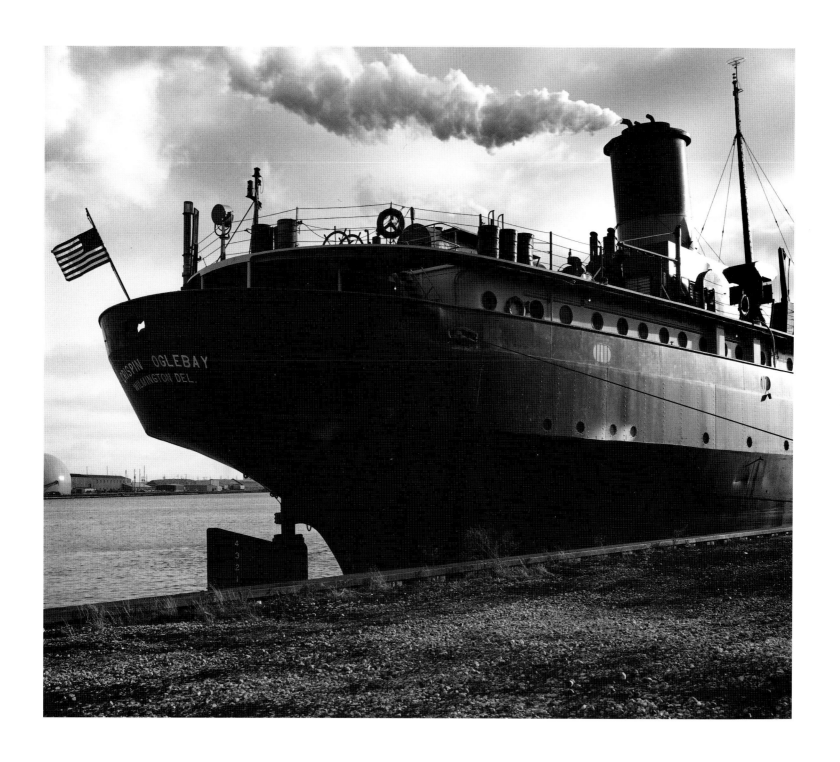

STEAMER *CRISPIN OGLEBAY*, MILWAUKEE, WISCONSIN, 1990

PITTSBURGH

Imagine sleeping through Pittsburgh! I would stay awake all night on the train to be sure not to miss a mile of that "smokey old town, solid steel from McKeesport down," as Woody Guthrie sang. For an hour or more it was nothing but seething, smoky industry to the edge of night and beyond. Nothing but mills, nothing but industry. Here, it seemed as if all the resources that brought about the great industrial transformation of the world had been gathered together in one extraordinary confluence of genius, raw material, and brute strength at the Golden Triangle, where the Monongahela and the Allegheny Rivers come together to form the Ohio.

Pittsburgh from "McKeesport on down" wasn't the only place to have stirred my blood. When I was young and the steam engine was still rampant, smoke poured forth from the stacks in mill towns everywhere. I knew the smell of hot grease, coal smoke, and steam. I saw "the reddening Poker glowing fierce" (to use the words of the poet William Blake), heard the clanging of the mills reverberating. I remember then being roused by the "hellfire and brimstone" of the great mills, which turned the night sky fiery orange over Pittsburgh, Buffalo, and Chicago. Perhaps better than anywhere, those no-nonsense, burly, old "boiler-plate" cities have come to symbolize the energy and aspirations that characterized America a century ago. I would lie back in my berth with the reassurance that all was well. The heart was strong, the nation healthy, and I was in the midst of it all. This was an age when smoke was not a dirty word but a sign of productivity and pride, a time of grand works and unshaken confidence. I was passing through what was once the land of smokestacks, America's Ruhr, a place that had produced some of the most remarkable man-made landscapes on earth. Here were more blast furnaces, grain elevators, ore docks, coke ovens, foundries, rolling mills, and railroad yards than in any other place in North America.

"Make no little plans; they have no magic to stir men's blood," said the architect Daniel Burnham. And we didn't.

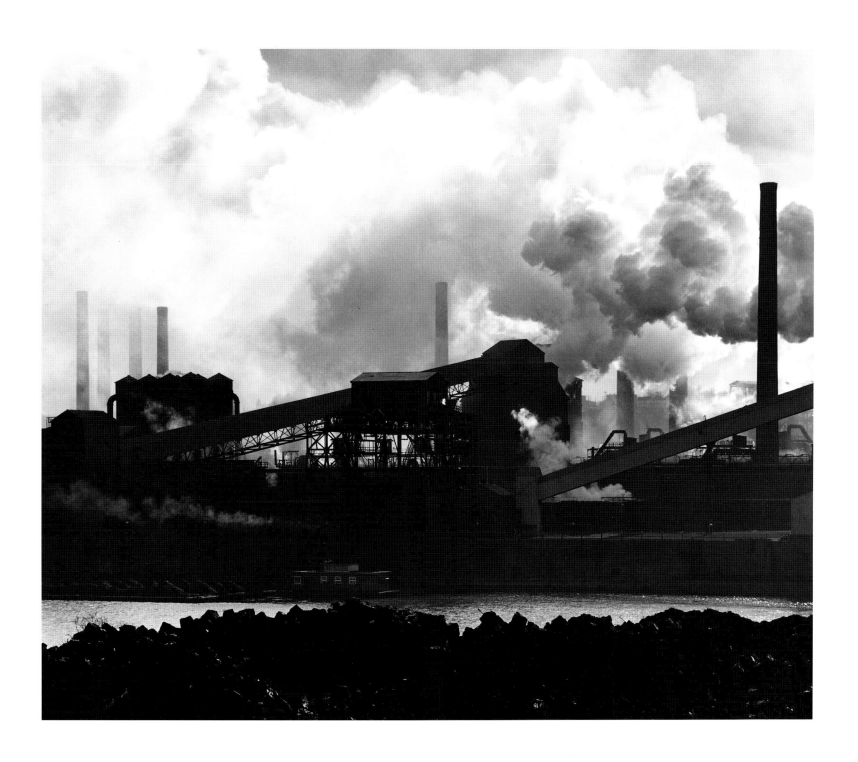

PITTSBURGH COKE COMPANY, CLAIRTON WORKS, CLAIRTON, PENNSYLVANIA, 1962

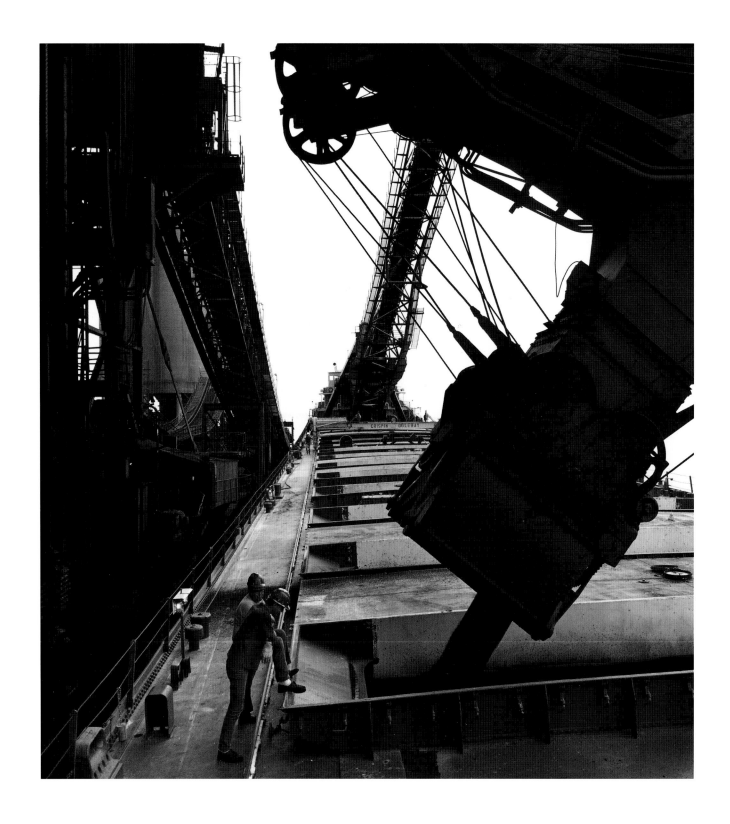

STEAMER *CRISPIN OGLEBAY* LOADING COAL AT NORFOLK SOUTHERN RAILWAY COAL DOCK, SANDUSKY, OHIO, 1990

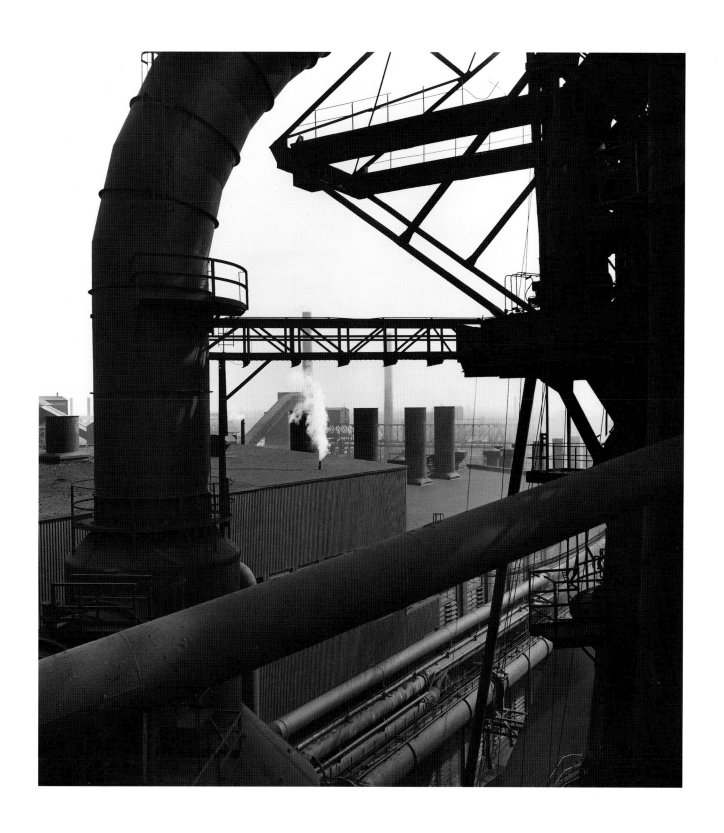

STEEL MILL, EAST CHICAGO, INDIANA, 1979

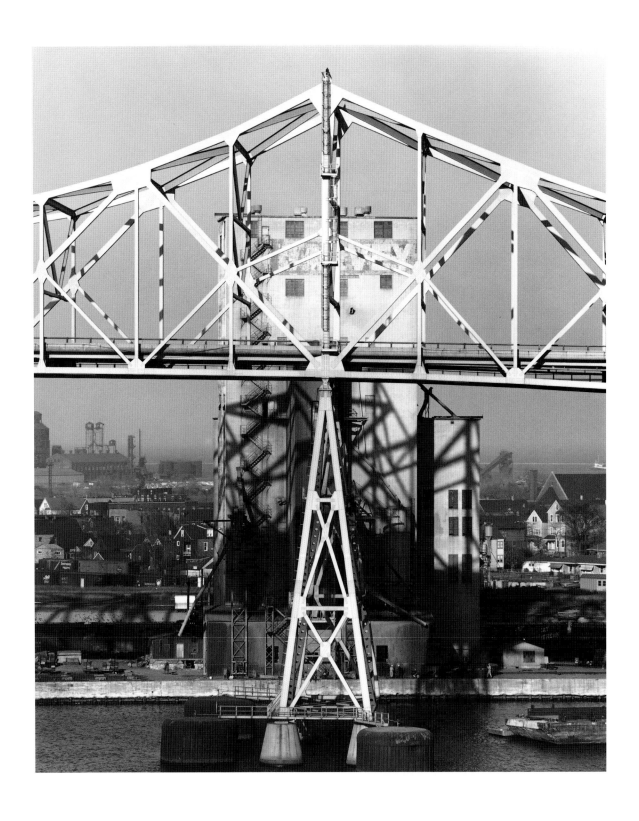

CHICAGO SKYWAY BRIDGE, CHICAGO, ILLINOIS, 1966

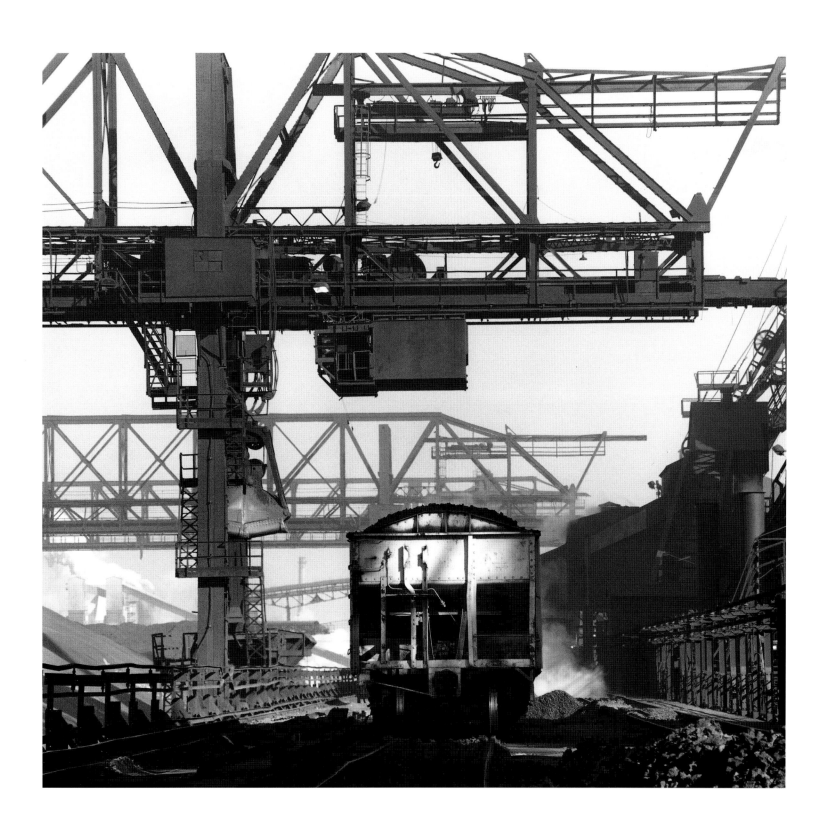

"HIGH LINE," STEEL MILL, EAST CHICAGO, INDIANA, 1979

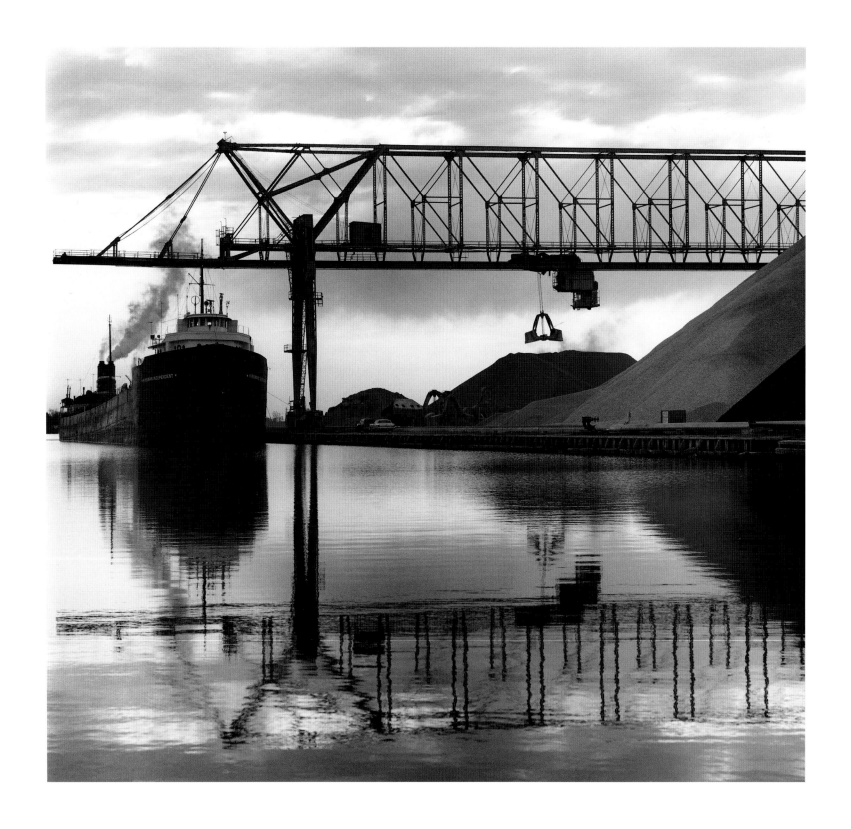

STEAMER *KINSMAN INDEPENDENT* UNLOADING CEMENT CLINKER AT SUPERIOR, WISCONSIN, 1985

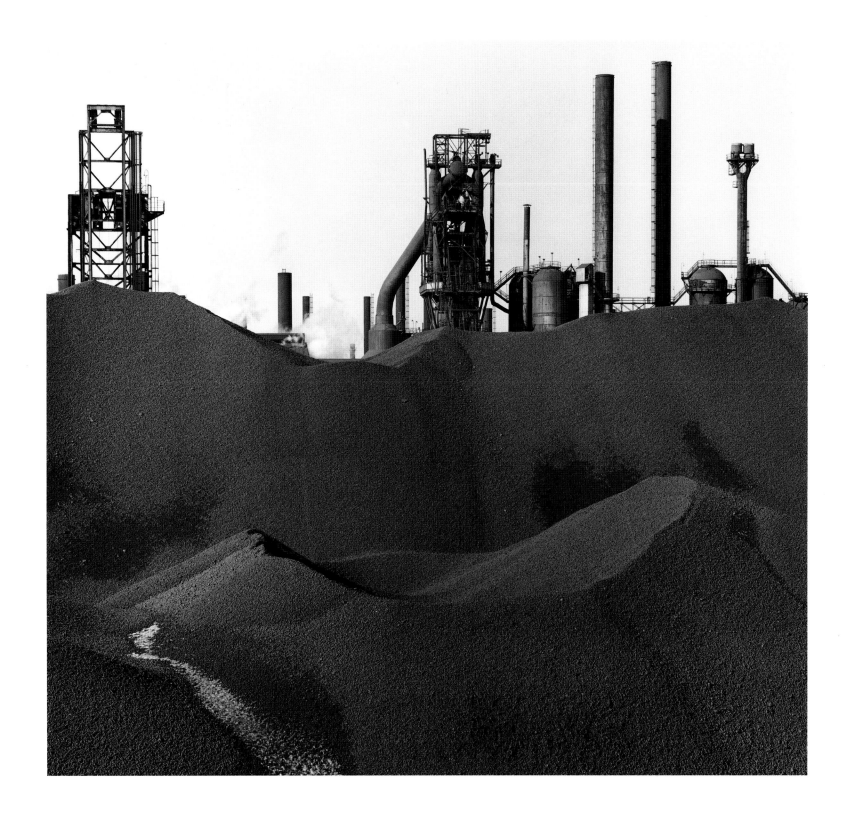

STEEL MILL, EAST CHICAGO, INDIANA, 1979

THE STEEL MILL

It wasn't until I spent years photographing steel mills that I came to understand why mankind always seems at odds with himself. However perceived, the mills are extraordinary places, where it seems that all the resources at our command have been gathered together and put to use. Here is a place where we melt rock and turn it into metal; man-made vulcanism harnessed, a miraculous accomplishment indeed. Despite their inestimable value, these great steelworks are filthy, dangerous, noisy, barbaric places, which can break body and spirit, fouling the air and water alike.

Steel may be the material from which our skyscrapers and great bridges take form, but steelmaking is hardly the gentlest or cleanest of occupations, a fact that even steelmakers themselves admit.

Despite OSHA, the EPA, and the industry's public relations departments, the working conditions are sometimes almost medieval. Ask those who have worked in the mills and you'll find there's hardly anyone that doesn't have a firsthand experience with maiming and death. Is it little wonder that the streets leading away from the mill gates are lined with barrooms?

In all the years I have spent photographing both the spectacular and the hideous, there is one particular incident I shall never forget. It was in a steel mill in the Ohio Valley. At the end of my day of photographing, the man who had been assigned to keep watch over me asked if I wanted to see what steelmaking was really like. I would have to leave my cameras behind, he said, and promise not to tell anyone that he had taken me there, for fear of losing his job. Then he took me to a building in a far distant corner of the mill that was "off-limits" to photographers.

Dante or Goya could not have conceived anything more grotesque. It was an apocalyptic scene that I could imagine only as a nightmare. I was led into an immense chamber that had the aspect of a bombed-out cathedral. It was filled with opaque, choking vapors. The ever present din of machinery, half seen, clanging and grinding, was almost deafening, despite my earplugs. In the center of the dirt floor was a pit of fumerous acid in which steel plates were being "pickled." From what I could see in the murky light, this was being accomplished by the crudest of apparatuses. The plates, weighing a ton or more, were attached to immense hooks and chains that hung from the ceiling. In a circle around the pit, shadowy figures of men trudged, slowly pushing the mechanisms that raised and lowered the steel plates into the pit. Their measured gait seemed timeless, as if like Sisyphus, they had been condemned to endless labor. They were wearing masks and protective silverlike "armor" as a defense against the poisonous atmosphere, which only made the scene more surreal — not unlike a medieval torture chamber.

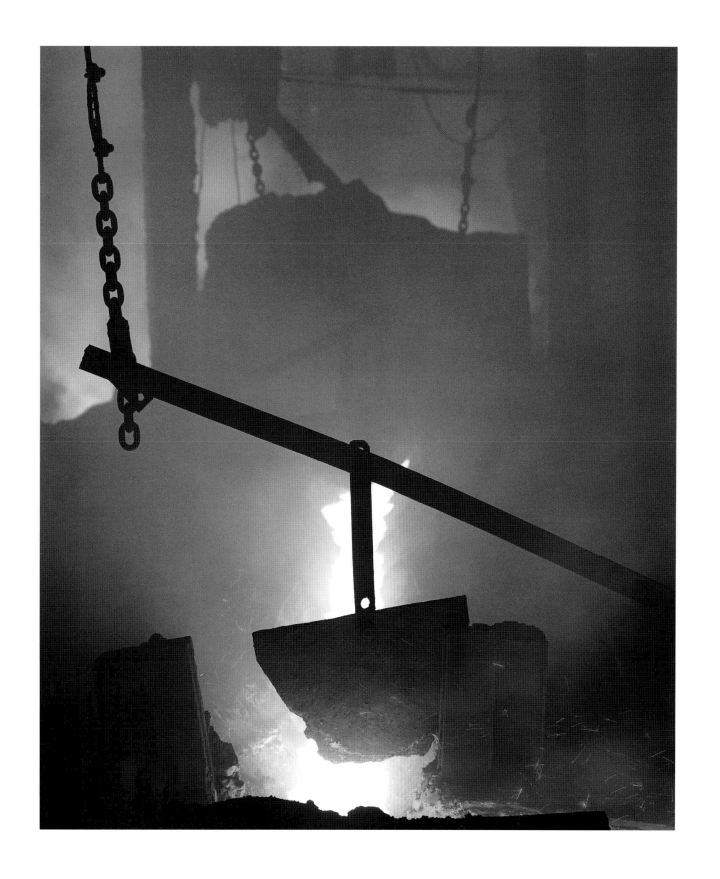

BLAST FURNACE CAST HOUSE DURING CASTING, STEEL MILL, EAST CHICAGO, INDIANA, 1982

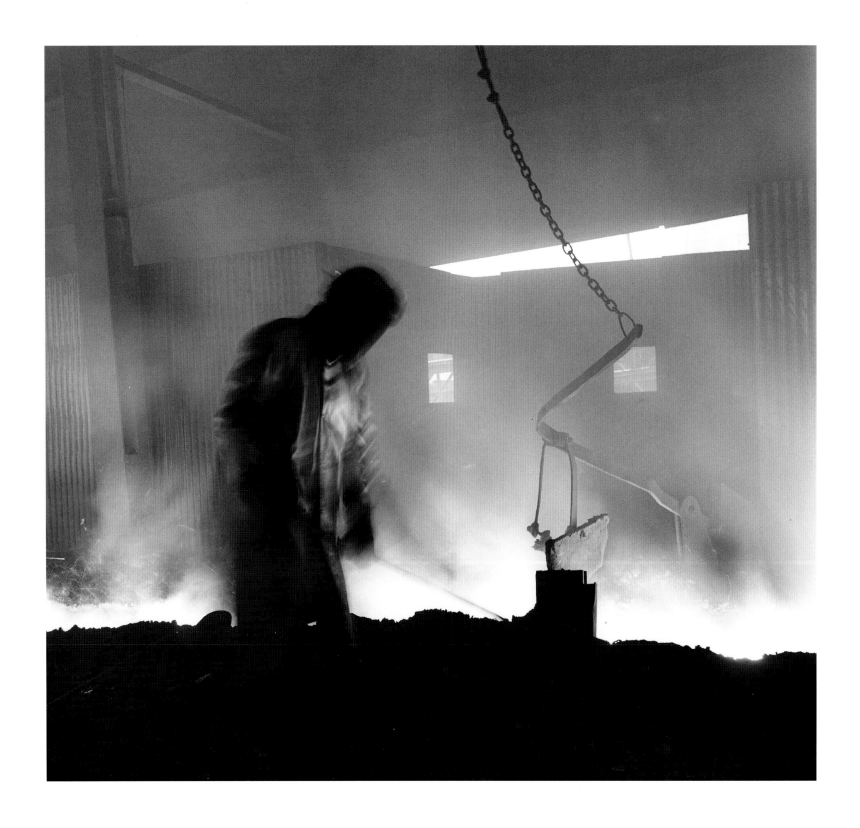

PUDDLER IN BLAST FURNACE CAST HOUSE, STEEL MILL, EAST CHICAGO, INDIANA, 1982

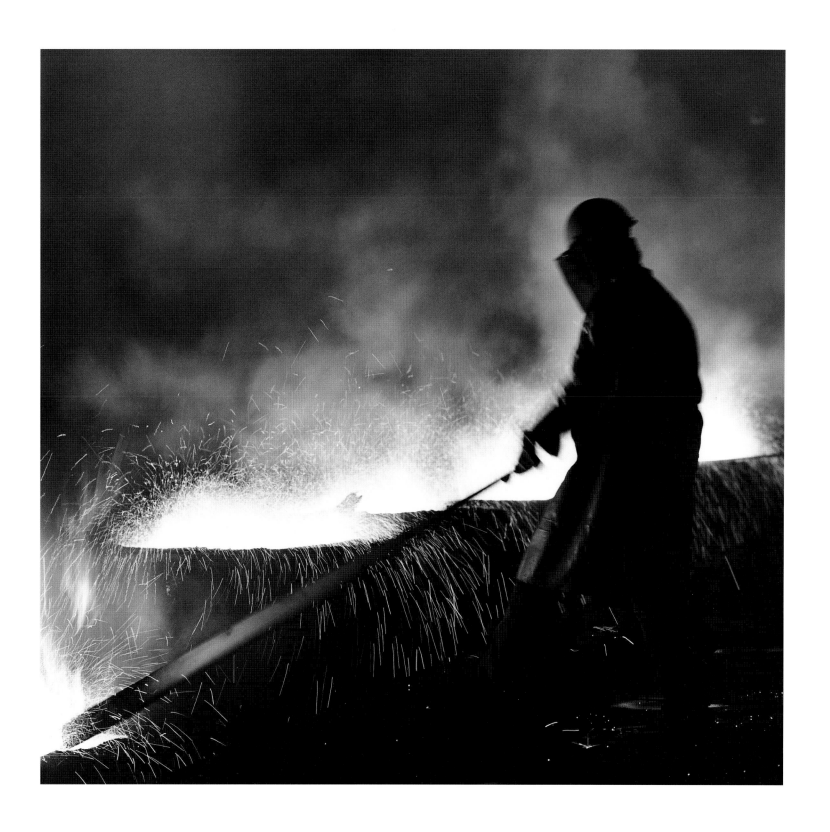

SLAGGING INGOTS, STEEL MILL, EAST CHICAGO, INDIANA, 1979

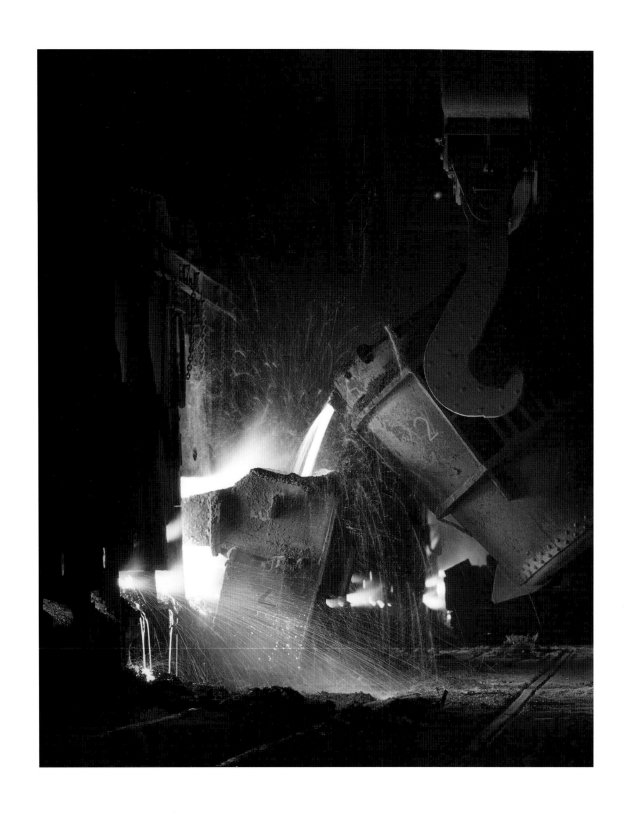

CHARGING OPEN HEARTH FURNACE, STEEL MILL, EAST CHICAGO, INDIANA, 1979

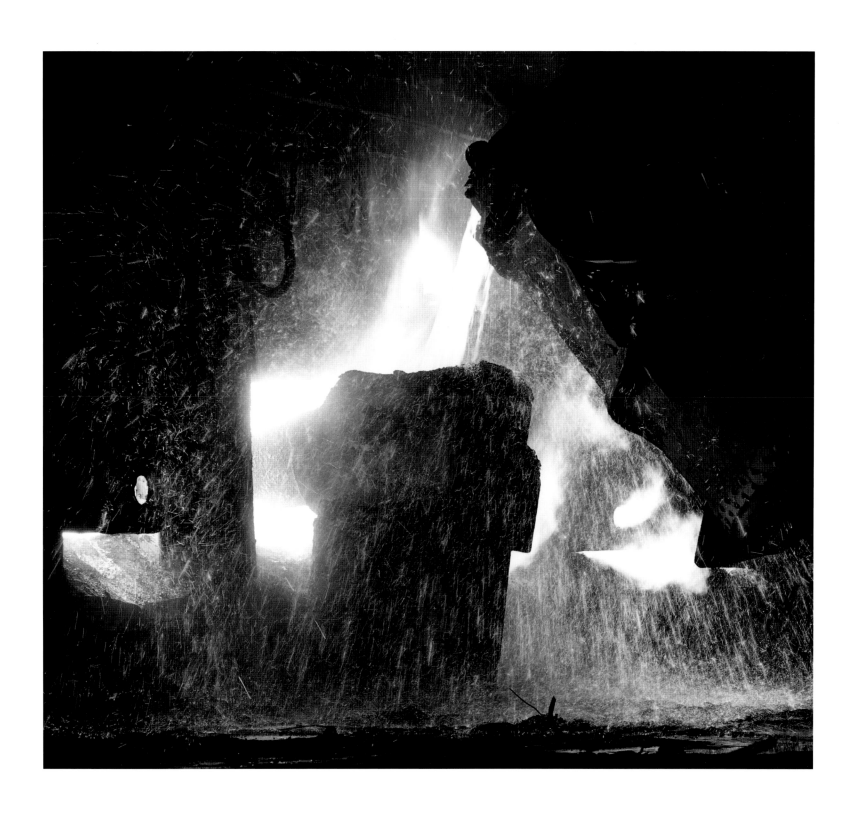

CHARGING OPEN HEARTH FURNACE, STEEL MILL, EAST CHICAGO, INDIANA, 1979

GRAIN ELEVATORS

Today, when the creations of our new technology are becoming more intangible and arcane, the need for self-evident masterpieces of human endeavor and genius becomes all the more important. For my part, I have always looked upon our grain elevators, our great bridges, and skyscrapers as being America's preeminent icons. They are our cathedrals.

Among the most powerful icons of what Henry Luce called the "American Century" are our gargantuan grain elevators, a fact not lost on the architectural community. The noted architect Walter Gropius said that grain elevators, among other examples of American industrial architecture, "present an architectural composition of such exactness that to the observer their meaning is forcefully and unequivocally clear. . . . They are not obscured by sentimental reverence for tradition nor by other intellectual scruples which prostrate our contemporary European design and bar true artistic originality."

Once considered the "magnificent FIRST FRUITS of the new age," they are among the most powerful symbols of a boisterous, productive young America. Today, they provide an iconography, which is a truer gauge of our nature than so much of what we build today — at least, I would like to believe so.

Nowhere is this more evident than along the banks of the Buffalo River, which are lined with massive concrete grain elevators, most of which have defied demolition. In scale they are like few other structures ever created — or likely to be again. When one stands by the river amid their desolate grandeur, it is impossible not to be overwhelmed by what seems an almost Egyptian monumentality. There, it is possible to feel as if one had been transported back in time to an ancient civilization.

Pyramids they are not. They are hard evidence of another time's achievements. Like the portraits of our ancestors, they, too, remind us why we are the way we are, that we have all walked in someone else's footsteps. It is well to remember that nothing was ever done in the past, only in someone else's present. True innovators, it has been said, do not destroy the past, they amplify it. In this age of remarkable scientific achievement, it is often hard not to indulge in the arrogance that we shall be the only ones to have made history.

"Indifference to history," David McCullough, the historian and writer, has said, "is a form of ingratitude. Ignorance of history is not only stupid, it is rude."

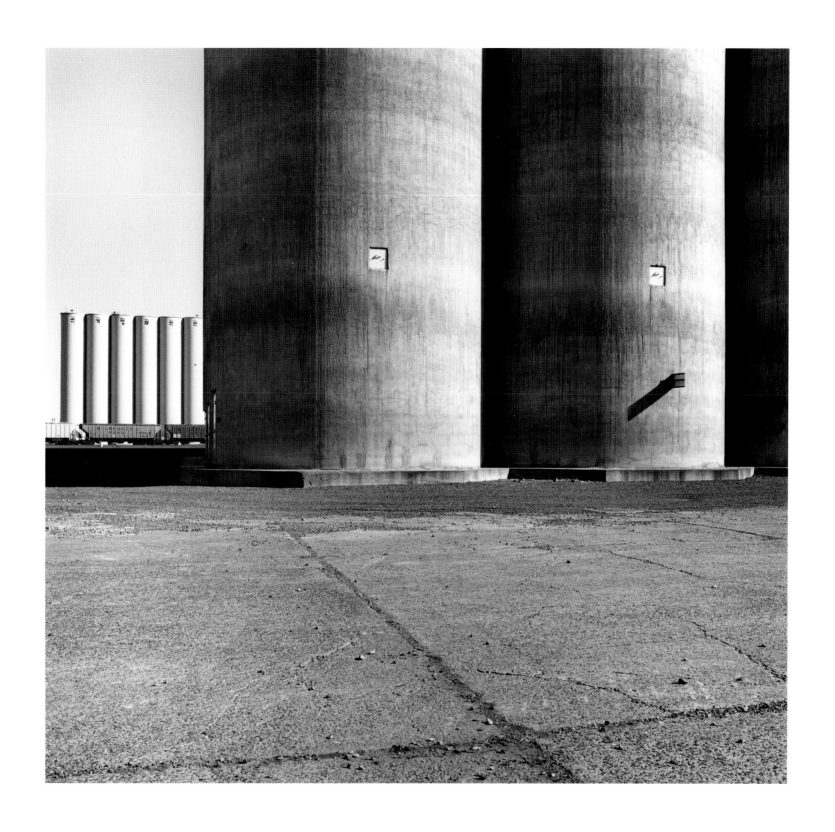

GRAIN ELEVATORS, DULUTH, MINNESOTA, 1985

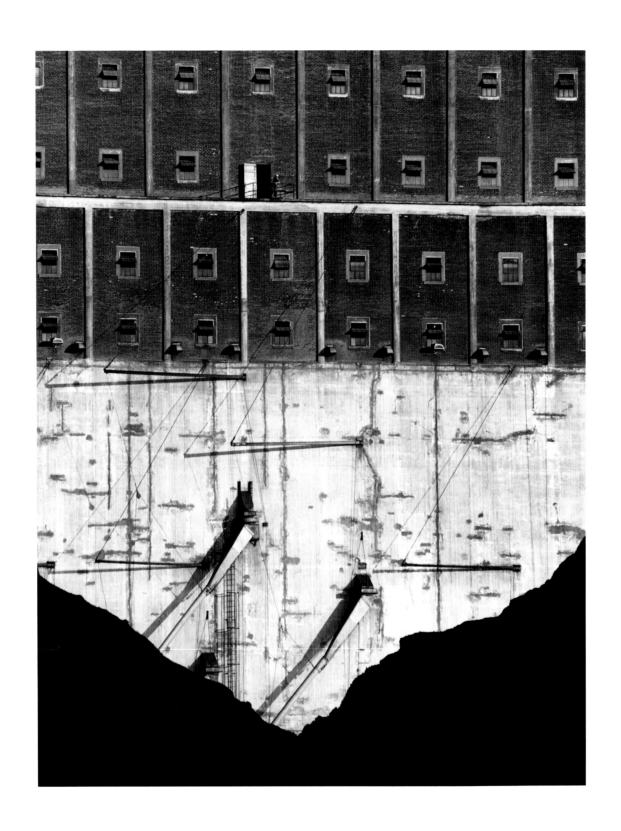

GRAIN ELEVATOR, DULUTH, MINNESOTA, 1968

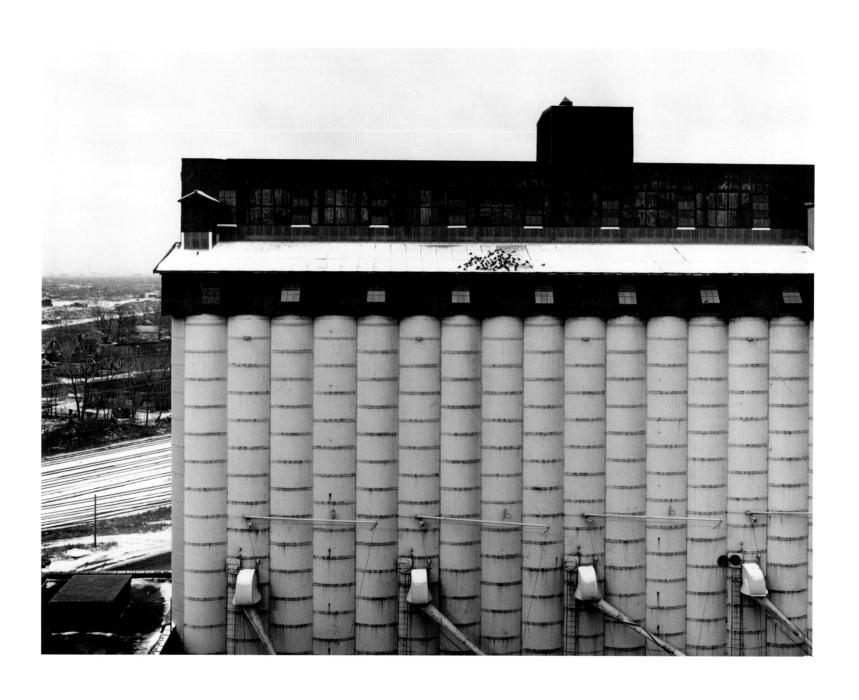

GENERAL MILLS ELEVATOR, CHICAGO, ILLINOIS, 1983

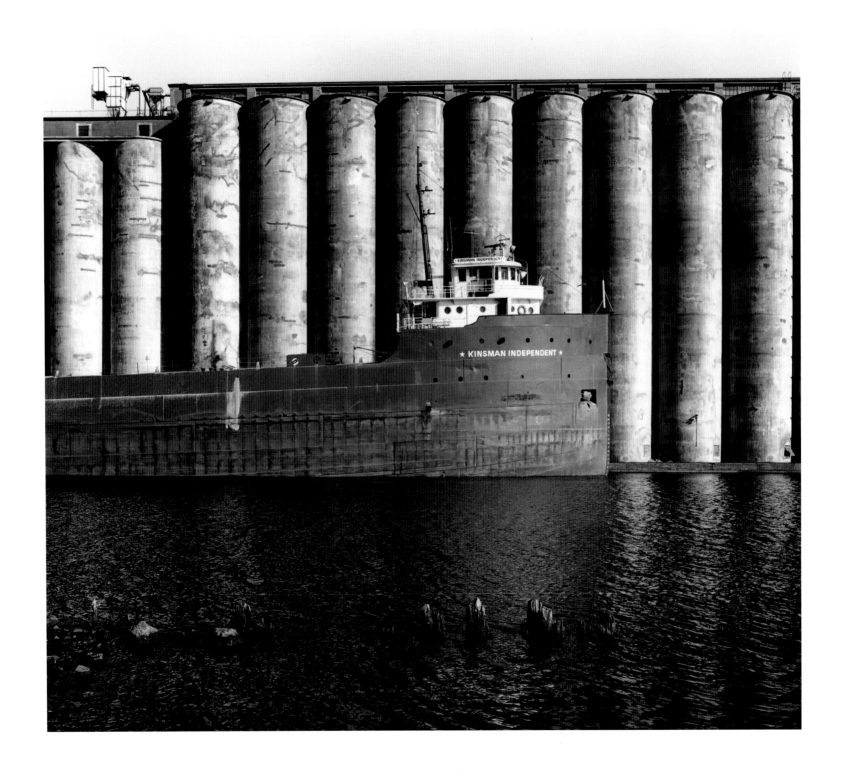

STEAMER *KINSMAN INDEPENDENT*, DULUTH, MINNESOTA, 1985

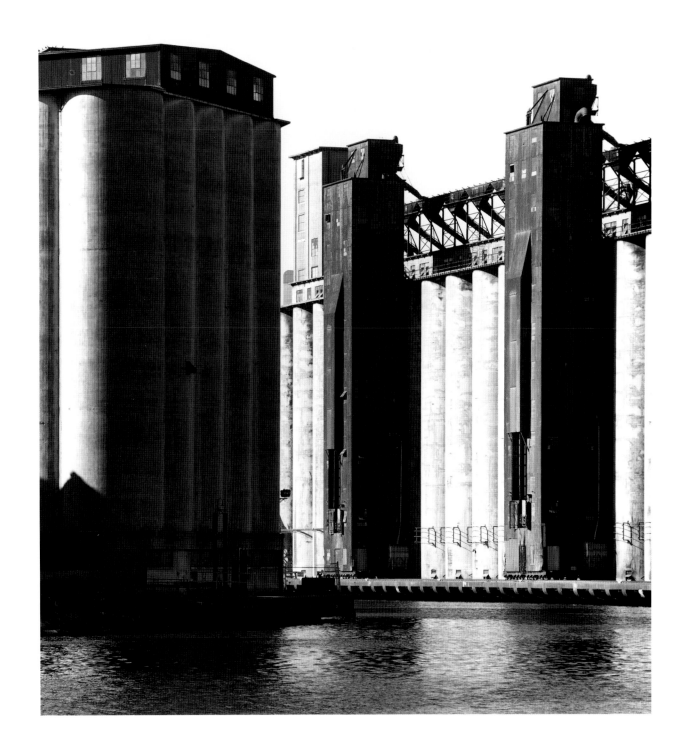

GRAIN ELEVATORS, BUFFALO, NEW YORK, 1990

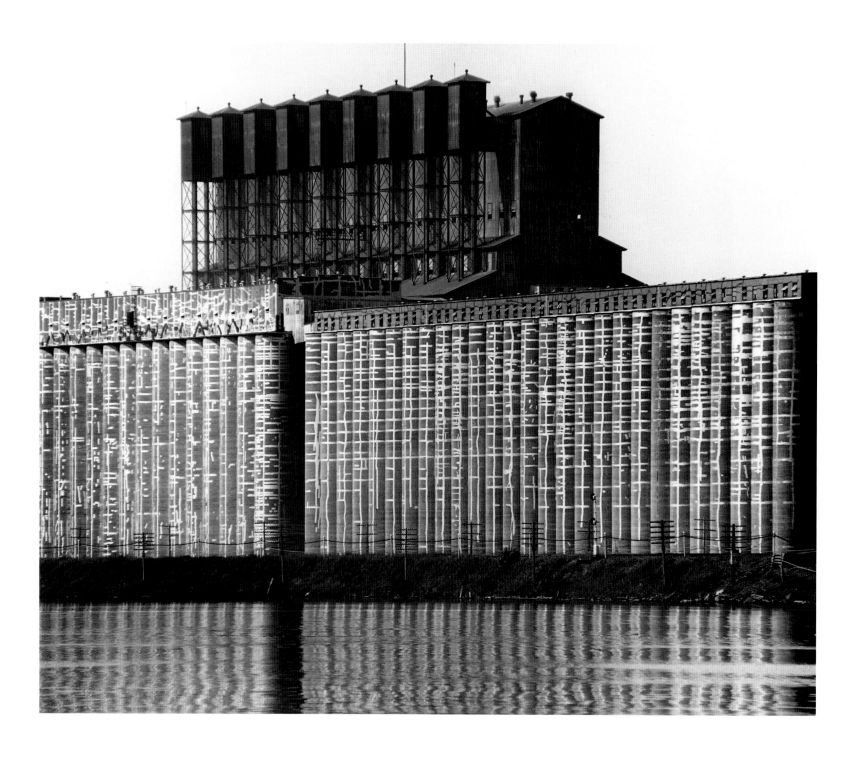

GRAIN ELEVATORS, SUPERIOR, WISCONSIN, 1968

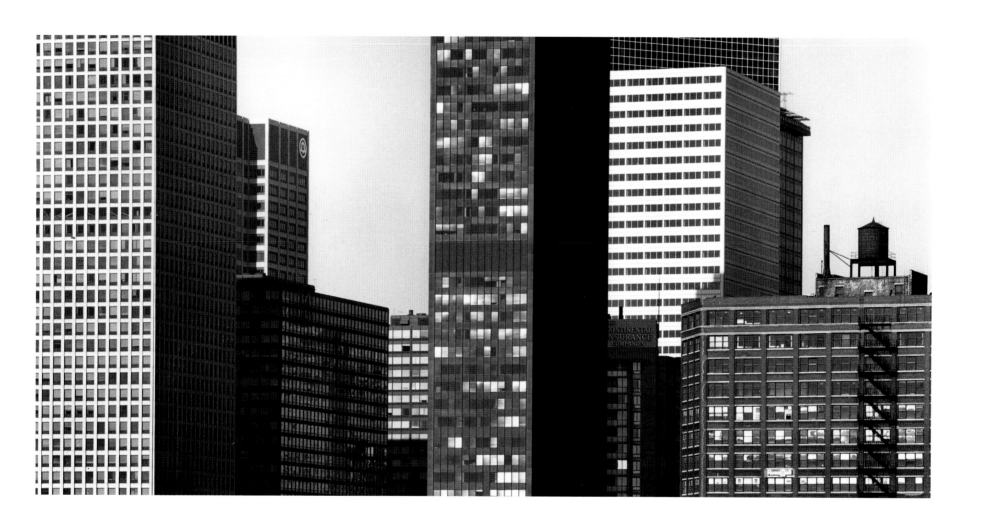

CHICAGO, ILLINOIS, 1981

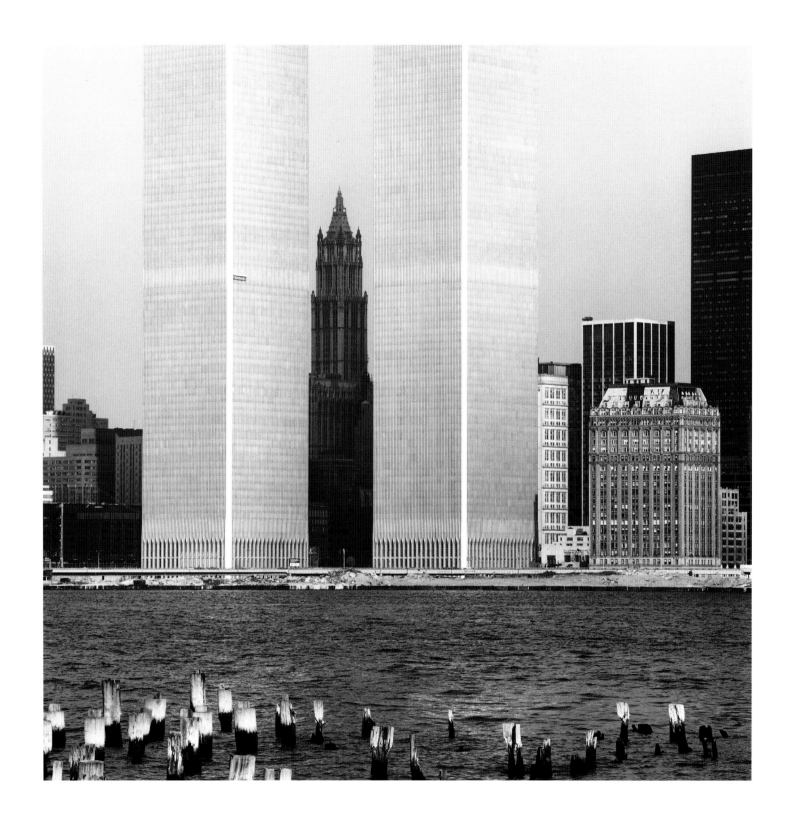

NEW YORK CITY FROM JERSEY CITY, NEW JERSEY, 1972

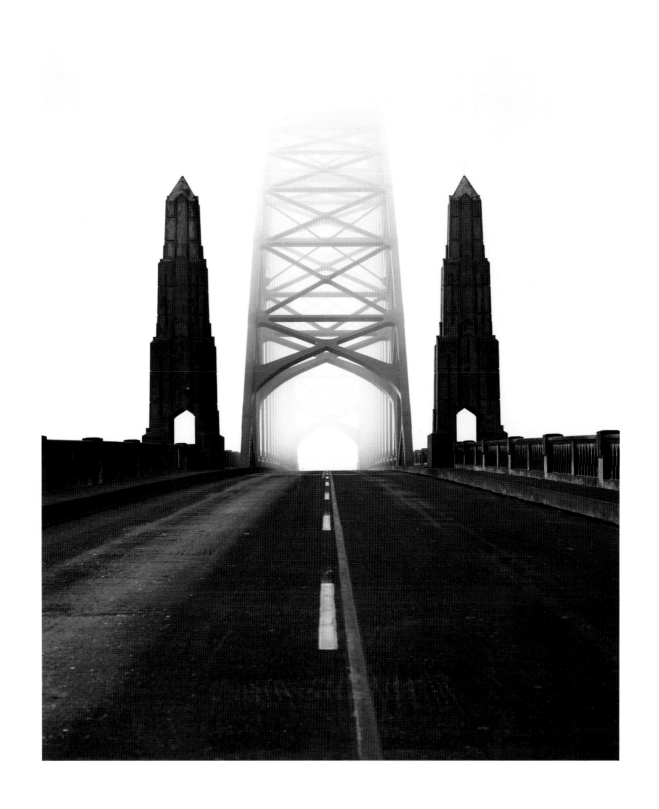

YAQUINA BAY BRIDGE, NEWPORT, OREGON, 1968

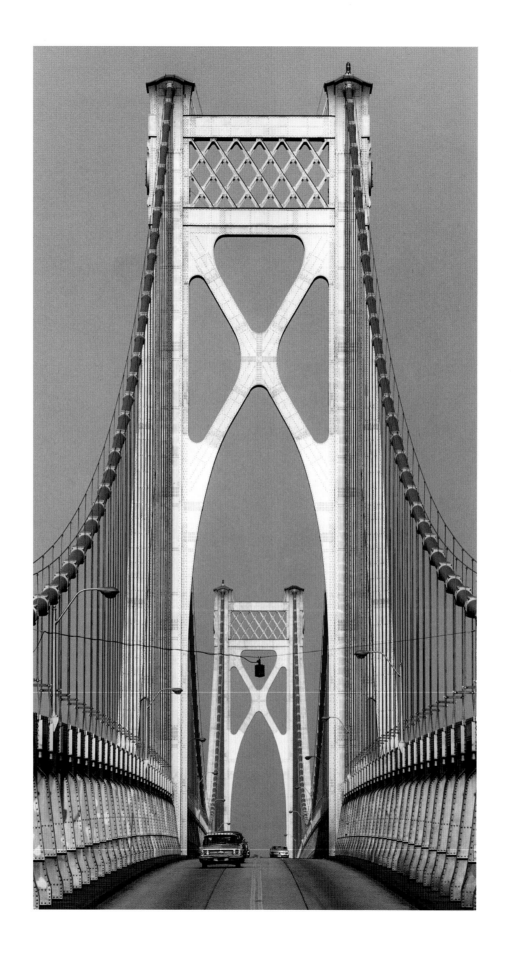

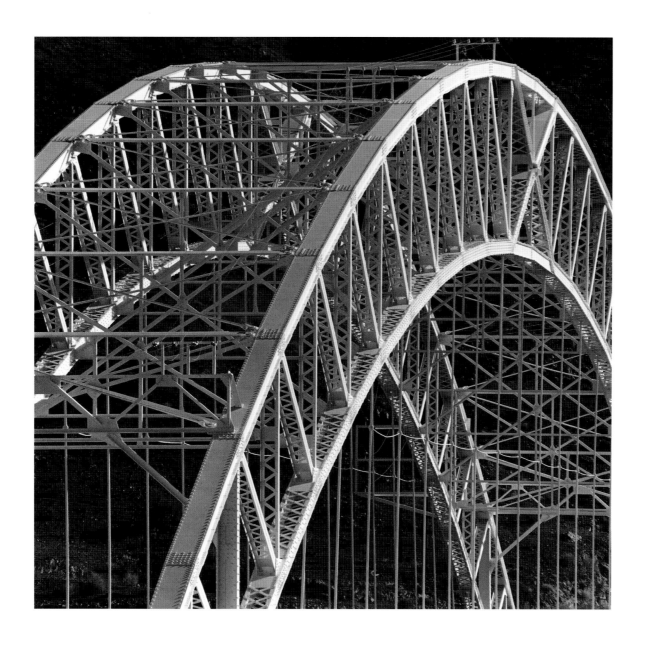

FORMER HIGHWAY BRIDGE, COLORADO RIVER, TOPOCK, ARIZONA/CALIFORNIA, 1968

MID-HUDSON BRIDGE, POUGHKEEPSIE, NEW YORK, 1969

THE BRIDGE

Here was Romance, here again was man, the great adventurer, daring to think, daring to have faith, daring to do. Here again was to be set forth to view man in his power to create beneficently. Here were two ideas widely differing in kind. Each was emerging from a brain, each was to find realization. One bridge was to cross a great river, to form the portal of a great city, to be sensational and architectonic. The other was to take form in the wilderness, and abide there; a work of science without concession.

These are the words of the architect Louis Sullivan, taken from that marvelous story of his life, *The Autobiography of an Idea*. He was writing about two bridges, the Eads Bridge over the Mississippi at Saint Louis, and the Kentucky River Bridge, designed by Charles Shaler Smith and Louis Frederic Gustav Bouscaren. The former, completed in 1874, was the first work of consequence in the world to use steel. The latter, completed in 1877, was the last great iron bridge and the first cantilever bridge to be built in America.

What better example of mankind's creative genius and ability to make beautiful and useful works is there than a great bridge? It may never have been the American nature to embellish, but for sheer monumentality, the stark utility of our bridges are without peer. There is nothing to distract the eye from the essentials. Unlike so much of what we build today, their importance is unequivocal.

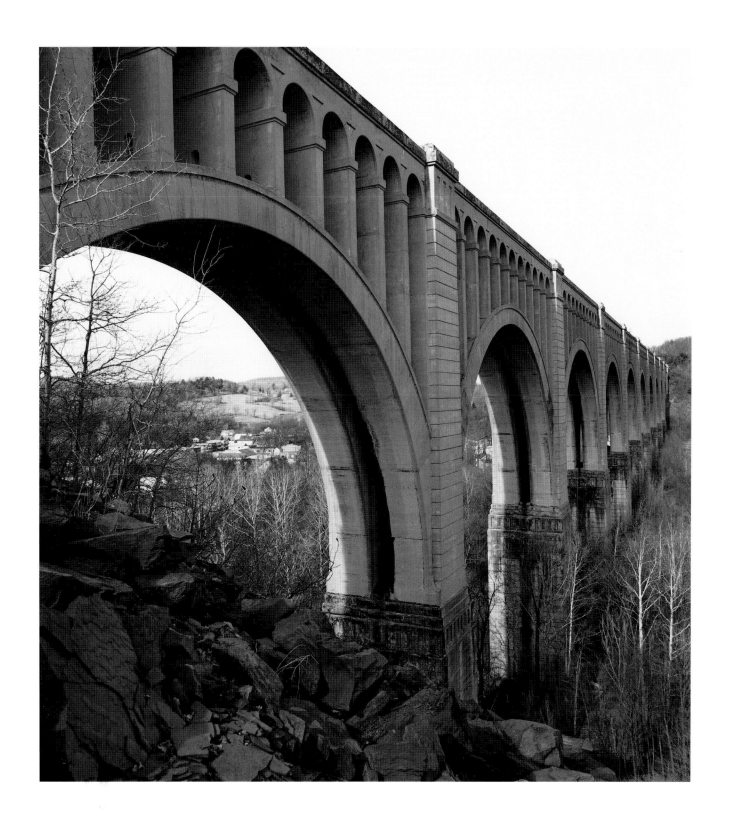

TUNKHANNOCK VIADUCT, NICHOLSON, PENNSYLVANIA, 1973

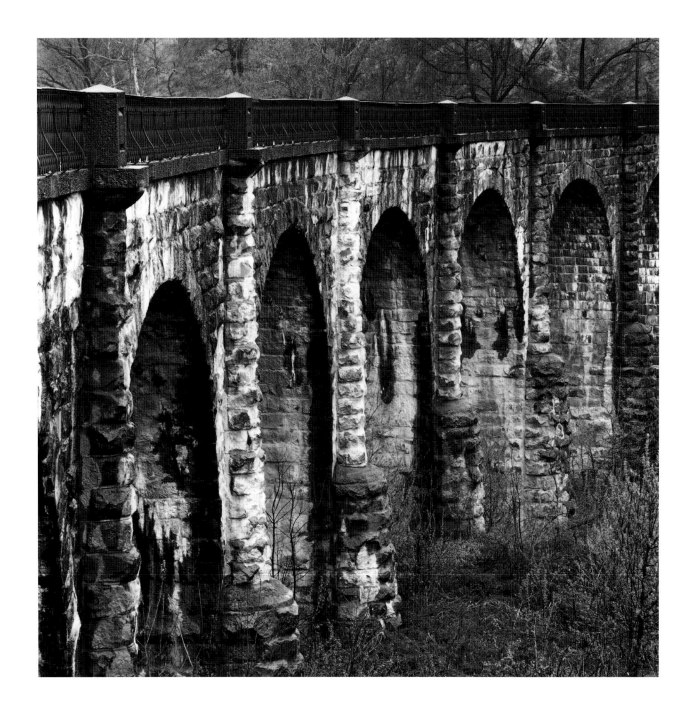

THOMAS VIADUCT, RELAY, MARYLAND, 1964

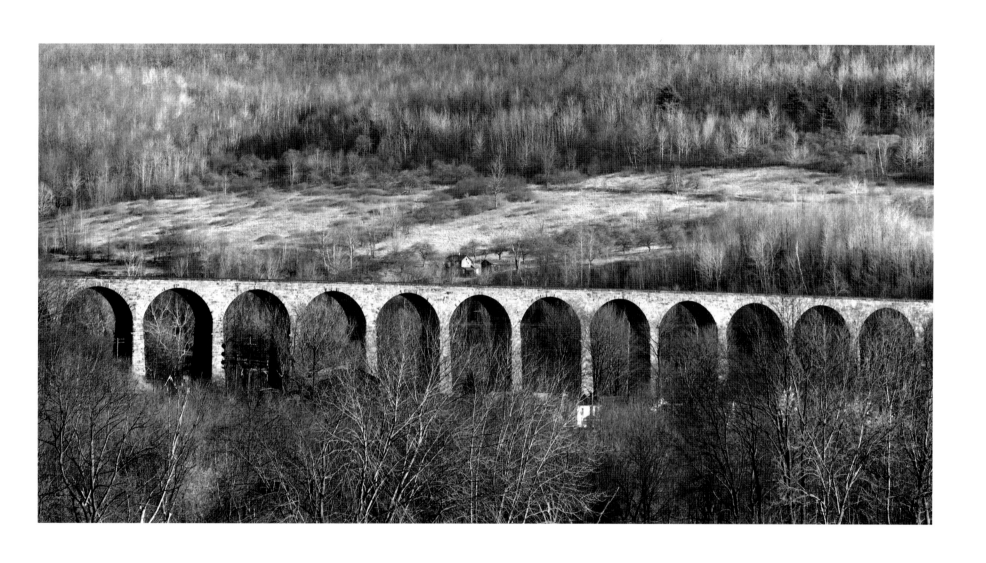

STARRUCCA VIADUCT, LANESBORO, PENNSYLVANIA, 1973

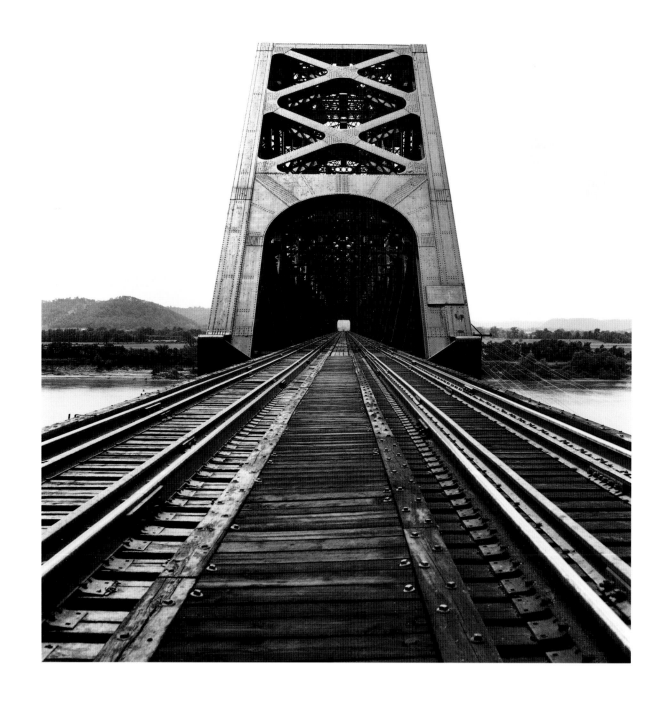

SCIOTOVILLE BRIDGE, OHIO RIVER, SCIOTOVILLE, OHIO, 1968

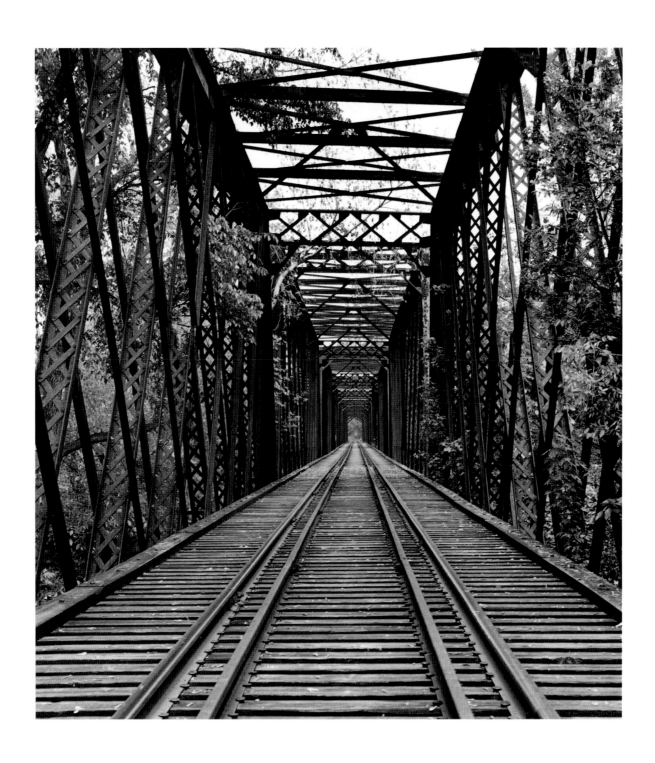

FORMER BOSTON AND MAINE RAILROAD BRIDGE, CONNECTICUT RIVER, NORTHAMPTON, MASSACHUSETTS, 1968

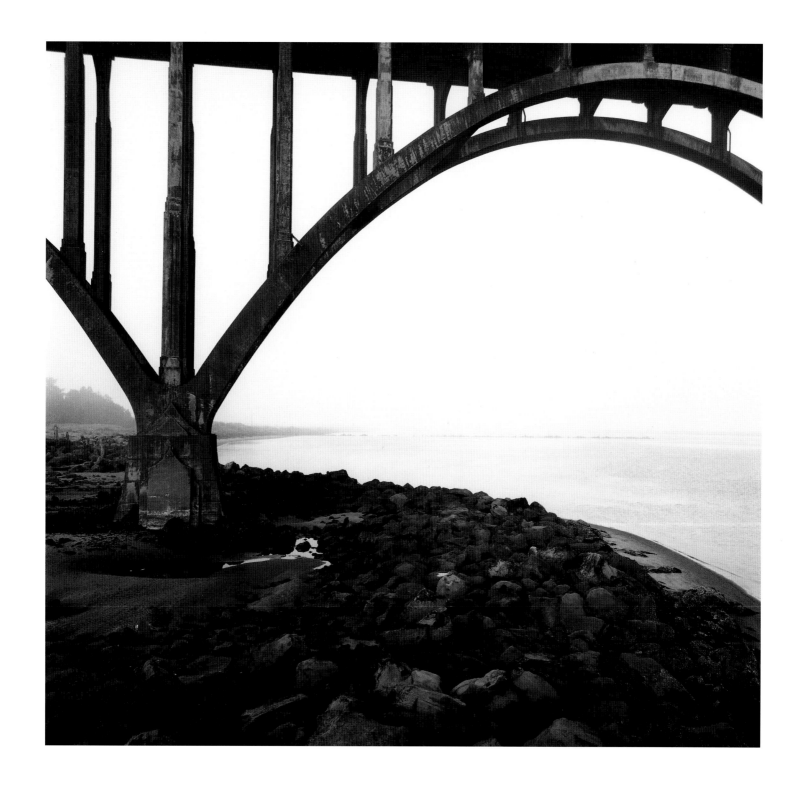

APPROACH SPAN, YAQUINA BAY BRIDGE, NEWPORT, OREGON, 1968

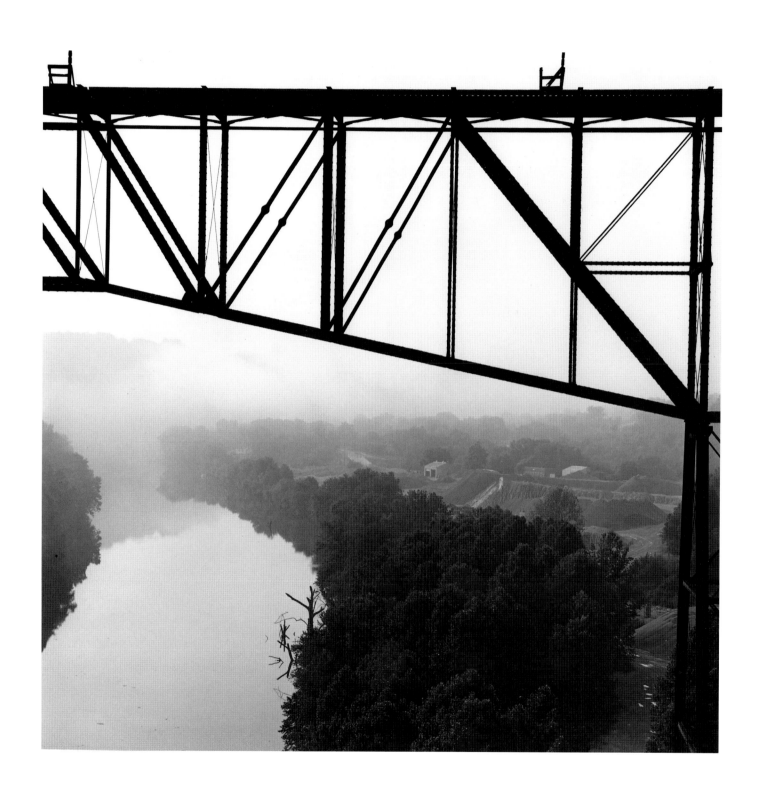

TYRONE BRIDGE, KENTUCKY RIVER, TYRONE, KENTUCKY, 1968

141

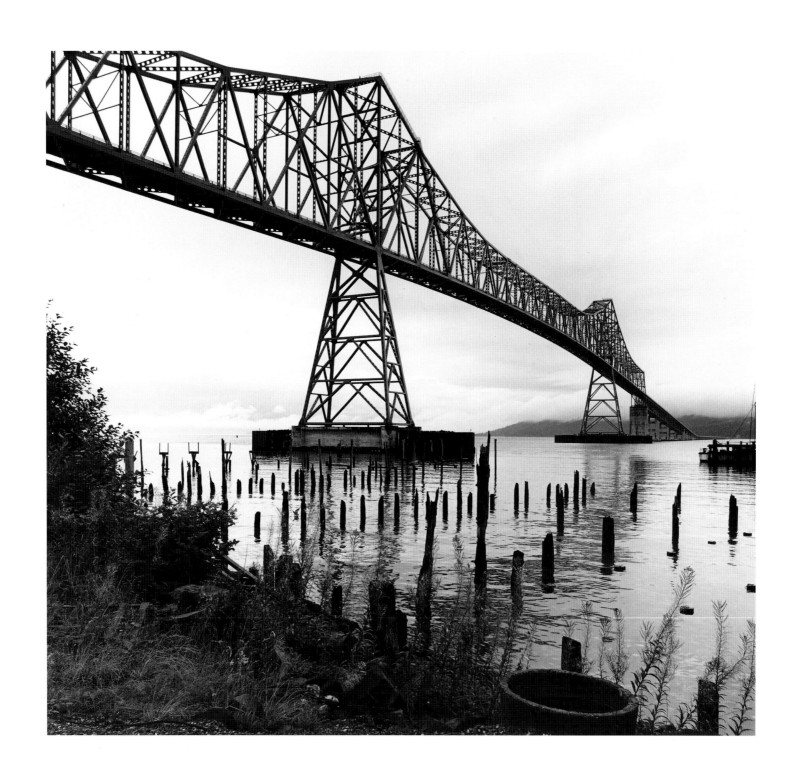

ASTORIA BRIDGE, COLUMBIA RIVER, ASTORIA, OREGON, 1968

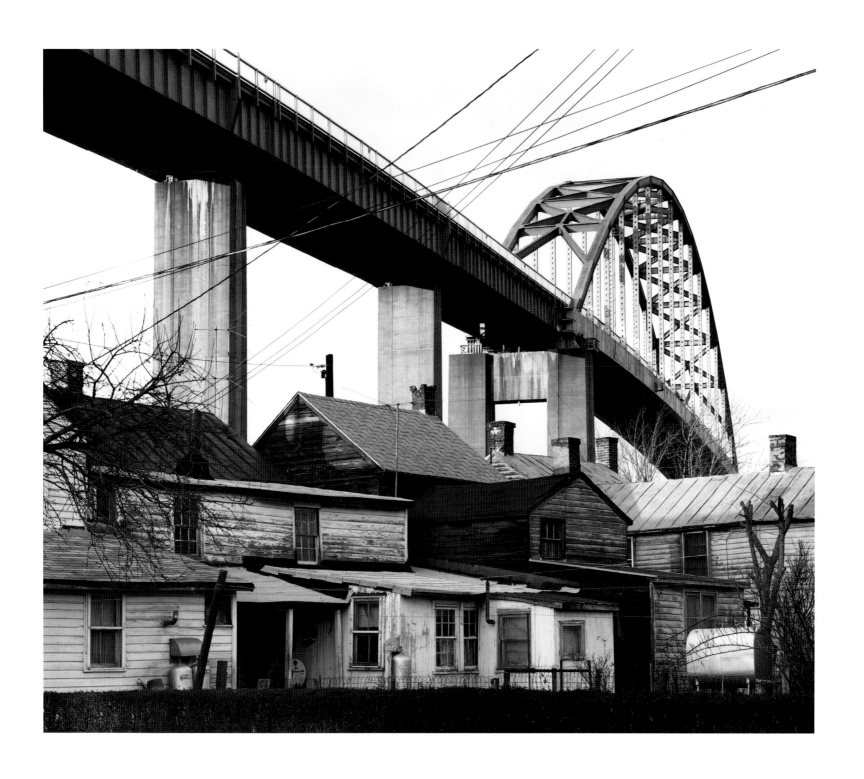

CHESAPEAKE CITY, MARYLAND, 1971

DONORA

"What the hell you think you're doin' taking pictures in front of my house?" an unfriendly voice interrupted my thoughts.

I wasn't photographing his house — that is something I learned years ago never to do without asking first. My camera was pointed down the street toward the Monongahela, at the site of an abandoned mill.

I explained that I was taking pictures for a book about America, but I made the mistake of saying I was in Donora because of the smog.

He strode out into the middle of the street where I was standing. "The smog," he shouted. "The smog! That's all anyone remembers about Donora."

Somewhat shaken by his fury, I asked if he remembered it himself.

"Remember? See that down there," he said shaking his finger at me and then in the direction of the river. "That's where the smog came from. That's where I used to work. That's where we all worked before they closed it down. Closed the mill. Damn them! Damn the bastards who closed us down. Damn the smog!

"You, why weren't you here with your cameras when the mills were running, eh? You shoulda been here then; Donora was something to take pictures of then. What do you see now? Nothing!"

Donora, Pennsylvania, is about as depressing as any place I have ever been, all the more so because it is indistinguishable from almost every other forgotten town on the backside of industry. I had come to Donora to photograph the place where many had choked and died in 1948 when that lung-searing smog hung over the city. But the smog had dissipated some thirty years before, leaving no visible trace. Donora was no more than a clone of every other cheerless mill town that had fallen on hard times. I had half expected it would still be reeking with acrid smoke and reverberating with clanging mills. But as far as I could tell, nothing was being made in Donora anymore — not even smog.

As I drove away, I asked myself, Which was worse — the smog or the sense of hopelessness that was so apparent in Donora now that the stacks weren't smoking anymore?

Donora is not the only drab, gray town I have seen. For fifty years from the windows of countless trains I have looked out on the same sad neighborhoods that reside in the shadows of industry. It did not matter whether it was Buffalo, Braddock, or Johnstown, the view would still be the same in any old northern industrial city: "ethnic" neighborhoods,

generic and interchangeable: rows of time-worn frame houses lining forlorn streets. From the train I always remember them as being in the predawn, when the reflection of naked streetlamps on damp pavement and an occasional light in a back hall window spoke eloquently of despair. This was home to generations who kept the fires of industry alive and who came home from the mills' gates and the factories to bathe, to eat, to go to bed, to make love, to raise a family, to argue, to complain and worship, and to get up in the light of dawn to face the day once again. Whether Pole or Czech, whether Smith or O'Leary, it was the same, one generation followed by the next, with little change in the basic pattern of existence: routine, predictable, and secure — until now. Today, it would appear that the cachet "Made in America" is an anomaly, that the industrial bulwark upon which so many relied has disintegrated, and that the patterns of life have become unraveled in America's Donoras.

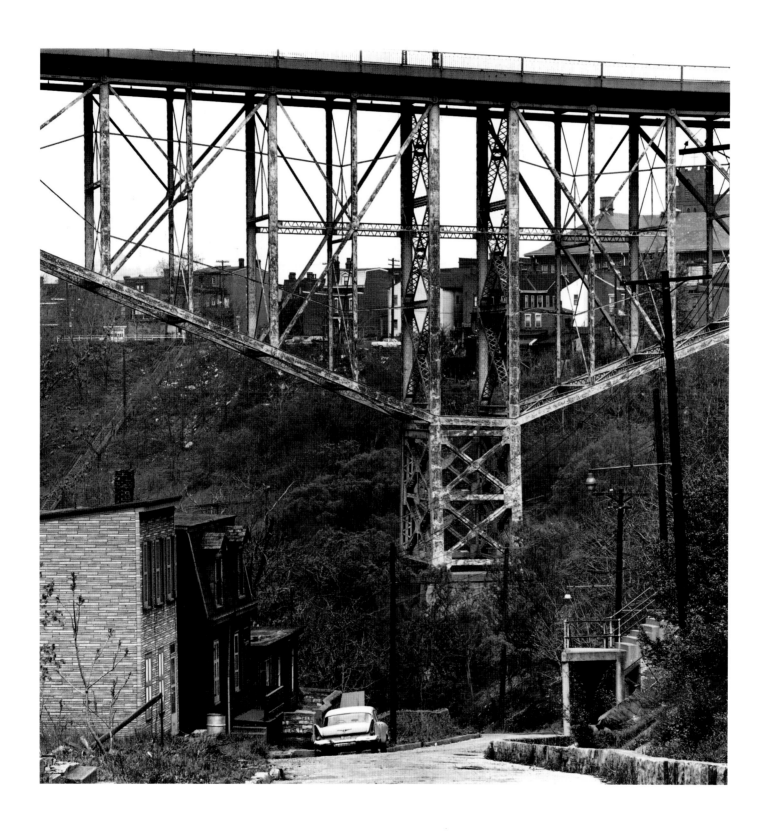

BLOOMFIELD BRIDGE, PITTSBURGH, PENNSYLVANIA, 1967

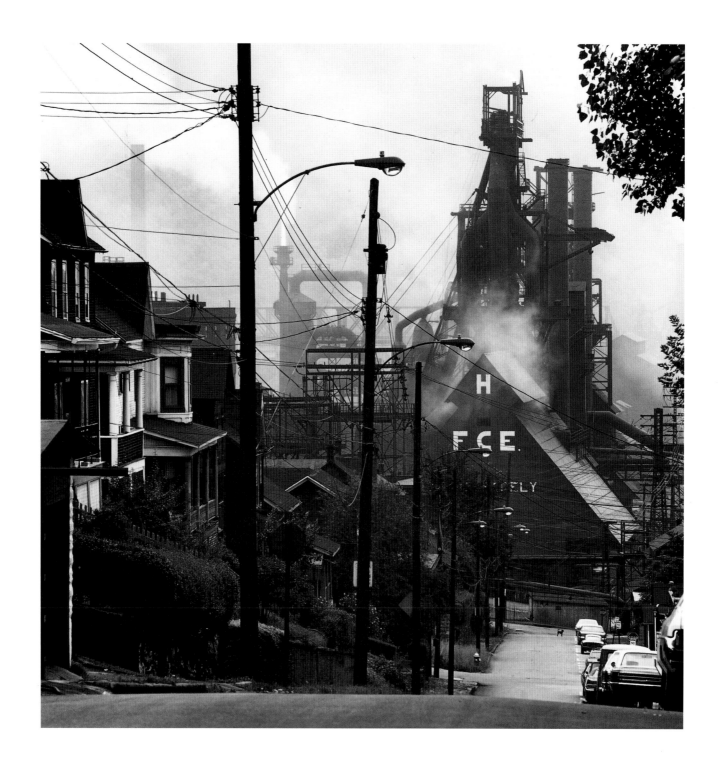

HOUSES NEAR STEEL WORKS, JOHNSTOWN, PENNSYLVANIA, 1975

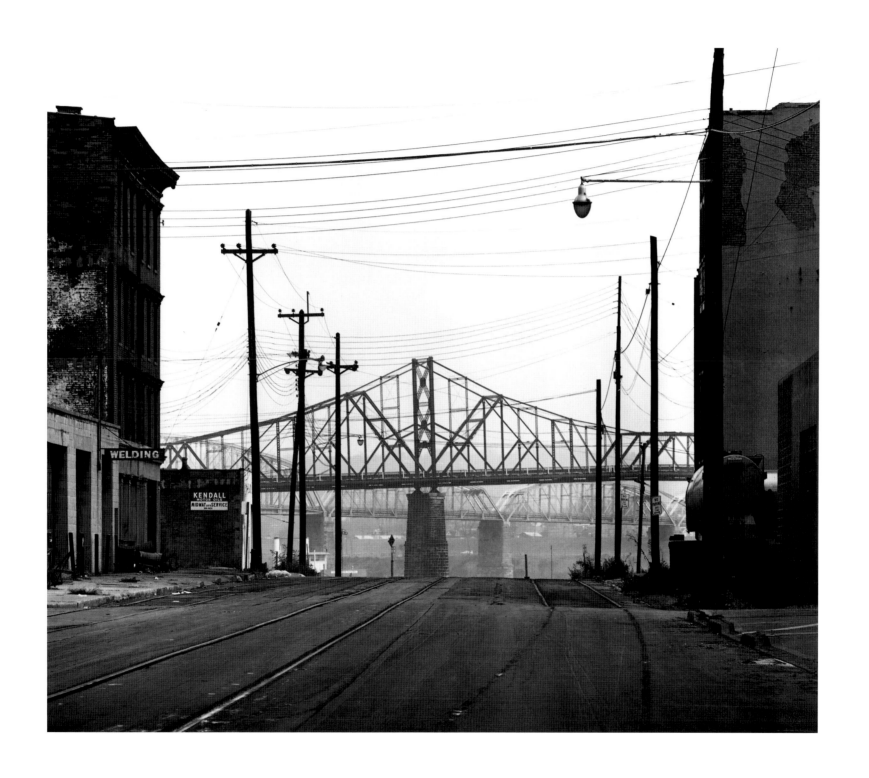

CINCINNATI, OHIO, 1966

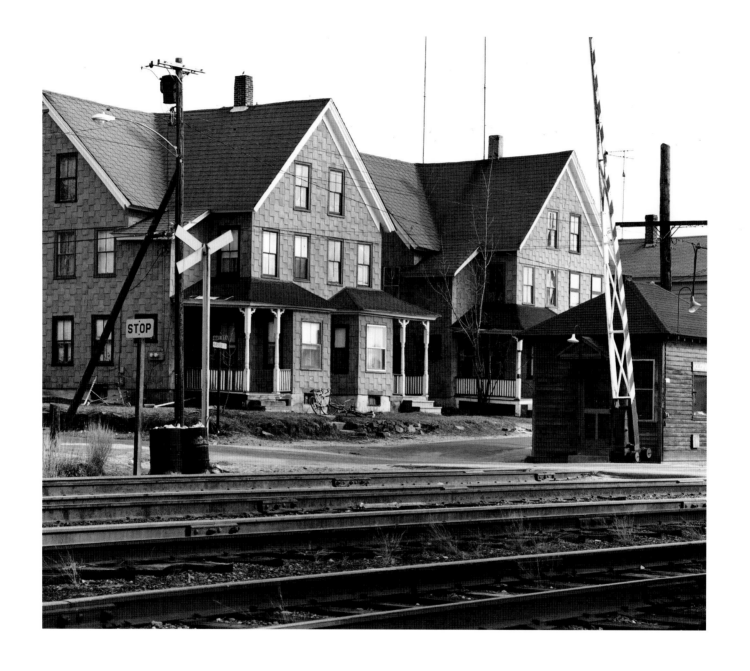

PUTNAM, CONNECTICUT, 1975

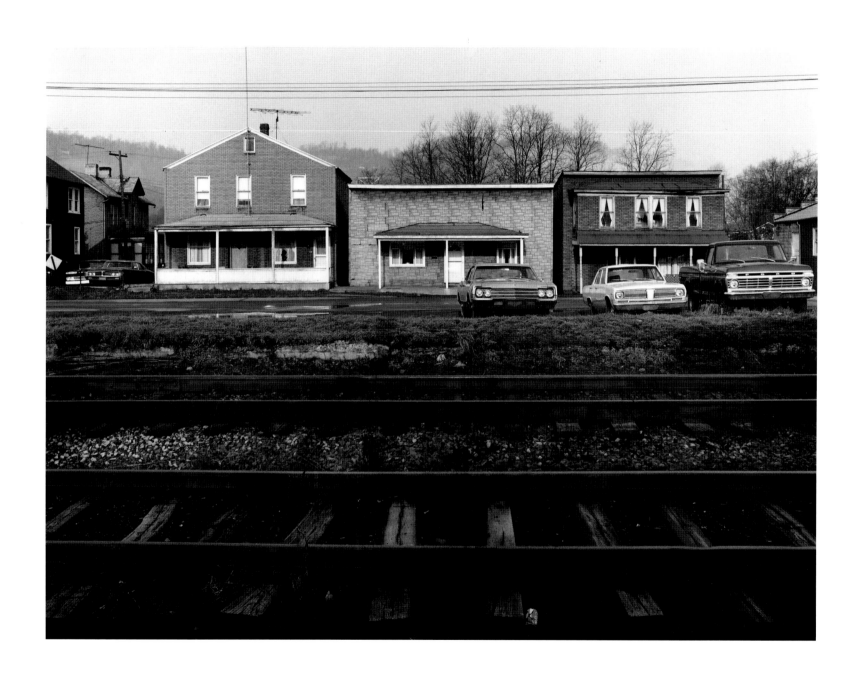

POINT MARION, PENNSYLVANIA, 1974

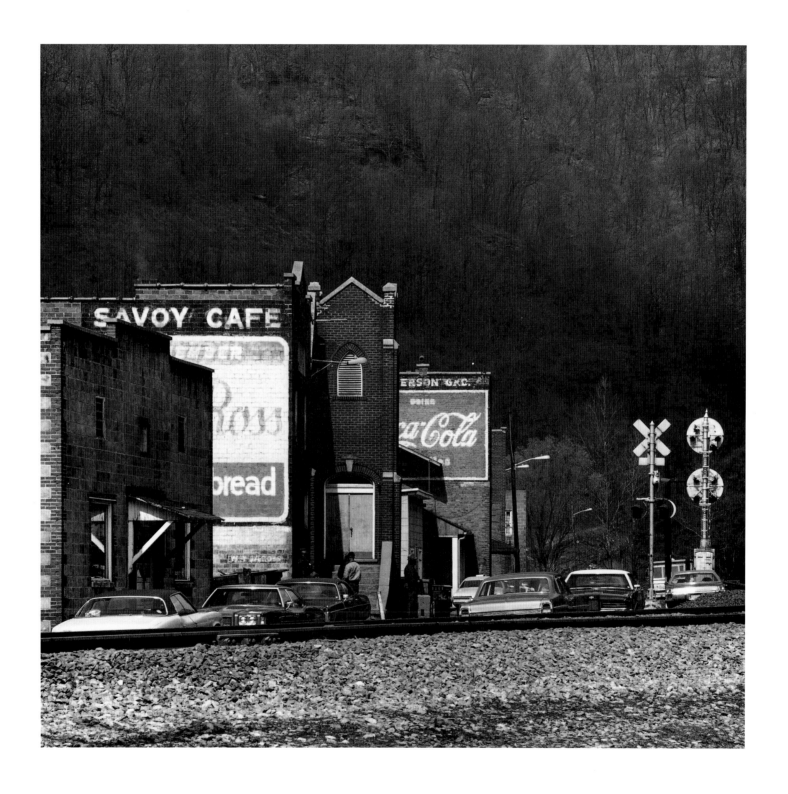

KEYSTONE, WEST VIRGINIA, 1974

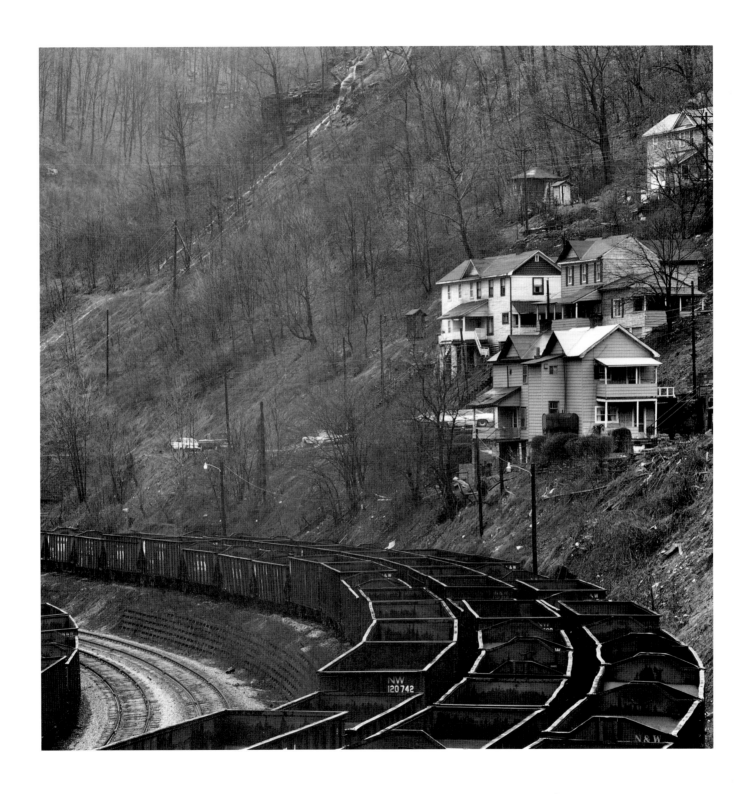

WELCH, WEST VIRGINIA, 1974

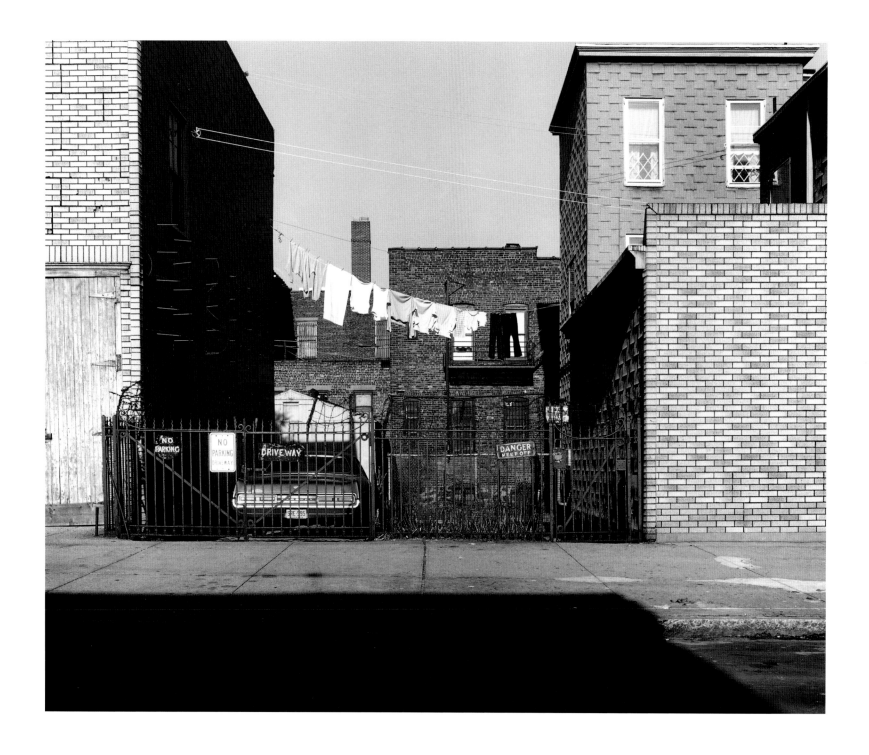

SECAUCUS, NEW JERSEY, 1974

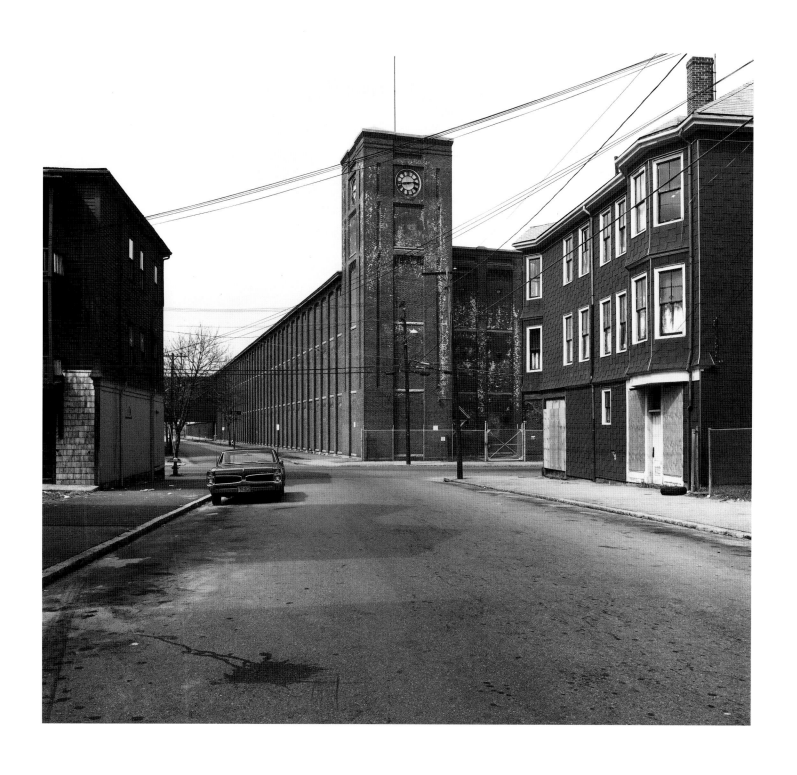

NEW BEDFORD, MASSACHUSETTS, 1975

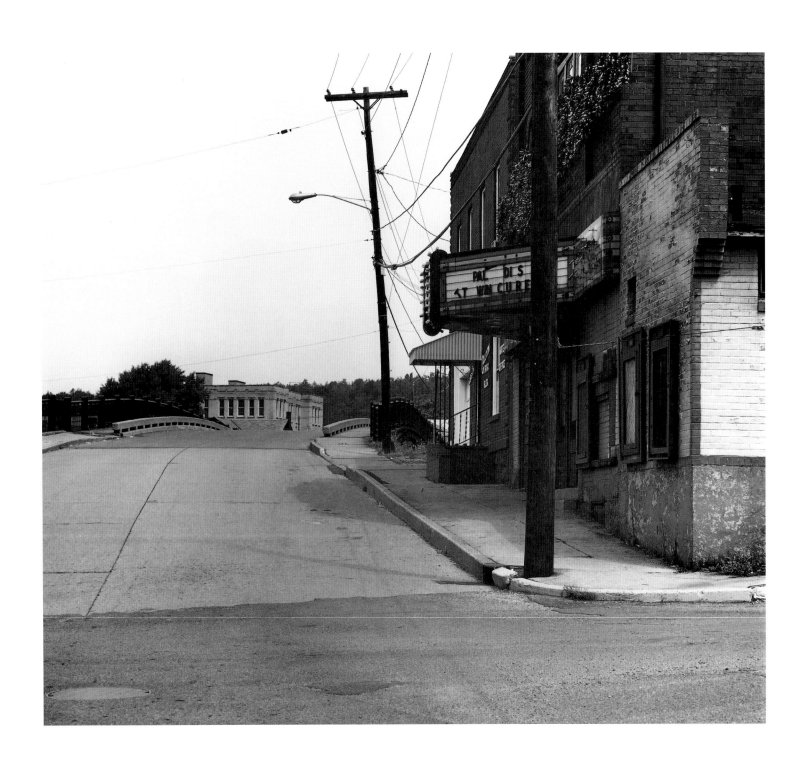

GALLITZIN, PENNSYLVANIA, 1975

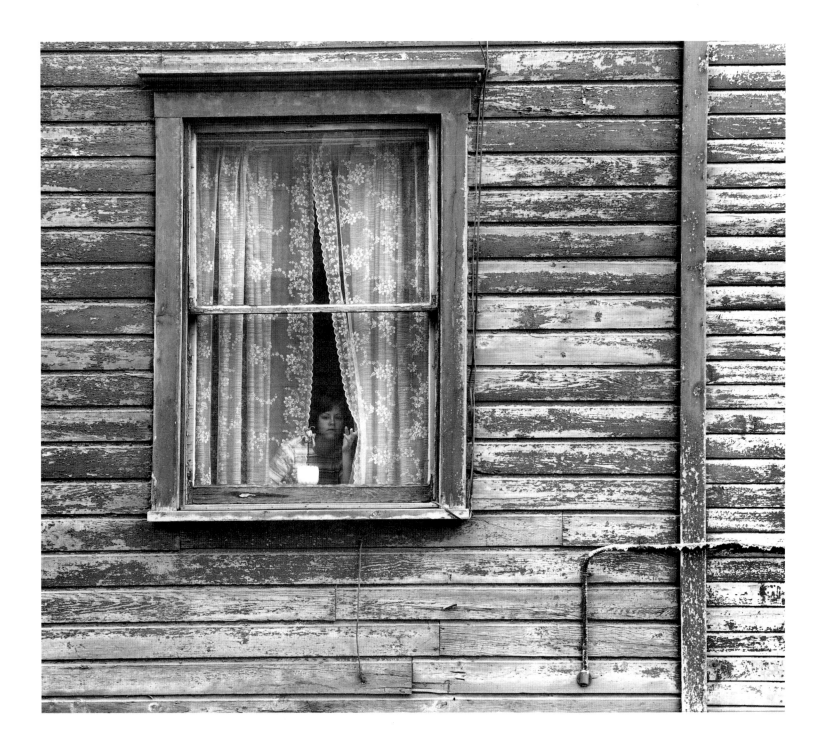

GIRL IN WINDOW, CRESSON, PENNSYLVANIA, 1975

WASTELAND

Everything changes west of La Porte, as the environs of Chicago begin to spread over the land like a lava flow. In what is left of the fields, legions of nondescript buildings are bivouacked like an army about to make its final assault. Highways, country roads, streets of split-level houses, abandoned factories, falling-down barns, gas stations and shopping centers, half-finished buildings, interchanges, and overpasses are almost everywhere: the disparate accumulation of a century and a half of endeavor sprawled across what was once prairie. Everywhere power lines are spun across the sky, seemingly without design or regard for anything beneath them. The discarded litter of an affluent, profligate society is scattered where spring flowers once bloomed: wind-blown detritus; yellow, blue, and white plastic caught in chain-link fences; shards of broken glass glistening by the roadside; tires; an abandoned panel truck left to rust in a grove of saplings; a disembow-eled sofa by the edge of a half-acre lot; defunct cars; discarded iceboxes; even an old toilet sitting defiantly all by itself upright in a field. Highways and wires; more cars, more trucks; more tract houses; more, ever more monotonous, windowless buildings; corrugated metal and concrete slab architecture; Ziebart, Shell, Kmart, Arbys, embodied in garish, molded plastic by the roadside, all vying for space — more of everything, except land. What there is, is scrub; gone-to-seed farms begging to be tended, soon to be developed, or degraded wetlands choked with bulrushes and phragmites, a sure sign that little else can survive.

In the distance, smoke from Gary's steel mills drifts across the horizon. Closer by, a huge cloud of white steam boils up from the coke plant at Bethlehem's Burns Harbor works. Enormous triangular shapes, cranes and unloading equipment by the lakefront, appear over the trees like distant, browsing dinosaurs.

Yet, there was a glimmer of hope — as there always seems to be — like the sprig of grass that fights its way through the crack in the concrete. Amid all this squalor somebody had scribbled the word "Love." Another had inscribed "Jesus" on a bridge abutment. JESUS! Yes, and "God Lives!" God lives? Here on the underside of an overpass?

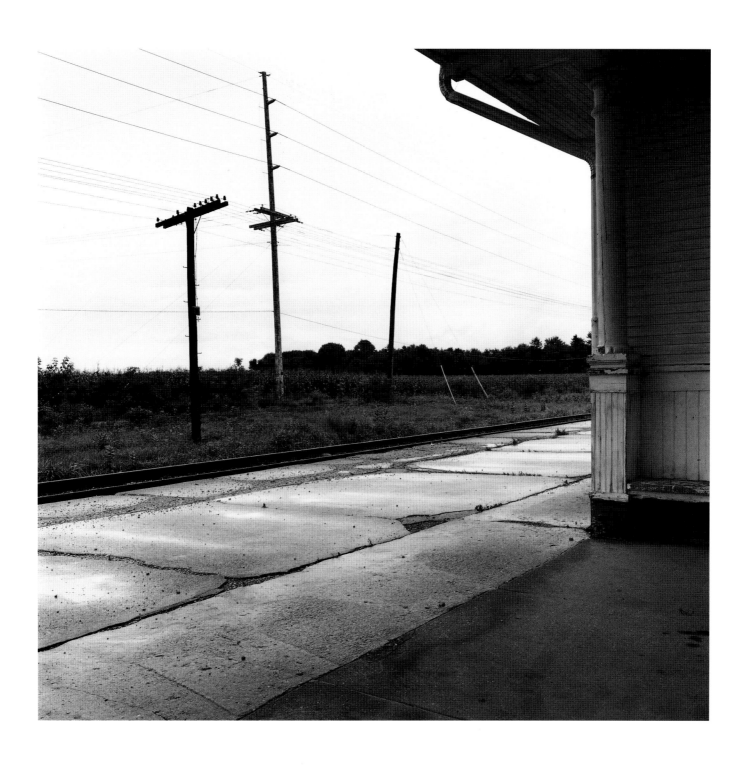

FORMER MILWAUKEE ROAD DEPOT, WALWORTH, WISCONSIN, 1980

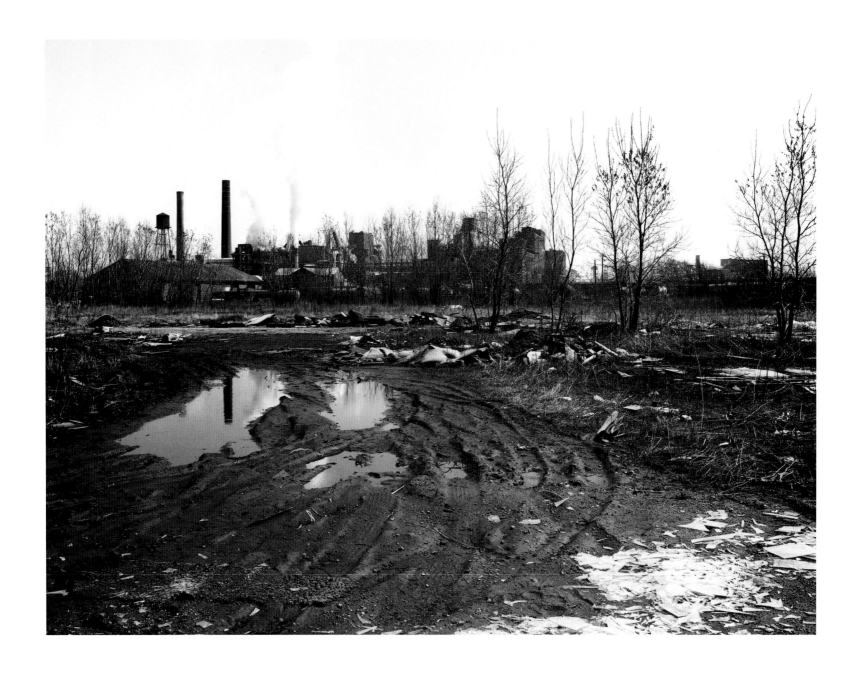

HAMMOND, INDIANA, 1982

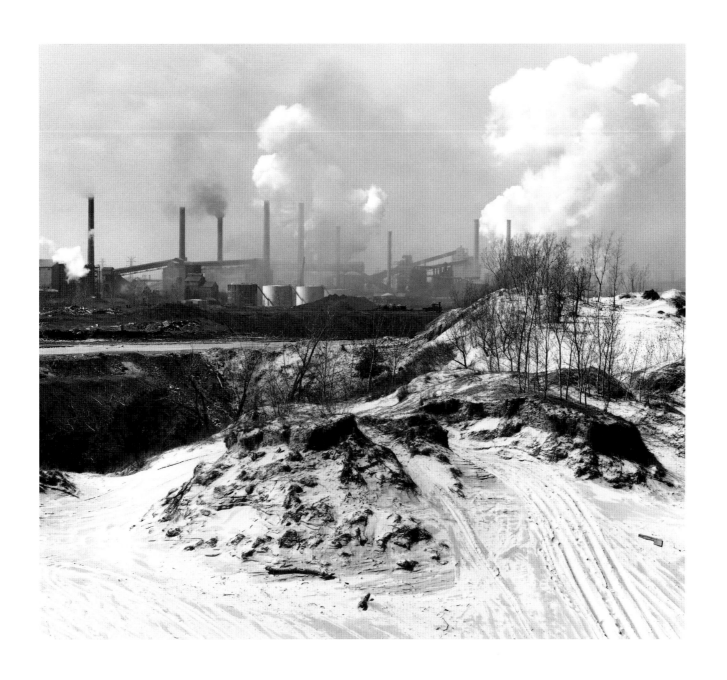

STEELWORKS, GARY, INDIANA, 1973

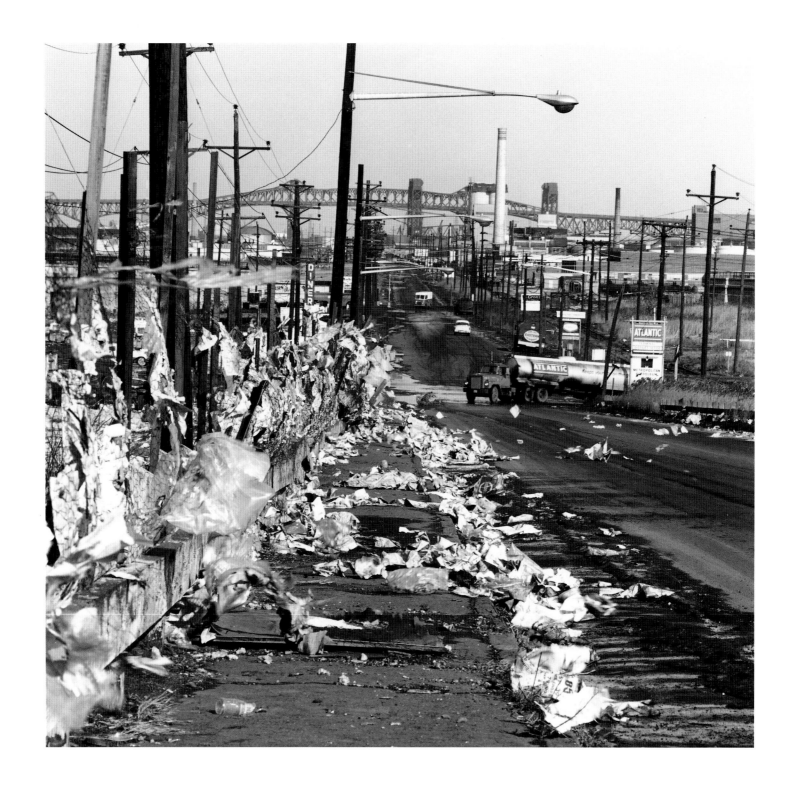

NEWARK, NEW JERSEY, 1964

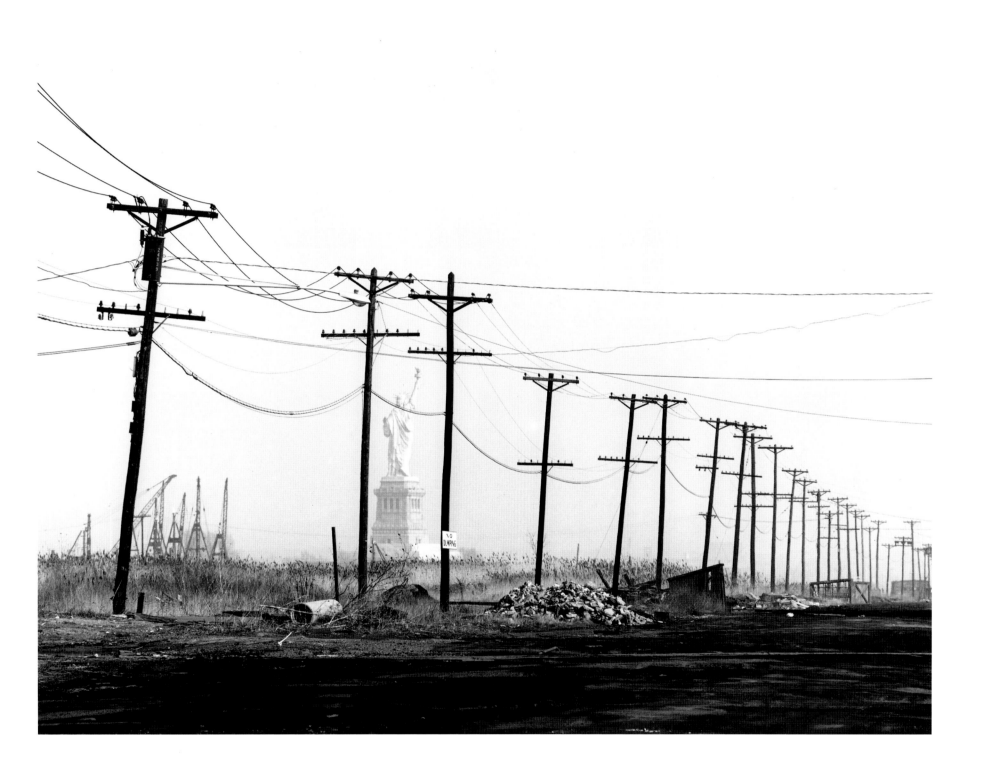

STATUE OF LIBERTY FROM CAVEN POINT ROAD, JERSEY CITY, NEW JERSEY, 1967

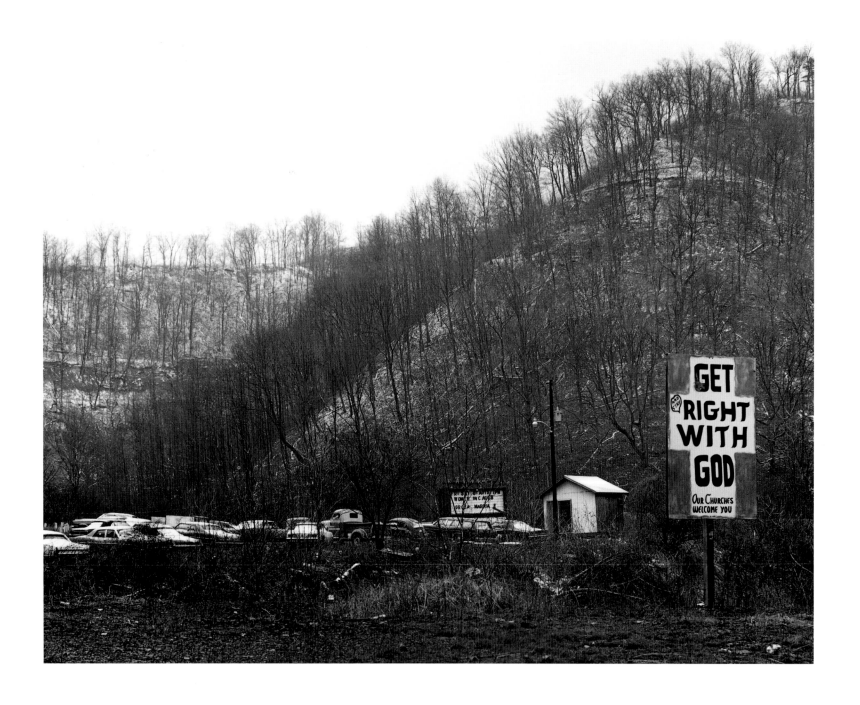

HARLAN COUNTY, KENTUCKY, 1974

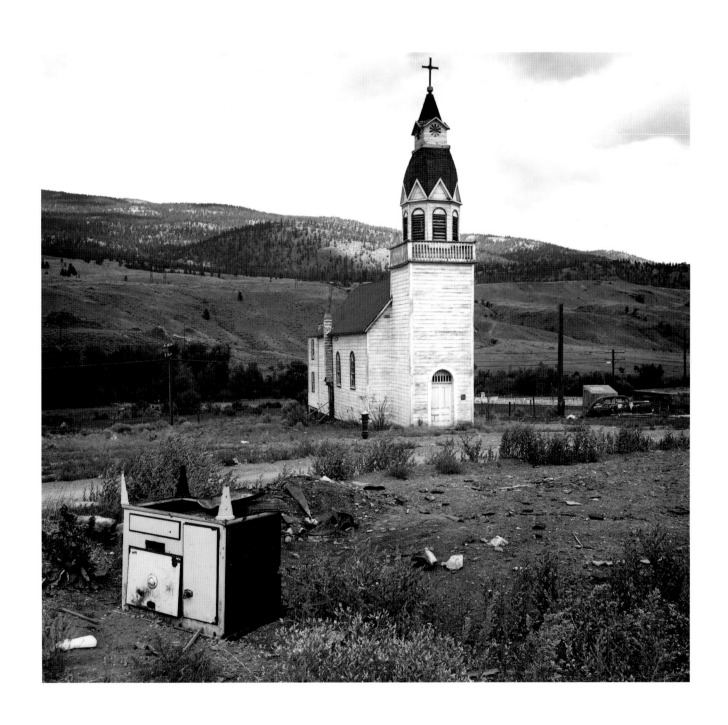

INDIAN RESERVATION, CACHE CREEK, BRITISH COLUMBIA, 1968

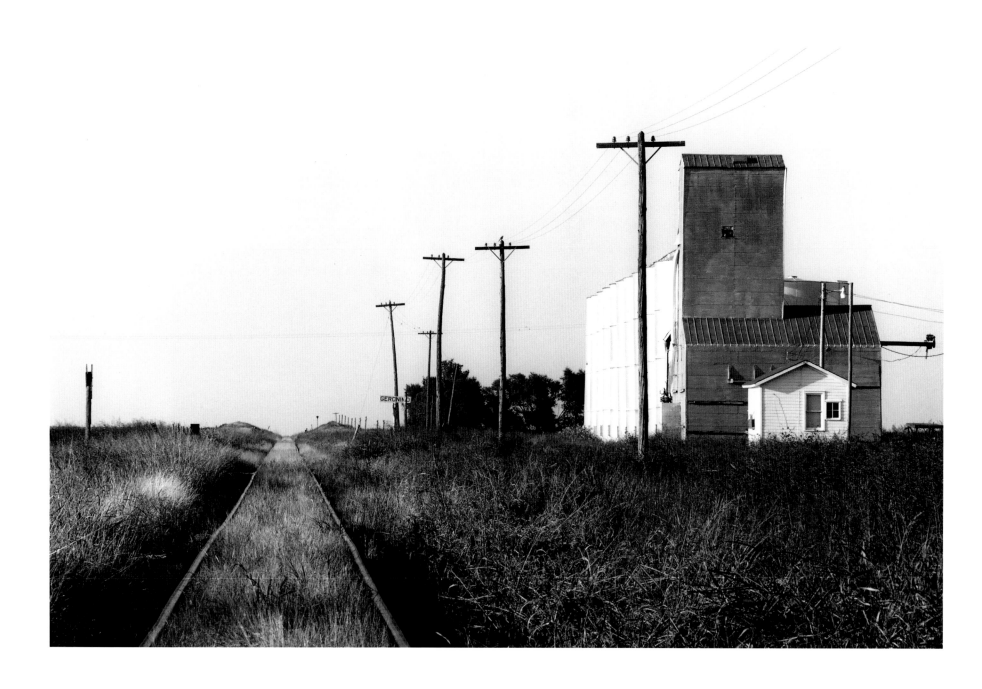

GERONIMO, OKLAHOMA, 1969

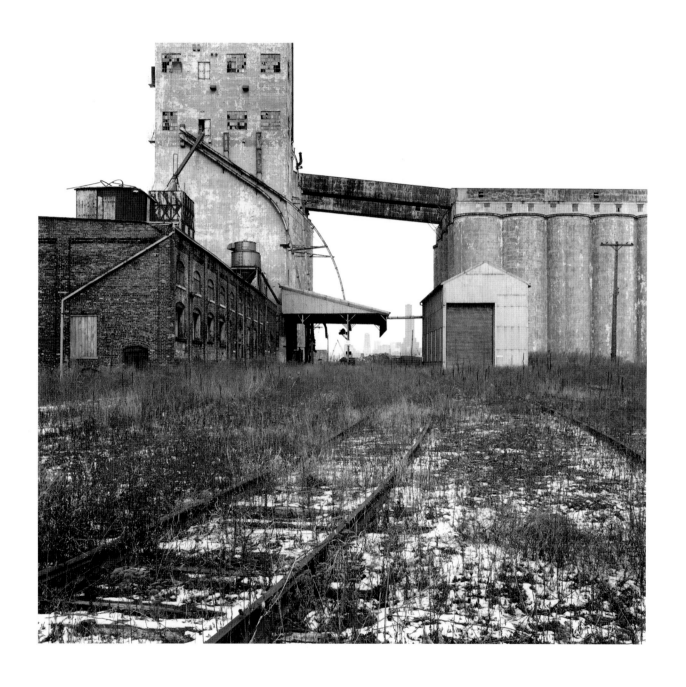

CHICAGO, ILLINOIS, 1983

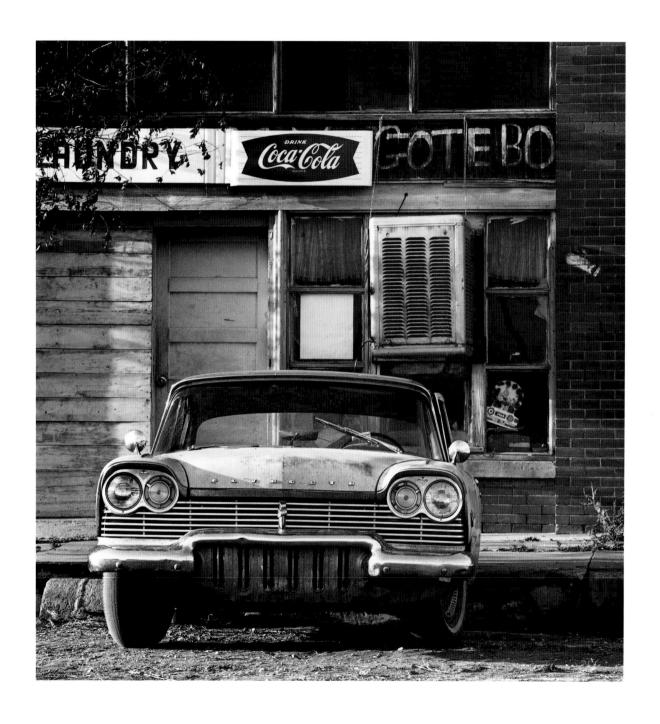

GOTEBO, OKLAHOMA, 1969

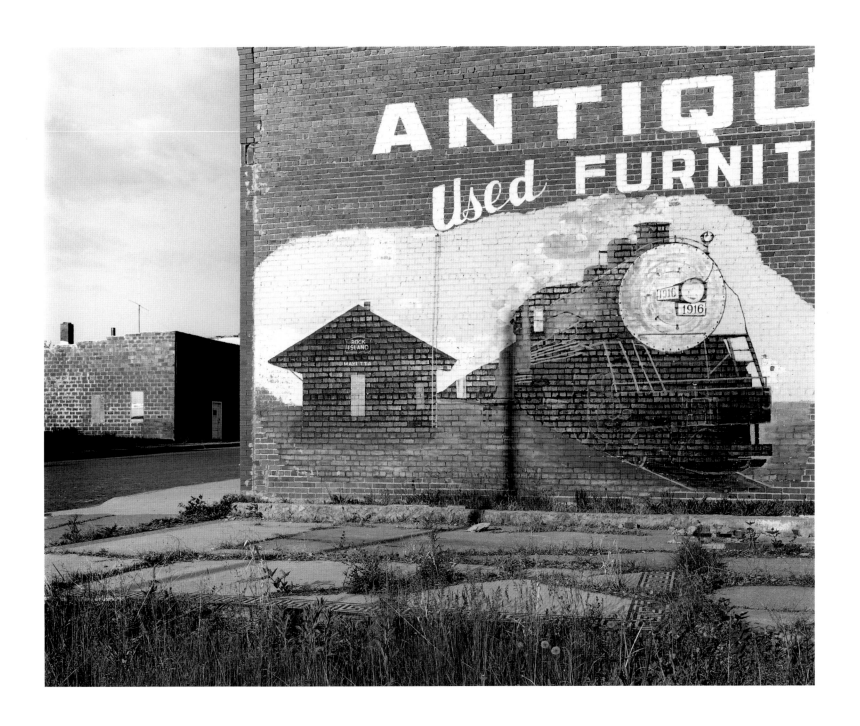

MAYETTA, KANSAS, 1991

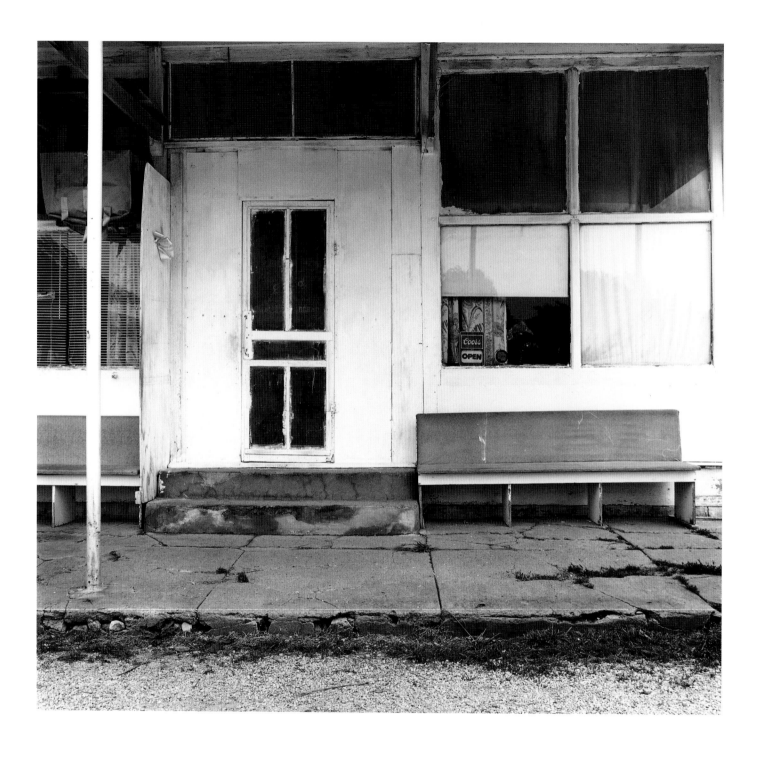

SADER'S CAFE, RAMONA, KANSAS, 1991

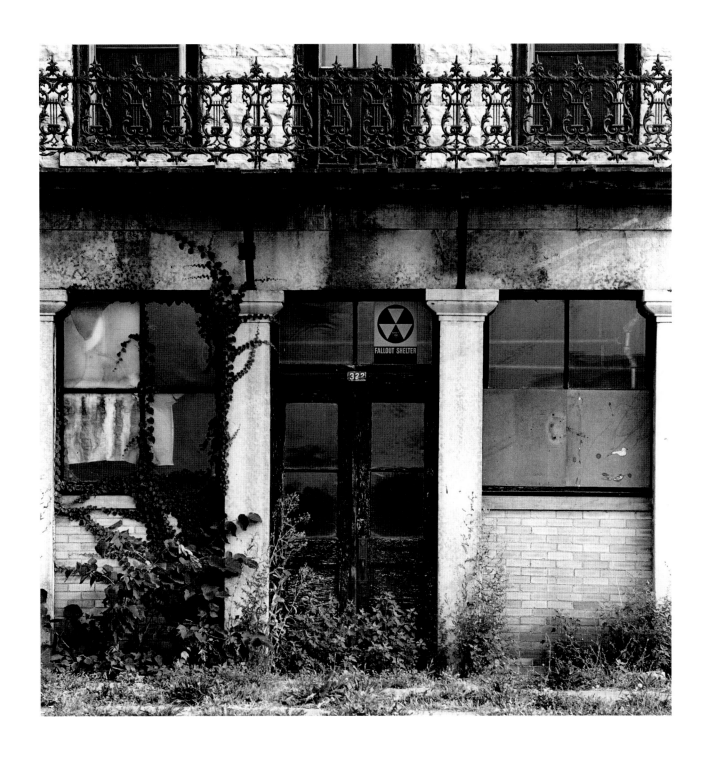

SANDUSKY, OHIO, 1969

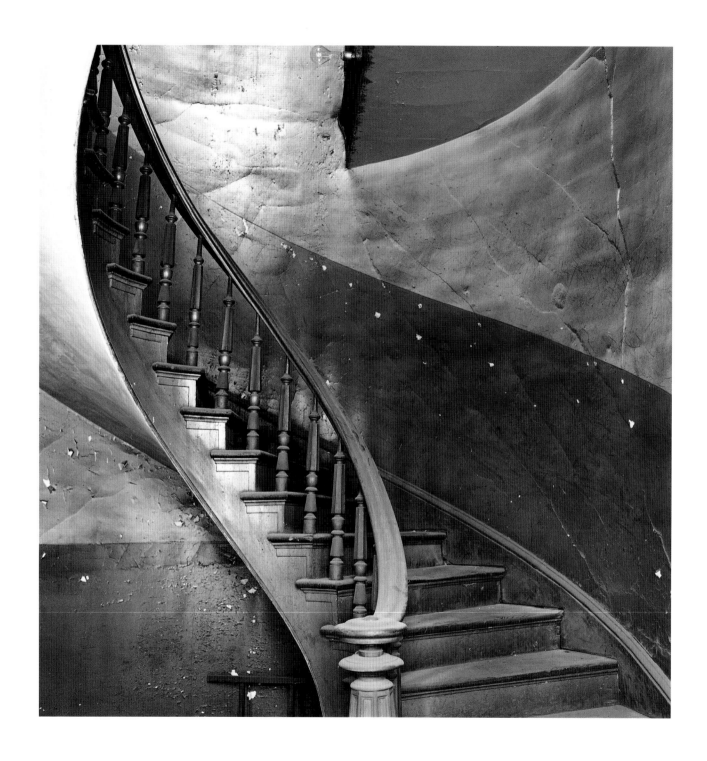

ABANDONED RAILROAD DEPOT, WILKES-BARRE, PENNSYLVANIA, 1964

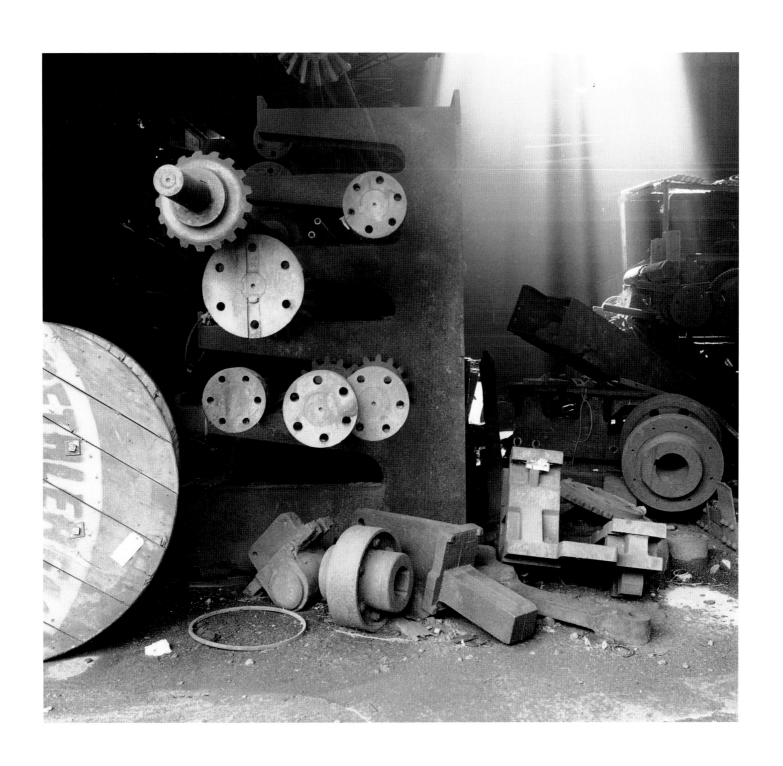

ABANDONED ROLLING MILL, BETHLEHEM STEEL, LACKAWANNA WORKS, LACKAWANNA, NEW YORK, 1985

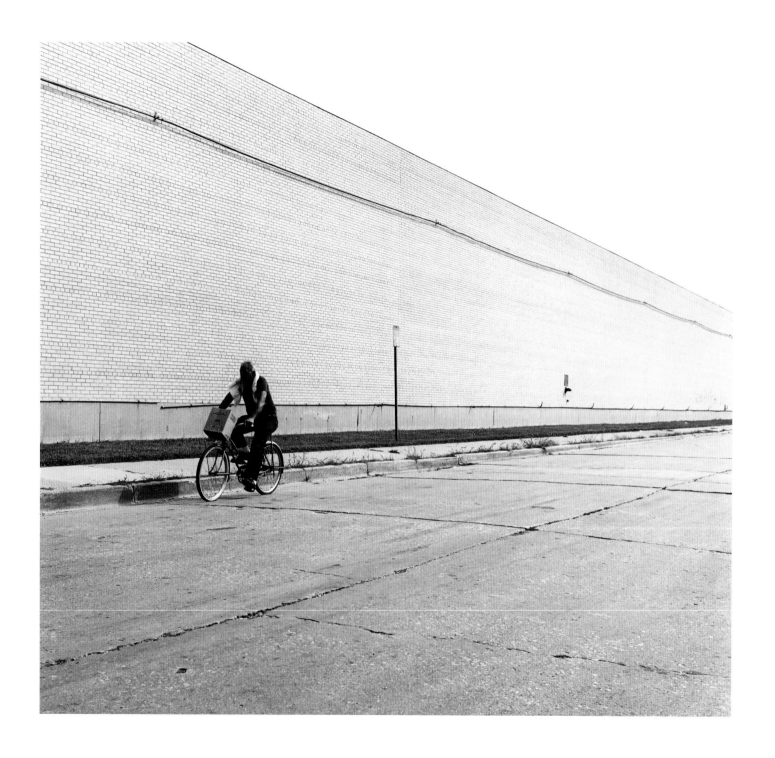

MAN BICYCLING IN INDUSTRIAL PARK, CHICAGO, ILLINOIS, 1982

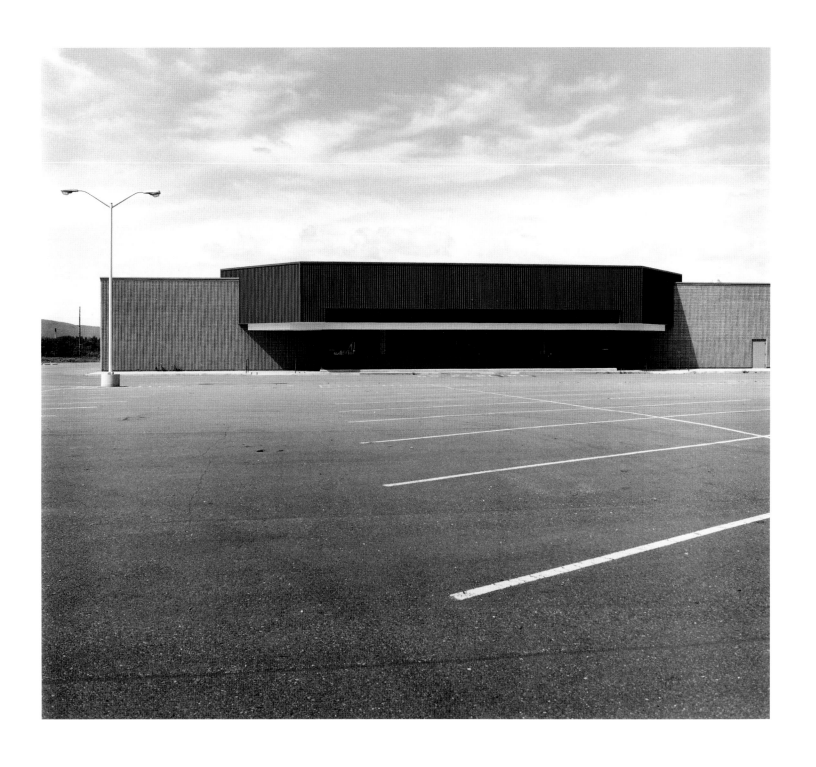

ABANDONED A&P MARKET, WAUSAU, WISCONSIN, 1980

SIDE OF BUILDING IN INDUSTRIAL PARK, CHICAGO, ILLINOIS, 1982

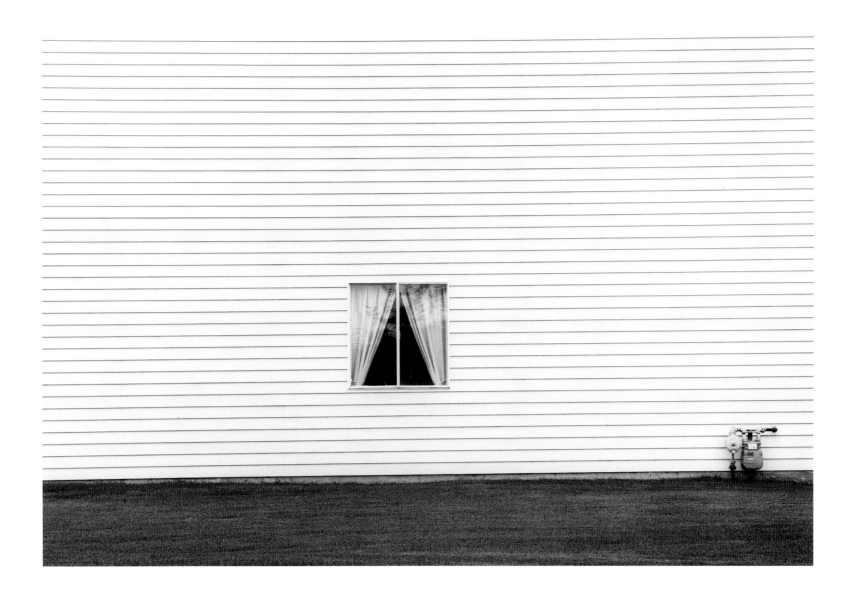

TRACT HOUSE, WARRENVILLE, ILLINOIS, 1981

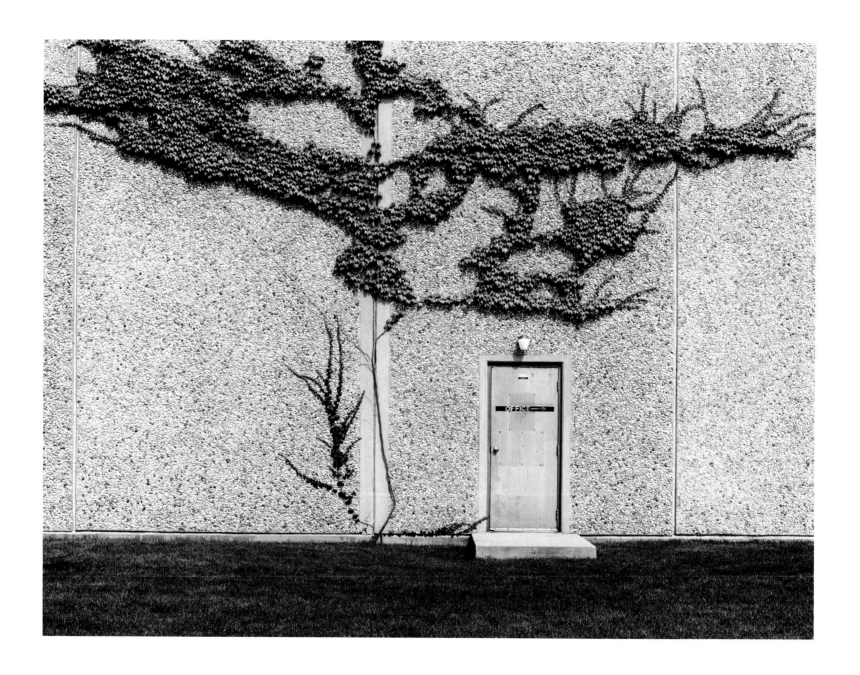

ELK GROVE VILLAGE, ILLINOIS, 1981

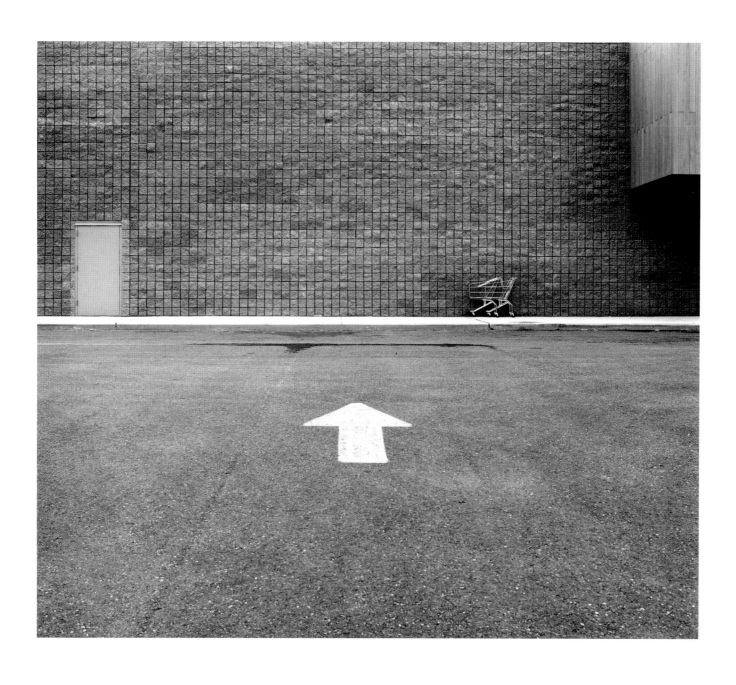

SHOPPING MALL, BEAVER DAM, WISCONSIN, 1981

ECLIPSE

May 10, 1869, was the day the "golden spike" was driven at Promontory, Utah. The date marked the completion of North America's first transcontinental railroad — one of the major events in our history.

May 10, 1994, was marked by an event of more cosmic significance. There was an annular eclipse at midday in Chicago. A shadow passed over Earth, which left no tangible mark. It did nothing to change the course of a nation's history. There was no celebration, no joyous debauchery to mark the event, as there had been in the desert north of the Great Salt Lake in 1869. Then, A. J. Russell was on hand with his wet plates to preserve the image of the two locomotives "touching head to head." The eclipse of May 10 produced no such iconography — CNN Headline News gave it a thirty-second bite that evening. It was never close to being totally dark in Chicago. The Moon covered 94 percent of the Sun. That was dark enough, though, to send a shudder down my spine at high noon's eerie twilight. Things were not right; the natural order had gone awry, albeit almost imperceptibly. At midday it was neither dusk nor dawn, the Sun was too high, the shadows too short. The world seemed suffused in ominous stillness. The birds stopped singing. As I looked out the window, disquieting thoughts of hurtling asteroids and comets and the demise of the dinosaurs came to mind on that otherwise sunny spring day.

The last eclipse of this magnitude in this part of the world occurred in 1806, when Chicago wasn't even a city: 188 years earlier, a mere nanosecond in cosmic reckoning, yet ancient history in ours. The year 1806 was sixty-three years before the events at Promontory, the same year that Lewis and Clark returned from one of the great epics in human endeavor. The "startling shriek" of the locomotive whistle had not yet rudely awakened Hawthorne from his "slumberous peace." The United States was barely thirty years old — still more of a concept than a nation.

Two hours later the Sun shone as brightly as ever. It was as if nothing had happened. Well, not quite. The shadow might have passed, but not without leaving a shadow of a different sort to vex the mind. That brief darkening was a frightening reminder of our insignificance. All our inventiveness, all our glorious intellect, is useless against the forces of nature. I began to feel we should have eclipses more often, lest we become too bloated with technological hubris. They concentrate the mind wonderfully on humankind's powerlessness in the face of the larger forces that be.

Our next significant eclipse in North America won't occur until 2012 — and the next total eclipse not until 2017. What kind of world will its shadow cross a generation hence? It matters nothing to the conjunction of the Moon and Sun.

PILES OF TACONITE PELLETS (IRON ORE), SUPERIOR, WISCONSIN, 1979

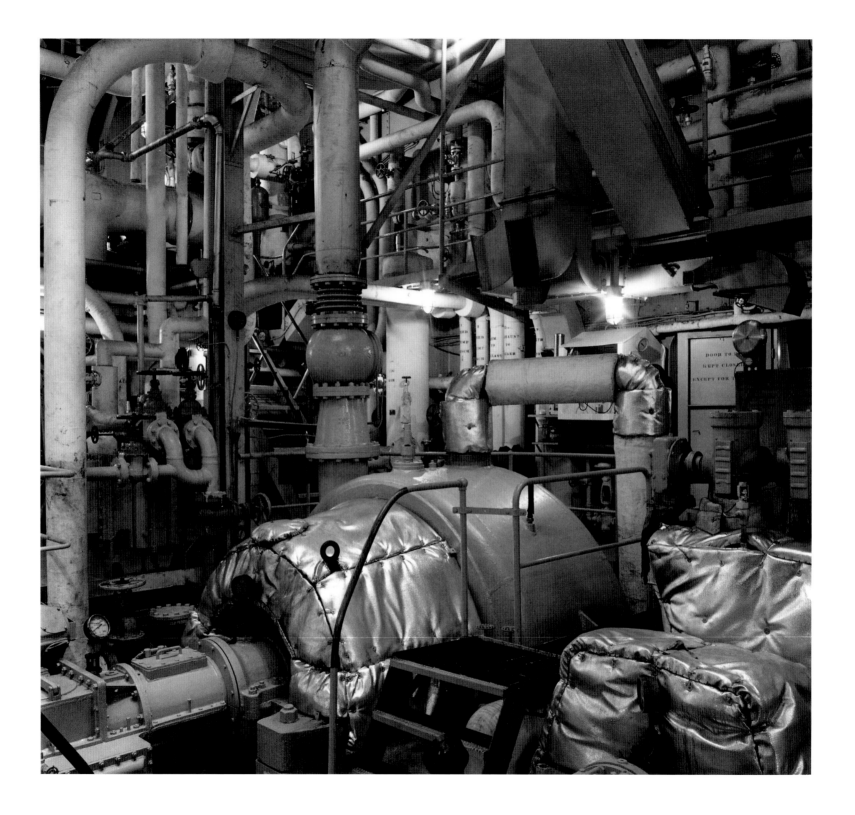

ENGINE ROOM, STEAMER *KINSMAN ENTERPRISE*, 1990

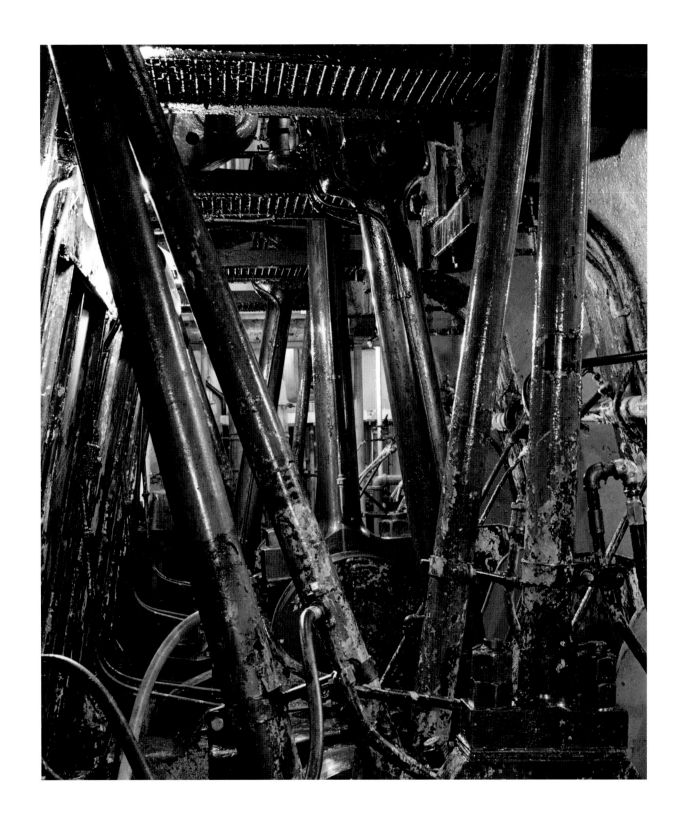

TRIPLE EXPANSION ENGINE FROM CRANK DECK OF STEAMER *CRISPIN OGLEBAY*, 1990

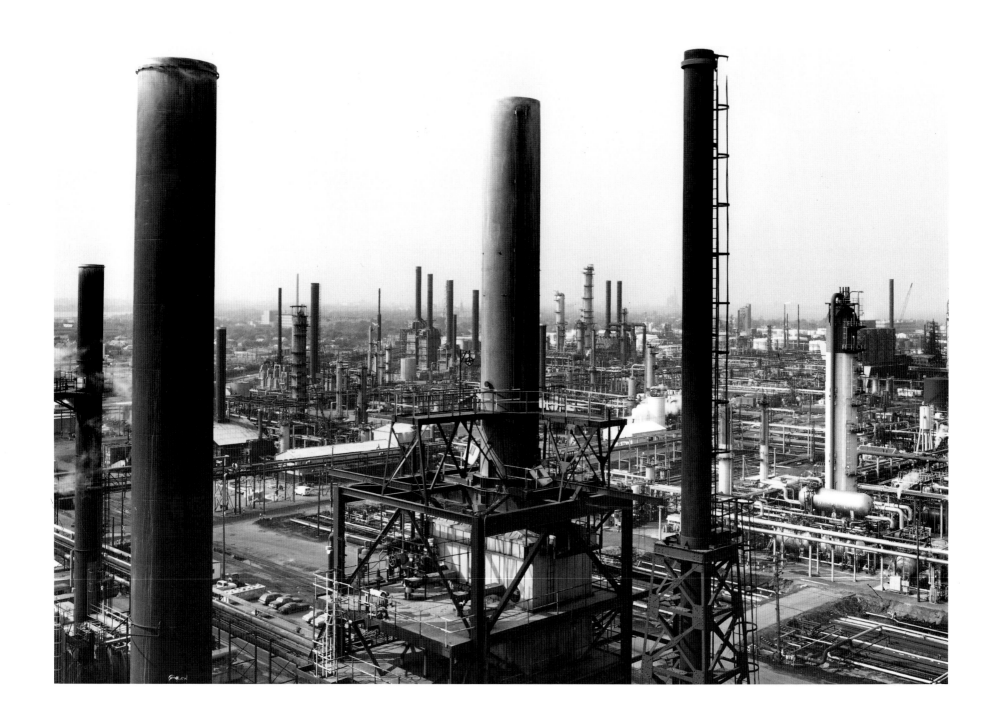

STANDARD OIL REFINERY, WHITING, INDIANA, 1981

NEW YORK CITY, 1966

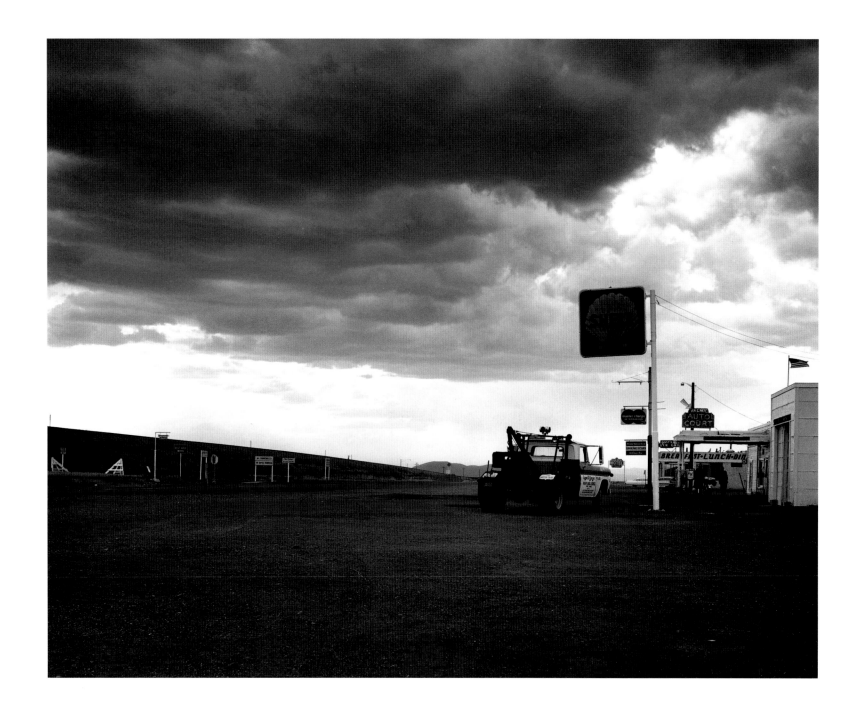

VALMY, NEVADA, 1973

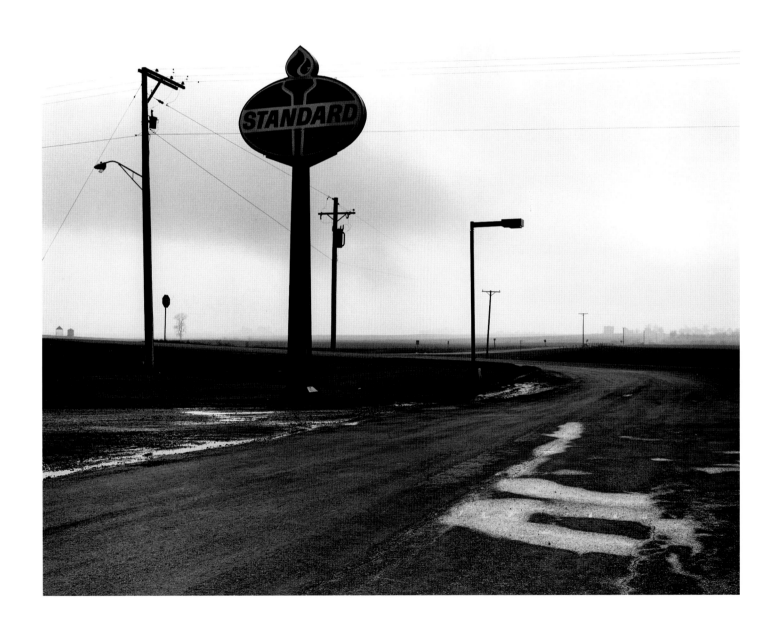

GAS STATION BY I-57, PEOTONE, ILLINOIS, 1981

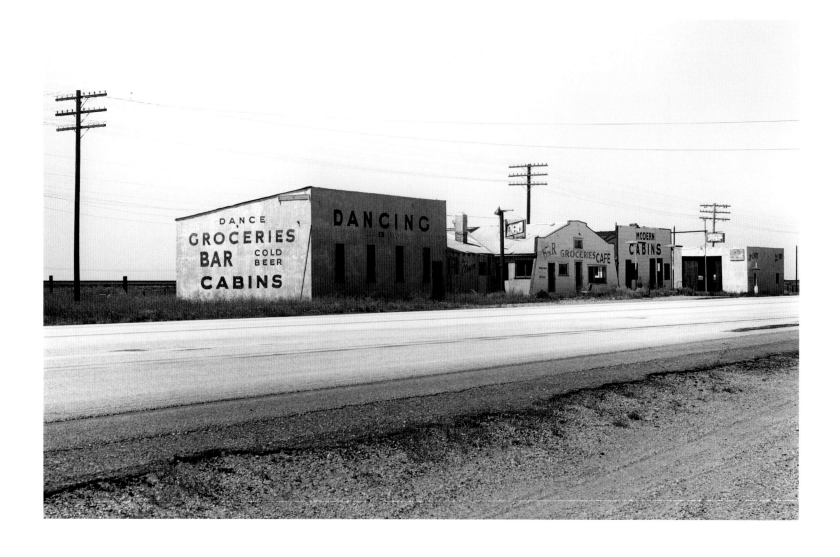

BOSLER, WYOMING, 1974

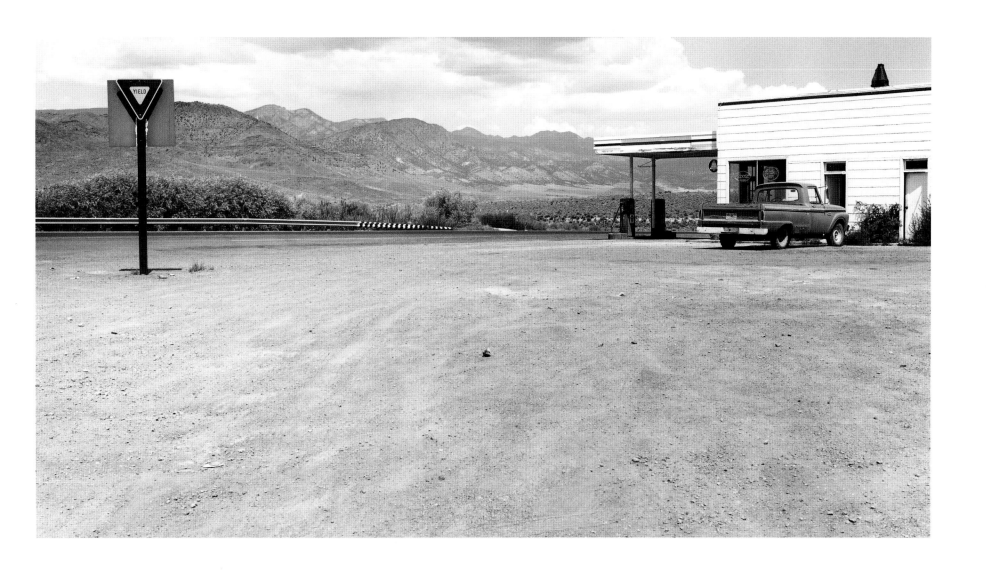

GAS STATION, PIUTE COUNTY, UTAH, 1973

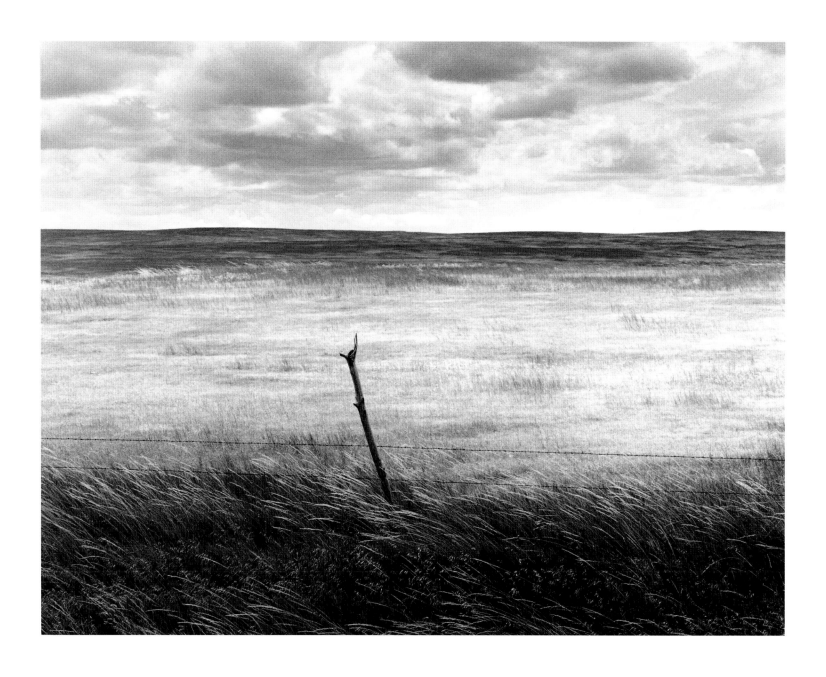

NEAR FAITH, SOUTH DAKOTA, 1971

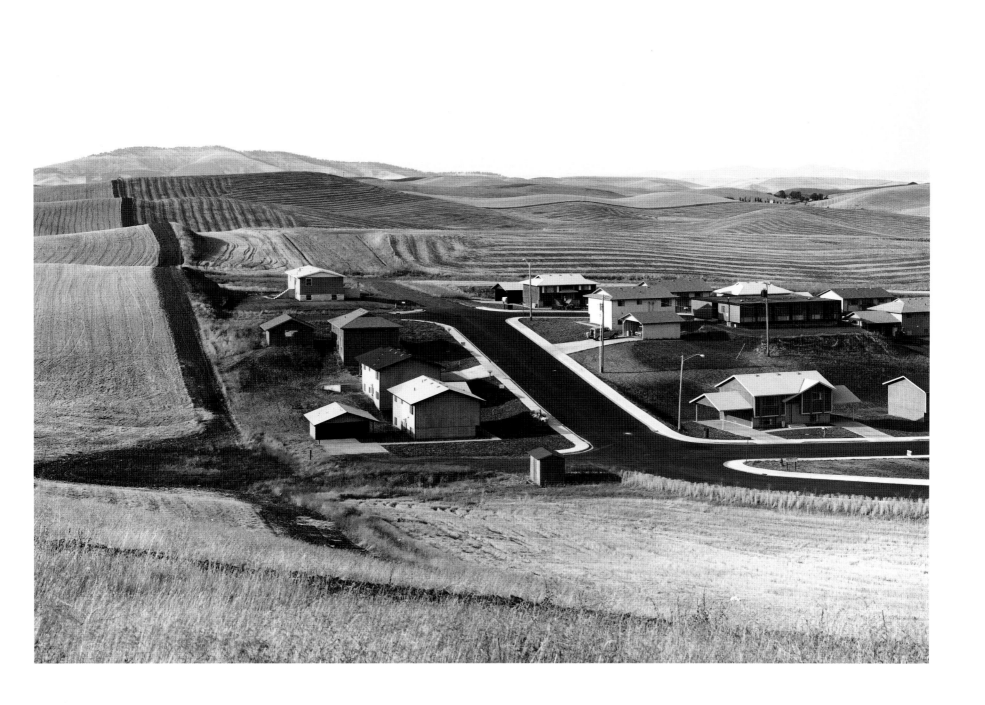

NEAR PULLMAN, WASHINGTON, 1973

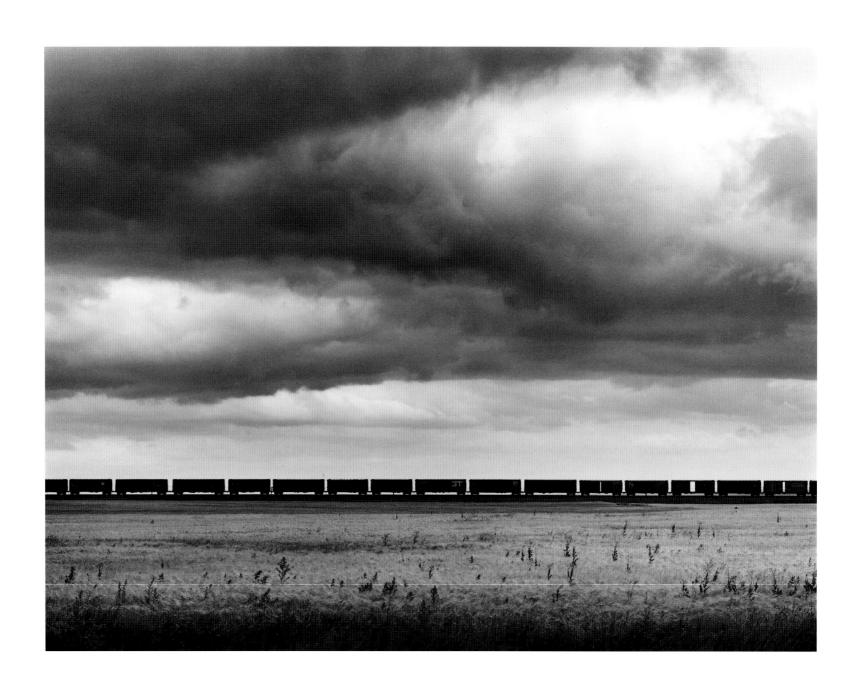

GREAT NORTHERN RAILWAY, FREIGHT TRAIN WEST OF HAVRE, MONTANA, 1968

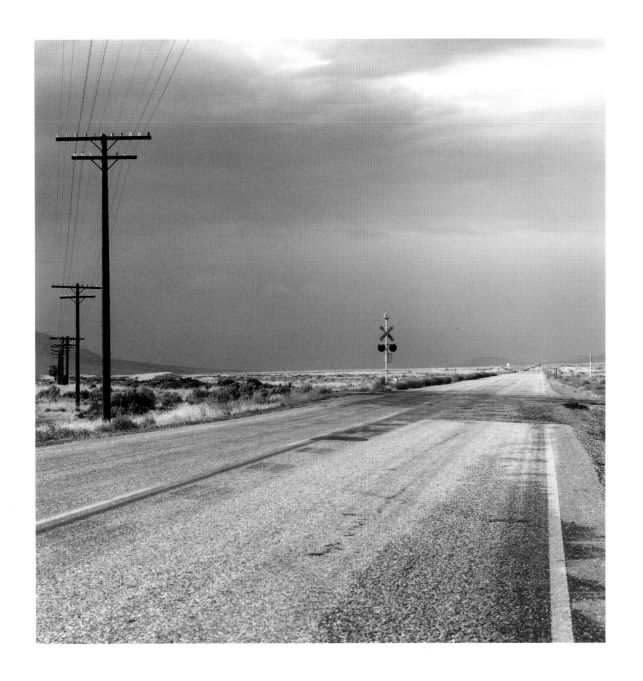

ROUTE U.S. 93, SOUTH OF WELLS, NEVADA, 1973

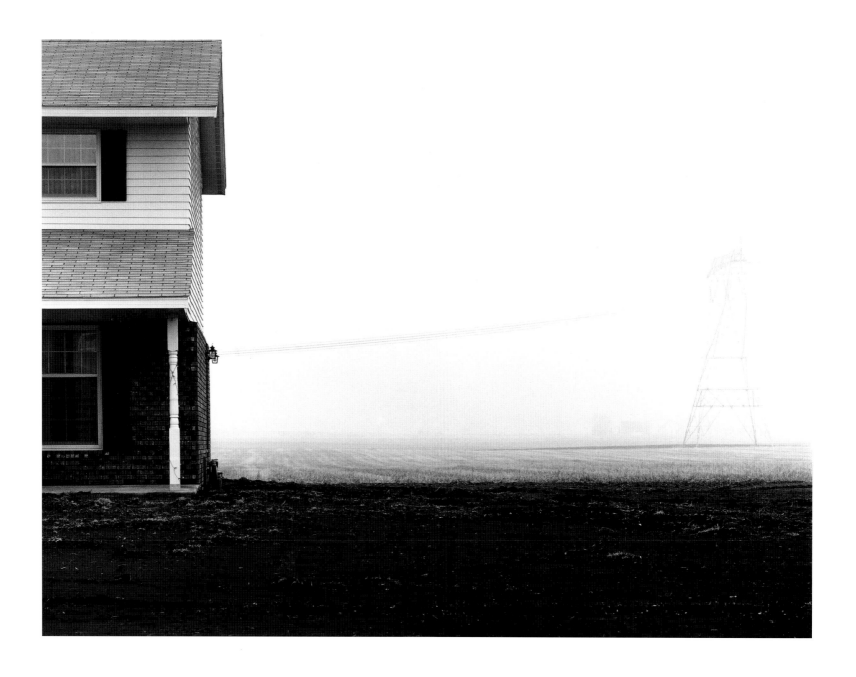

TRACT HOUSE NEAR MANTENO, ILLINOIS, 1981

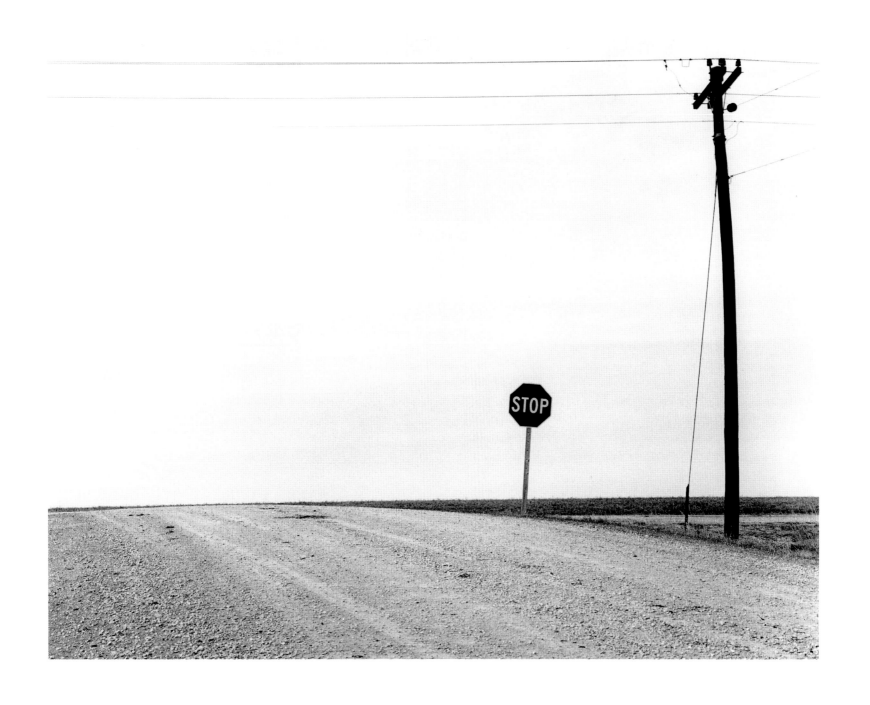

INTERSECTION NEAR WAUKON, ALLAMAKEE COUNTY, IOWA, 1987

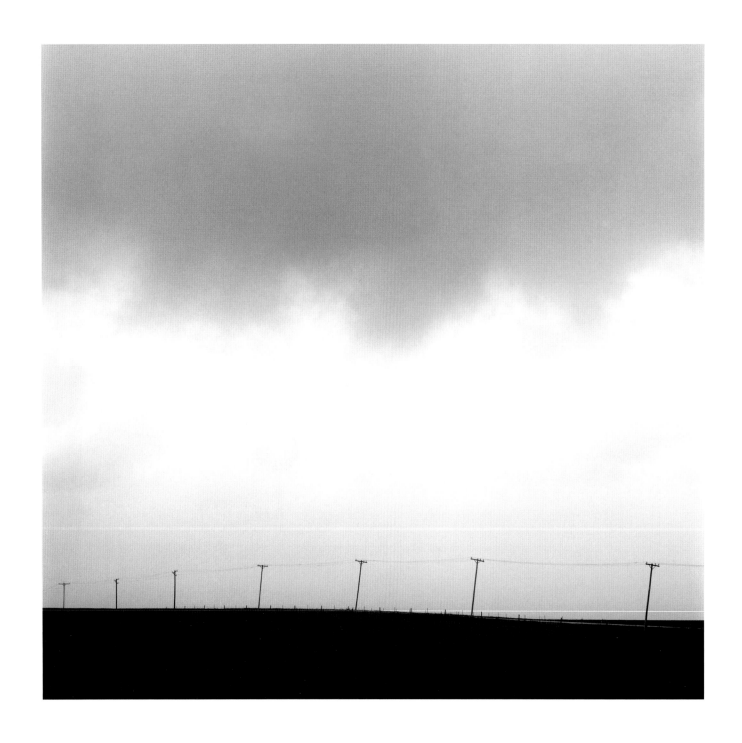

GRUNDY COUNTY, IOWA, 1983

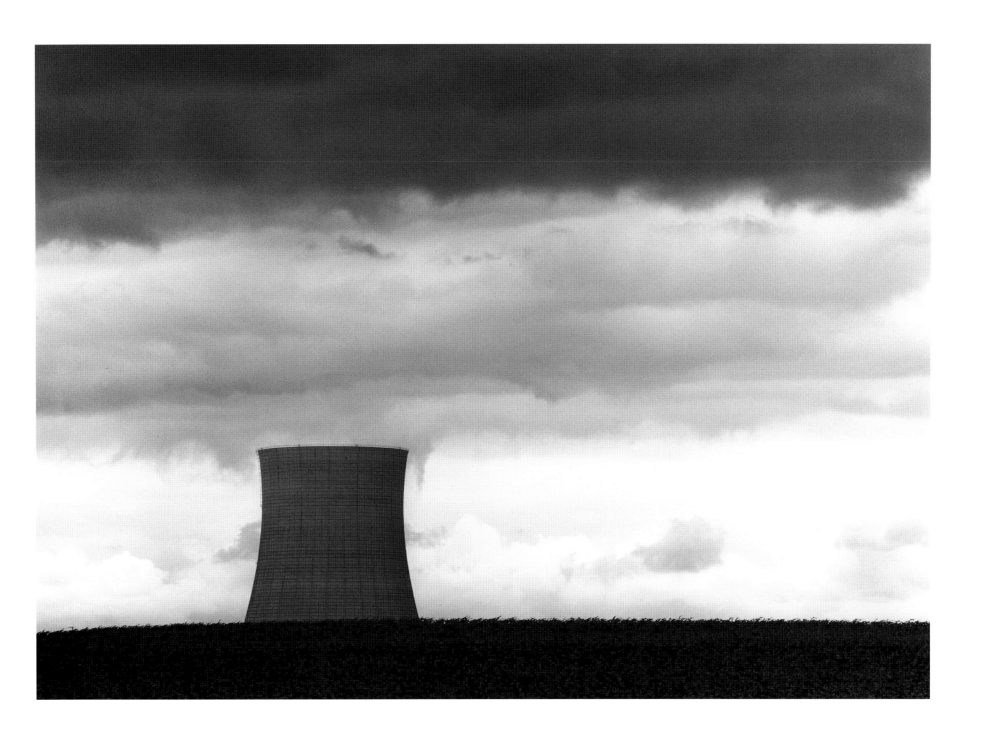

NUCLEAR PLANT, STILLMAN VALLEY, ILLINOIS, 1981

EAST OF LAS VEGAS, NEW MEXICO, 1971

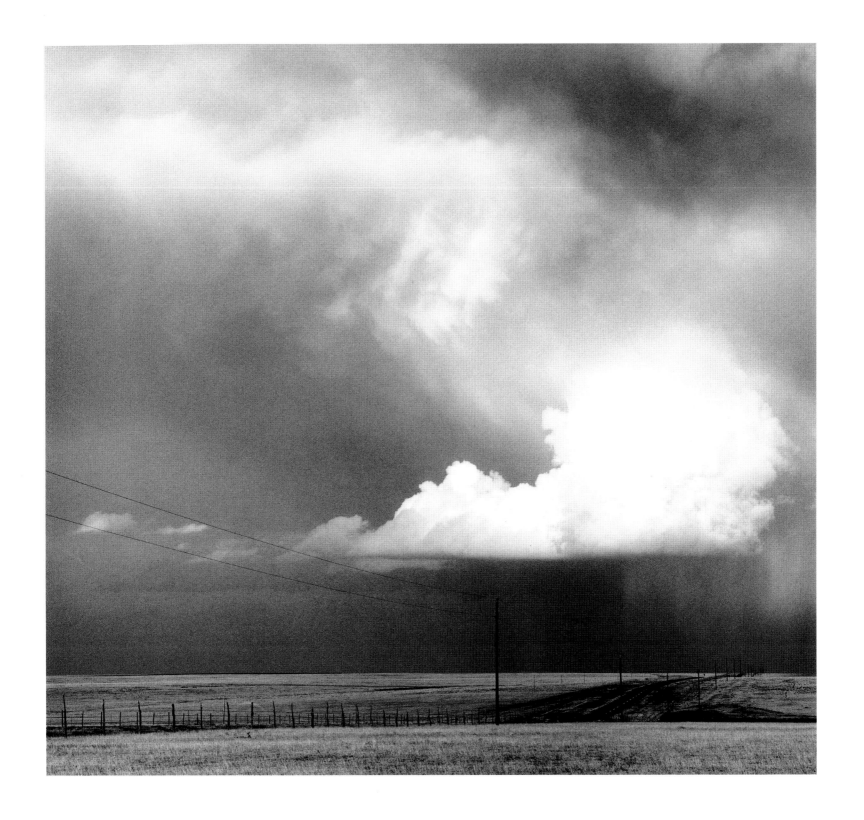

ACKNOWLEDGMENTS

I find writing acknowledgments almost the hardest part of making a book; never more so than now. Too many paths have intertwined with mine over the past forty years to thank all who have helped me along the way. Invariably, any attempt to do so would mean that I would forget many more who should be acknowledged.

There are, however, a few who must be singled out: Glenn Hansen, Michael Bryers, and Boram Kim, my three stalwart assistants, who over the past seventeen years helped me produce a truly prodigious amount of work. You managed to contend with my many moods and the fact that I am never satisfied. I shall never forget those seemingly endless days in the darkroom — nor should I imagine will you! Without your dedication, I would have never accomplished so much. Thank you!

It would be equally impossible not to mention my first and late wife, Pleasance, who spent so many years with me in the field during the many expeditions we made in quest of photographs. And to our two children, Daniel and John, who were forced to spend so many months waiting while your father waited for the light; forgive me for asking you to be so patient.

To Alan Trachtenberg I would like to say I am greatly honored to have had you write the introduction to this book. Your words reflect what I have always believed is the true nature of my work. I am most grateful for your insight and appreciation.

All books in my experience are collaborations, but the making of this book has been exceptional. It has truly been a joint effort, one in which I have relied on the judgment of two people: Janet Bush, my editor and the executive editor of Bulfinch Press, and Susan Marsh, who designed this book. We not only have worked together as a triumvirate, but you both have gone far beyond the call of duty. Thank you for being so indulgent and supportive. And to Ann Eiselein, who it seems carries the weight of Bulfinch on her shoulders, thank you for all your efforts — and unfailing cheerfulness. Thanks also to Steve Lamont for his fine copyediting. A heartfelt word of gratitude, too, to my old friend Carol Judy Leslie, the publisher of Bulfinch Press, for setting the wheels in motion that made this project a reality. It was nice to be working with you again.

On a personal level, I would like to say to my two youngest children, Philip and Karen, forgive me for not always being available when you needed me and thank you for not interrupting me during all those times when I was at work. You have my respect and my love, too, although there must have been times when you wondered if I loved you. Just for the record, I do.

And to Sandra, my dear wife, how do I thank you? You will deny it up and down, but I know better than anyone that we forged this book together. The photographs and words may be mine, but from the very beginning the project was ours. Your ideas, your thoughts, your dedication, your appreciation of my work — and your love — are here on every page. I shall always look back on this time — the years we spent molding an idea into a book — as among the happiest of my life. I shall never forget all those evenings at Betise filling the tableclothes (albeit paper) with notes; the hours we spent on vacation probing and searching for a direction; and those nights you read and reread my manuscript and sifted through a thousand photographs until we found the right combination. You always kept me on track, asking, asking if this was what I really meant to say, always encouraging me whenever I began to founder, insisting that I clarify my thoughts. For twenty years you and I have worked together as a team, finding solutions to myriad problems — laughing, crying, struggling, rejoicing at our efforts. Your dedication has never ceased to amaze me. You are a simply wonderful person and I love you with all my heart. I am so glad you and I happened to be alive at the same time.

CHRONOLOGY

1932
Born in Boston, Massachusetts, October 9 to Roger Stanley Plowden and Mary Butler Plowden.

1933–34
Lived in Paris, spring 1933–fall 1934.

1934–38
Lived on East End Avenue, New York City.

1938
Lived in Peterborough, New Hampshire, in the summer and Poundridge, New York, in the fall. Sister, Joan, born October 31.

1939–40
Lived in Greenfield Hill, Connecticut.

1940
Moved to Madison Avenue, New York City.

1941
Parents bought farm in Putney, Vermont.

1941–1945
Attended Walt Whitman School and Collegiate School in New York City.

1946
Attended Choate School in Wallingford, Connecticut.

1947
Attended Trinity School in New York City.

1948
Entered Putney School in Putney, Vermont, where he first learned darkroom techniques from classmates Timothy Asch, John Yang, and J. David Sapir.

1951
Graduated from Putney School and entered Yale University.

1954
First photograph published, in *Trains Magazine*.

1955
Graduated from Yale with B.A. in economics. Went to work for Great Northern Railway as assistant to trainmaster in Willmar, Minnesota.

1956
Returned to New York City.

1957
Traveled in Europe, June–November.

1958
Worked for American Express Company as travel clerk and Nametra, Inc., as travel agent. Went to Phoenix, Arizona, where after discussions with his aunt, Ellen Butler, he made the decision to become a photographer.

1959
Career as professional photographer began in January when he became assistant to O. Winston Link in New York City. Made first photography expedition, to eastern Canada and Maine to photograph steam locomotives, July–September. Studied with Minor White in Rochester, New York, October–February 1960.

1960
Undertook second expedition to eastern Canada and Maine to photograph the very last active steam locomotives in North America, March. Met Walker Evans; Bryan Holme, the publisher of Studio Books; and his first wife, Pleasance Coggeshall, April. Father died, September.

1960–61
Worked as assistant to photographer George Meluso, New York.

1961
Began regular assignments for *Columbia College Today* (1961–64).

1962

Married Pleasance Coggeshall, June 20. Had first assignment for *Fortune.* First exhibition was at New York Public Library, Hudson Park Branch.

1962–64

Lived on Remsen Street in Brooklyn Heights.

1963

Made first trip to photograph steamboats for book *Farewell to Steam.*

1963–66

Made numerous photographic expeditions for *Farewell to Steam* and *Lincoln and His America.*

1964

Given first major photographic assignment to photograph route of Lincoln's funeral train, for *American Heritage.* Took various trips to photograph American steamboats in what was to be the last of year of operation for most.

1964–65

Lived on farm in Putney, Vermont. Did extensive work for *Vermont Life, American Heritage,* and *Horizon.*

1965–69

Lived on East 87th Street, New York City.

1965

First son, John Stanley Plowden, born June 22.

1966

Commissioned by the New York State Council on the Arts to make photographic study of the architecture of Binghamton and Cazenovia, New York, for the book *Wayne County: The Aesthetic Heritage of a Rural Area* (not published until 1979.) Commissioned by the Committee of Advisors to the Federal Highway Administrator, U.S. Department of Transportation, to study urban highway design. *Farewell to Steam* published (Brattleboro, Vt.: Stephen Greene Press).

1967

Second son, Daniel Coggeshall Plowden, born March 2. Two portfolios published in *Fortune* ("The Bridges of Pittsburgh" and "Tugboats"). Photographed extensively for the book *Lincoln and His America. Gems* (illustrations only) published by Studio Books (New York: Viking Press). Work included in the exhibition "Photography in the Fine Arts V," Metropolitan Museum of Art, New York City, winter.

1968

Awarded Guggenheim Fellowship to make photographic study of North American bridges. Traveled with family 39,000 miles, coast to coast, June–November.

1969–76

Lived on Summit Avenue, Sea Cliff, New York.

1969

Continued to make study of bridges. Traveled with family, April, July–November.

1970

Lincoln and His America published by Studio Books (New York: Viking Press). Photographed Nantucket Island in color for book *Nantucket.* Took four trips, spring, summer, fall , and winter.

1971

Exhibition "The Hand of Man on America" opened at the Smithsonian Institution in Washington, D.C. (Traveled March 1971– March 1981 under the auspices of the Smithsonian Institution Travelling Exhibition Service.) *The Hand of Man on America* published (Washington, D.C.: Smithsonian Institution Press). *Nantucket* (co-author) published by Studio Books (New York: Viking Press). Made two trips to the Great Plains to make photographs for *The Floor of the Sky,* April, July–October.

1972

Took third trip to Great Plains, March. *Floor of the Sky* published (New York: Sierra Club Books). Traveled to West Coast to photograph bridges and continued research on bridges project.

1973

Traveled extensively throughout United States to photograph bridges and make pictures for book *Commonplace,* January–November. Finished text and photographs for *Bridges: The Spans of North America. Cape May to Montauk* (all color) published by Studio Books (New York: Viking Press). Paperback edition of *The Hand of Man on America* published (Riverside, Conn.: Chatham Press).

1974

Commissioned by the American Association of State and Local History to illustrate five books in the series "The States and the Nation": *New Jersey, North Dakota, South Dakota* (New York: W. W. Norton & Co., 1977), *Vermont* (New York: W. W. Norton & Co., 1979) and *New York* (New York: W. W. Norton & Co., 1981). Traveled extensively to make photographs for above project. Also made trips to Appalachia, Nebraska, and Idaho and came up Mississippi River on towboat to make photographs for *Desert and Plain:*

The Mountains and the River. Bridges: The Spans of North America published by Studio Books (New York: Viking Press). *Commonplace* published (New York: E. P. Dutton & Co.).

1975

The exhibition "Bridges: The Spans of North America" opened at the Smithsonian Institution. (Traveled October 1976–May 1981 under the auspices of the Smithsonian Institution Travelling Exhibition Service.) Commissioned by Department of Transportation and Smithsonian Institution to photograph railroad men and by *Audubon* to photograph for several stories, including barn portfolio. Photographed onboard New York Harbor tug *Julia C. Moran* for children's book *Tugboat. Desert and Plain, The Mountains and the River* (co-author) published (New York: E. P. Dutton and Co.).

1976

Tugboat published (New York: Macmillan). *"Railroad Men"* photographs taken for Department of Transportation in 1975 exhibited in boxcar on the Mall by Smithsonian Institution's Performing Arts division. Received grant from the United Board of Homeland Ministries, United Church of Christ, to make a photographic study of the United States at the time of

the Bicentennial. Exhibition "American Vernacular" opened at the International Center of Photography, New York City. Divorced first wife, Pleasance. Met Sandra Oakes Schoellkopf, December 8.

1977

Married Sandra Oakes Schoellkopf, July 8. Lived on East 75th Street, New York City. Work included in traveling exhibition "The Great West" sponsored by the Department of Fine Arts, University of Colorado. (Traveled by the Smithsonian Institution Travelling Exhibition Service 1978–80.) Farm in Putney, Vermont, sold.

1978

Accepted appointment as Visiting Associate Professor at the Institute of Design, Illinois Institute of Technology, Chicago. Moved to Winnetka, Illinois. Bought house on Walden Road in August. *The Iron Road* (co-author) published (New York: Four Winds Press).

1979

Third son, Philip Schoellkopf Plowden born August 30. *Wayne County: The Aesthetic Heritage of a Rural Area* (co-author) published (New York: Publishing Center for Cultural Resources). Began making photographs for book *Steel.*

1980
Commissioned by the Chicago Historical Society to make photographic study of the industrial landscape of Chicago. Appointed Associate Professor of Design at the Institute of Design, Illinois Institute of Technology.

1981
Steel published by Studio Books (New York: Viking Press). Continued work on Chicago industrial project. Moved to current home on Cherry Street, Winnetka, Illinois, November.

1982
Daughter, Karen Calkins Plowden, born January 12. Awarded tenure at Institute of Design. Continued work on Chicago industrial project. *An American Chronology* published by Studio Books (New York: Viking Press). Exhibition shown at the Chicago Center for Contemporary Photography, September–November. Exhibition shown at the Federal Hall Museum, National Park Service, New York City, October–November.

1983
Continued work on Chicago industrial project. Wrote introduction to *The Gallery of World Photography/The Country* (Tokyo: Shueish Publishing Company). Work included in exhibition "An Open Land: Photographs of the Midwest 1852–1982," Art Institute of Chicago, June–August. (Traveled 1983–86.) Work included in exhibition, "Chicago: The Architectural City," Art Institute of Chicago.

1984
Resigned from Institute of Design. Accepted post as Lecturer in the School of Communications at the University of Iowa, Iowa City. Paperback edition of *Bridges: The Spans of North America* published (New York: W. W. Norton & Co.).

1985
Industrial Landscape published (New York: W. W. Norton & Co.). Exhibition "Industrial Landscape of Chicago" put on by Chicago Historical Society, April–July. Exhibition shown at the Albin O. Kuhn Library and Gallery, University of Maryland, Baltimore, April–June.

1986
Began photographing Iowa for *A Sense of Place.*

1987
Work shown in exhibition at the Kuntzmuseum, Lucerne, Switzerland, in conjunction with the International Festival of Music, August–September. *A Time of Trains* published (New York: W. W. Norton & Co.). Grant awarded by the State Historical Society of Iowa and the Iowa Humanities Board in conjunction with the National Endowment for the Humanities to make photographs for the project "A Sense of Place." Work included in exhibition "Road and Roadside," Illinois State University, March–April; Art Institute of Chicago, July–September. Photographed Iowa.

1988
A Sense of Place published (New York: W. W. Norton & Co., in association with the State Historical Society of Iowa). Exhibition "A Sense of Place" traveled under the auspices of the Iowa Humanities Board, December–; at the Iowa State Museum, December–March 1989. Appointed Visiting Professor, Communications and Art Department, Grand Valley State University, Allendale, Michigan.

1989
Exhibition "A Sense of Place" shown at the Smithsonian Institution, National Museum of American History, January–February. Began photographing the last of the Great Lakes steamers.

1990
Appointed Artist-in-Residence and Senior Fellow at the University of Baltimore —

Institute for Publications Design, Yale
Gordon College of Liberal Arts, Baltimore
(1990–91). Exhibition "Changing America:
The Photographic Art of David Plowden"
traveled under the auspices of Exhibits
U.S.A. — a division of the Mid-America
Arts Alliance Touring Exhibits Program
(1990–93).

1991
Re-appointed Visiting Professor, Communi-
cations and Art Department, Grand Valley
State University, Allendale, Michigan.
Continued photographing onboard lake
steamers, April–December. Began
photographing for *Small Town America,*
May.

1992
*End of an Era: The Last of the Great Lakes
Steamers* published (New York: W. W.
Norton & Co.). Photographed for *Small
Town America.*

1993
Exhibition "End of an Era" shown at Grand
Valley State University, Allendale,
Michigan, in conjunction with the
Muskegon Museum of Art,
February–March. Spent year printing.

1994
Spent year printing. *Small Town America*

published (New York: Harry N. Abrams).
Exhibition "Small Town America" opened
at Kathleen Ewing Gallery, Washington,
D.C., June.

1995
Agreement reached with the Beinecke
Rare Book and Manuscript Library of Yale
University to acquire the complete archive
of his work to date, including prints and
negatives, all published works, manu-
scripts, correspondence, journals, tapes
and notes, etc. Spent year in darkroom,
printing.

1996
Spent year in darkroom, printing.

1997
Exhibition "American Views" opens at the
Baly Museum of Art, University of Virginia,
Charlottesville, June–October. *Imprints,
David Plowden: A Retrospective*
published (Boston: Bulfinch Press).
Exhibition "Imprints, David Plowden: *A
Retrospective*" opens at the Beinecke Rare
Book and Manuscript Library at Yale
University, September–December. Exhibi-
tion "Imprints, the Photographs of David
Plowden" opens at the Albright-Knox
Museum, Buffalo, New York,
November–January 1998.

**Library of Congress Cataloging-in-
Publication Data**

Plowden, David.
 Imprints : David Plowden: a retro-
spective / preface by David Plowden ;
introduction by Alan Trachtenberg.
 p. cm.
 "A Bulfinch Press book."
 ISBN 0-8212-2323-2 (hc)
 1. United States — Pictorial works.
2. Photography, Artistic.
 I. Title.
 E169.04.P569 1997
973 — dc21 96-48891

LEHIGH VALLEY RAILROAD DEPOT, SOUTH PLAINFIELD, NEW JERSEY, 1963

DESIGNED BY SUSAN MARSH

TYPE SET IN META

PRINTED AND BOUND BY AMILCARE PIZZI, MILAN, ITALY